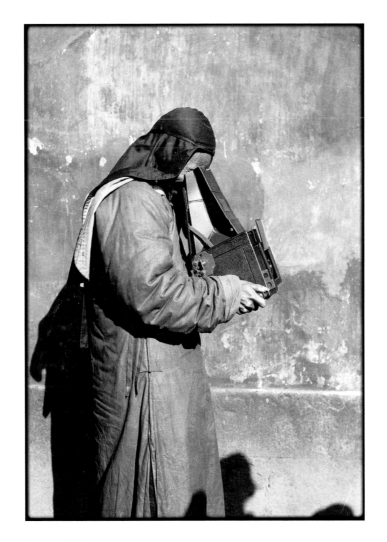

Japan, 1921

ODYSSEYS AND PHOTOGRAPHS

FOUR NATIONAL GEOGRAPHIC FIELD MEN

Maynard Owen Williams

Luis Marden

Volkmar Wentzel

Thomas Abercrombie

By Leah Bendavid-Val, Gilbert M. Grosvenor, Mark Collins Jenkins, and Viola Kiesinger Wentzel

FOCAL POINT

NATIONAL GEOGRAPHIC

WASHINGTON, D.C.

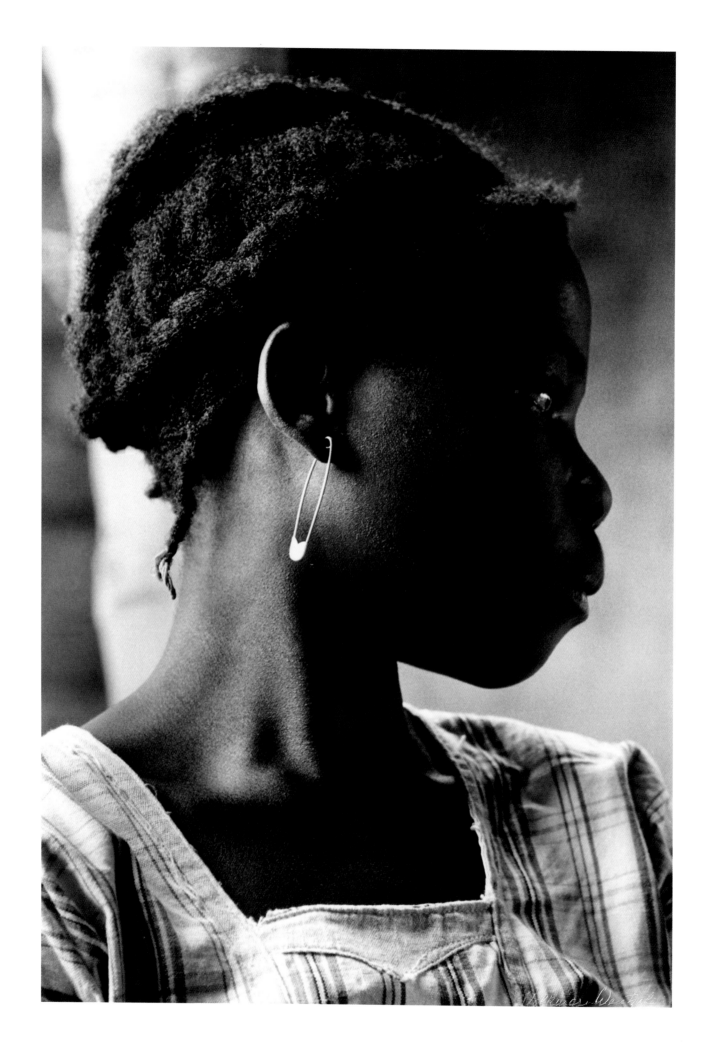

CONTENTS

—Volkmar Wentzel, Angola, 1961

Maynard Owen Williams
Iraq, April 15, 1931

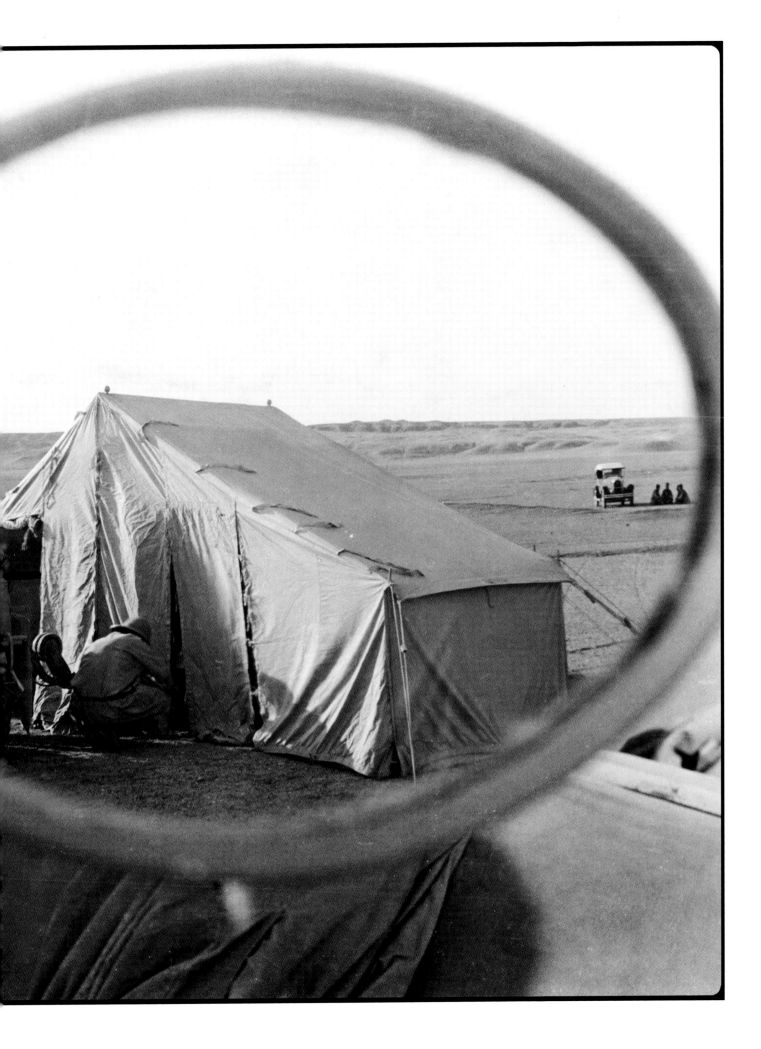

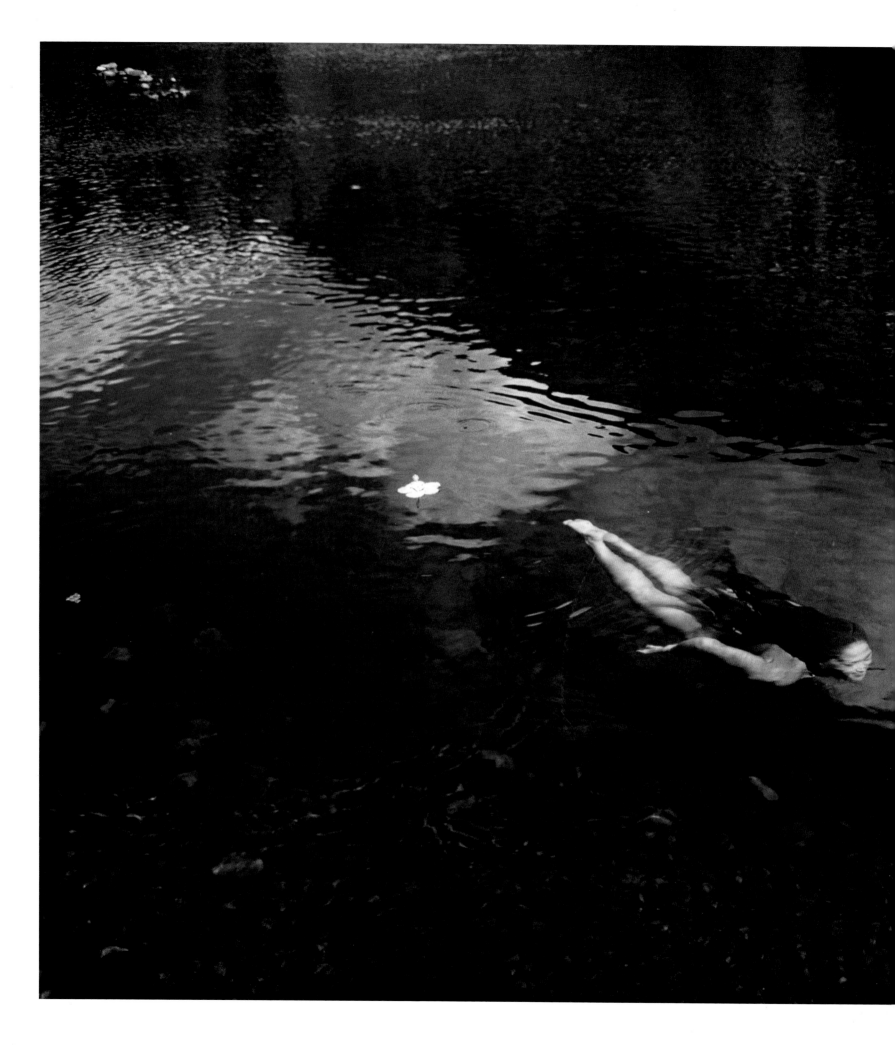

Luis Marden, Tahiti, 1962

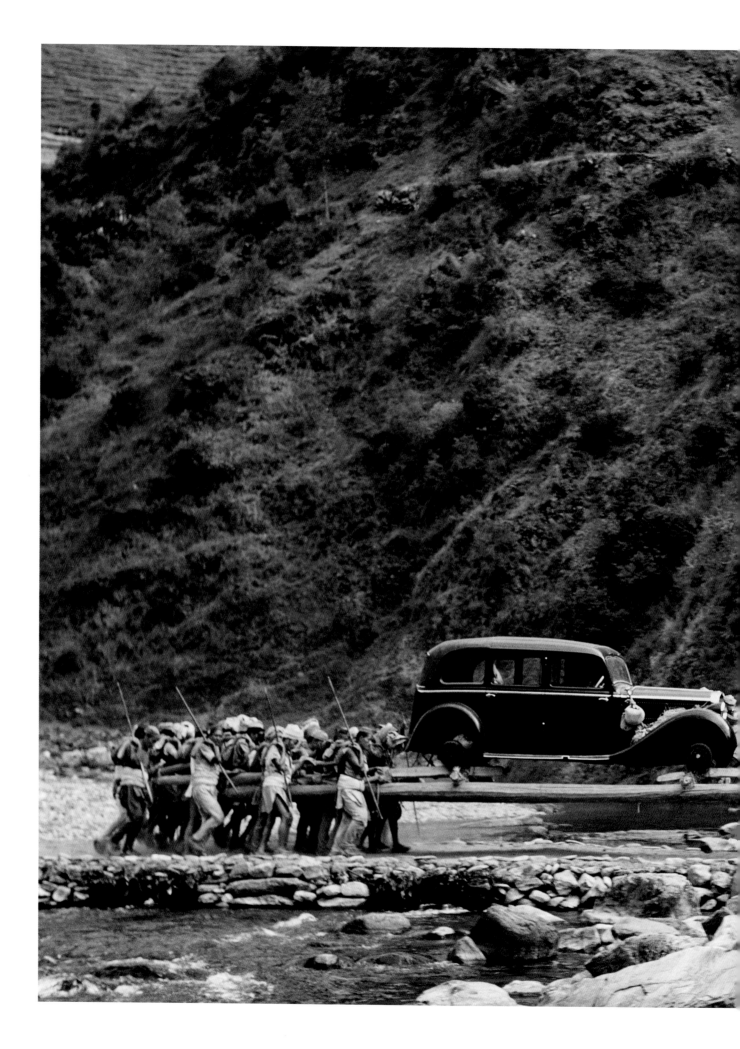

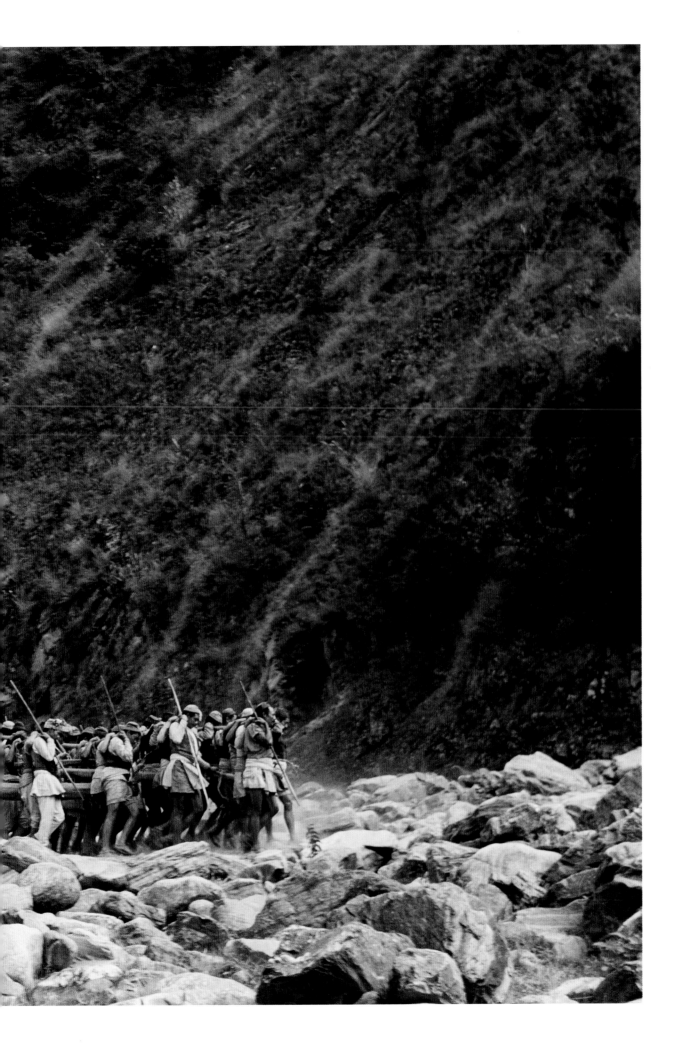

Volkmar Wentzel
Nepal, 1950

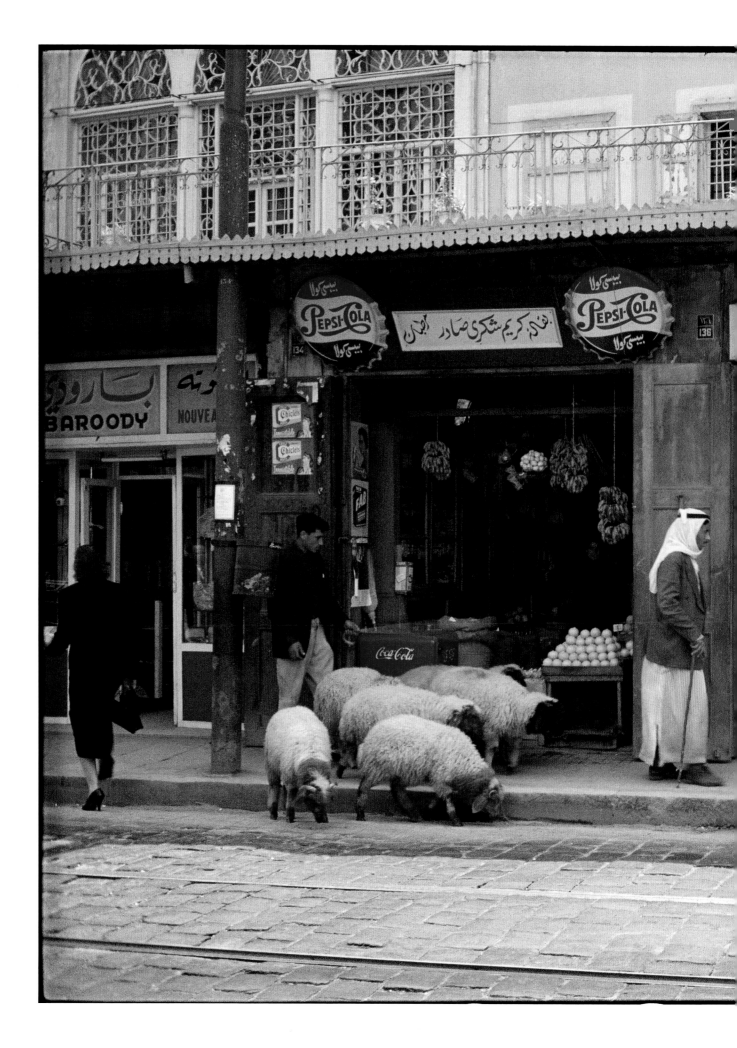

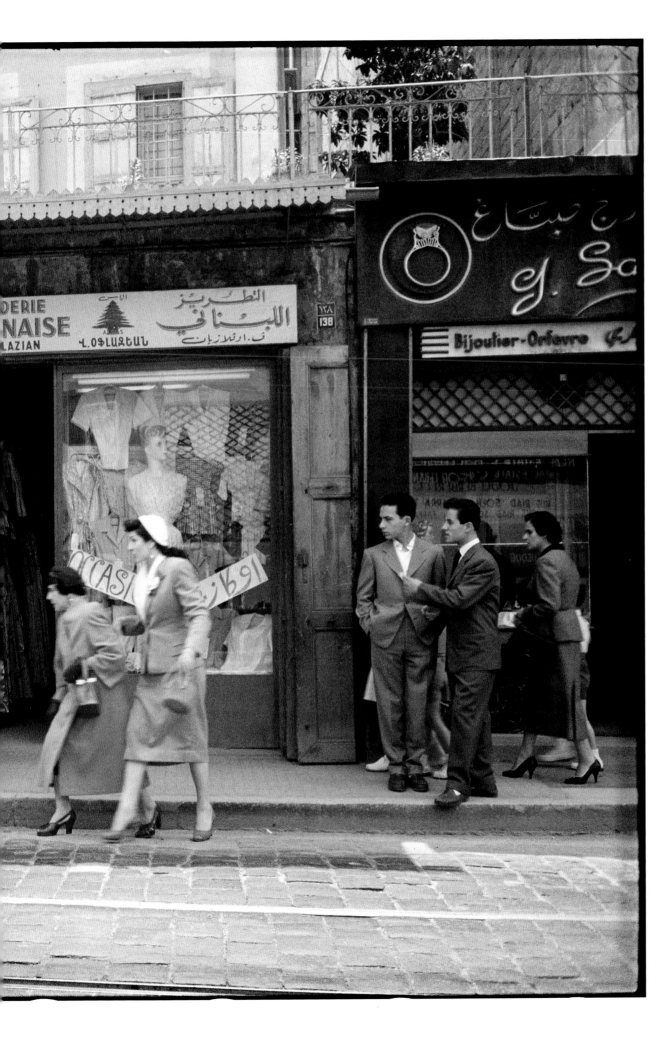

Thomas Abercrombie
Beirut, Lebanon, 1924

13

Introduction
Photography at National Geographic

BY GILBERT M. GROSVENOR

WHY HAS *NATIONAL GEOGRAPHIC* BEEN the most successful illustrated magazine in the past 120 years? To me the answer is simple, if twofold: superb photography and great storytelling. This book highlights four of the greatest photographer-storytellers in our history: Maynard Owen Williams, Luis Marden, Volkmar Wentzel, and Thomas J. Abercrombie.

For a photographic magazine to succeed certain stars must be perfectly aligned: There must be an enthusiastic audience; a determined, gutsy editor who *knows his readers;* the best modern technology; and of course, talented photographers. When the National Geographic Society was founded in 1888 these stars had not yet risen. Not one of the organization's 33 founders, however, could have dreamed that their small club, created for the "increase and diffusion of geographic knowledge," would one day be sending a full-color magazine each month to millions of members around the globe.

It was the Society's second president, Alexander Graham Bell, who realized that the small, penniless Washington-based organization needed a boost. So in 1899 he hired a young Amherst graduate, Gilbert Hovey Grosvenor, to build membership and refurbish the Society's lackluster journal, the *National Geographic* magazine. Bell and Grosvenor, who happened to be squiring Bell's daughter Elsie, teamed well together: Bell had money and ideas while Grosvenor possessed indefatigable energy and creativity. Bell believed that geography's purview was nothing less than the "world and all that is in it," and he emphasized the bond of membership, cemented by a widely admired journal, as opposed to mere subscription. Grosvenor, embracing both ideas, tenaciously signed up anyone—even people encountered on the street outside the Society's Washington, D.C., headquarters—who could afford the $2.00 membership fee.

When it came to improving *National Geographic*, Bell's advice was simple: "Use pictures, and plenty of them." Though half-tone photoengravings had been printed in the magazine for years, Grosvenor began using pictures more creatively. In the January 1905 issue, he published 11 pages of photographs depicting Lhasa, the mysterious capital of Tibet. It was like a revelation, and suddenly membership began to soar.

By then Bell had resigned the presidency, confident that the Geographic was on a steady

course with Grosvenor, now his son-in-law, at the magazine's helm. In the July 1906 issue, Grosvenor printed 74 splendid wildlife photographs; membership just continued to explode—as did two old-line geographers on the Society's board, who resigned in protest at this "popularization" of geography. Nevertheless, Grosvenor held his ground, continuing to show readers the world and its people as seen through a camera lens. He never shied away: a 1912 issue on the "Headhunters of Northern Luzon" featured images that might scandalize a prudent audience: one grisly photograph of a beheaded criminal as well as 20 pictures of bare-breasted tribal women.

The first two of those necessary stars—an enthusiastic audience and a determined, gutsy editor—had risen.

By 1916, on the strength of its popular illustrated journal, the Society had grown to over half a million members. Three years later, Maynard Owen Williams knocked at the door. His timing was perfect. GHG (as Grosvenor became known at headquarters) was busy editing this wildly successful magazine. He needed field photographers like Williams: young, educated, linguistically adept, and muscular enough to haul around the burdensome equipment needed in the field. It was a perfect fit. Williams was hired and assigned to Europe for several years. So another star was aligned in the magazine's firmament: the emergence of a staff composed of talented photographers.

For more than three decades, Williams crisscrossed Europe, the Middle East, and Asia. He was *National Geographic*'s first great photographer-storyteller and the first chief of its Foreign Editorial Staff, those multi-talented contributors who could write, take pictures, make movies, and be at home in faraway lands. He also ranks among the most prolific and influential contributors in our history. There is hardly an issue of the *Geographic* in the 1920s and '30s that does not bear the stamp of his pictures or words.

Yet the highlight of his life, the pinnacle of his career, was surely the months spent documenting the Citröen-Haardt Trans-Asiatic Expedition, a motorized crossing, using half-tracked vehicles, of Earth's largest continent that is perhaps the most celebrated odyssey in *Geographic* history. Crossing towering mountains and raging rivers, enduring sub-zero temperatures and scorching desert heat, and dodging Chinese warlords to boot, this French-led expedition spent nearly a year in the field. Williams was the lone American, and when he was not helping dismantle and reassemble vehicles on narrow mountain tracks, he was lugging around his large-format cameras and trunks full of glass-plate negatives, shooting great photographs.

Yet just as travel, in the span of a few decades, evolved from steamers by sea and horses by land to supersonic jet aircraft, photography moved on from such cumbersome equipment to handheld "miniature" cameras using high-speed 35mm Kodachrome film. In the time it took to load a plate, make an exposure, and remove the plate in the old days, photographers might be rattling through a roll of 36 frames.

This promised a revolution in photography. Though Maynard Williams was passing the peak of his career by the time 35mm photography arose, *National Geographic* was poised to take advantage of the new development.

That's because Luis Marden had appeared on the scene in 1934. A brilliant young man fascinated by color photography, Marden at the astonishing age of 19 had authored a pioneering treatise on color photography with 35mm cameras. Working in the Photo Lab and always alert to new developments, he was the first at the Geographic to discover the new 35mm Kodachrome film, released in 1936, and to realize that, in freeing photographers of burdensome equipment and slow emulsions, it marked the future for color photography. Yet initially he was derisively dismissed by his superiors.

He was proved right in the end, though. The Beck Engraving Company, responsible for the magazine's color work, unveiled a new process to engrave the "postage stamp" negatives so that they would be suitable for magazine reproduction. That opened the era of 35mm color photography at *National Geographic*—and *National Geographic* opened it for the world. Thanks to Luis Marden's foresight, another star—modern technology—took its place.

Marden followed that accomplishment with another of our storied careers. He pioneered new techniques in underwater photography and made a habit of discovering new species of flora and fauna around the globe. Most of all, he harnessed his dizzying array of talents and superb intellect to produce a long line of great stories for the magazine—most memorably, his quest to discover the remains of the *Bounty*, the ship made famous by the most celebrated mutiny in history.

Volkmar Wentzel arrived at the magazine in 1937. Born in Germany, he was a model of Old World courtesy and charm, possessing the diplomatic skills of Williams and the creativity of Marden. In 1946 he was assigned to "Do India," a huge and extraordinarily complex piece of geography. In Calcutta he purchased a surplus World War II Army ambulance, which became a combination of transport, hotel, and photo lab. Then for two years he navigated the shoals of Indian bureaucracy, schmoozed Maharajas—and as a bachelor, Maharanis as well—all critically important for gaining privileged photographic access. GHG loved the resulting pictures. Yet Wentzel was not only known for his India odyssey; his later coverage of African tribes also became legendary, largely because of his ability to befriend local chiefs, who allowed him to witness exclusive coming-of-age ceremonies, weddings, and coronations.

By the mid-1940's *National Geographic* was being sent to more than a million members a month. Yet like an aging actress whose makeup no longer hid the wrinkles, it needed a facelift. The "speak no evil" policy that GHG had long promulgated ("Only what is of a kindly nature [should be] printed about any country or people" is how he put it) had taken its toll. Meanwhile, *Life* magazine, with its remarkable, often gritty photojournalism, was beginning its long reign over American coffee tables. Melville Bell Grosvenor (inevitably called MBG) was GHG's

son, and he saw that change was needed, but he was not in a position at that time to implement it. Then one day a young David Douglas Duncan called on MBG. A sometime contributor to the *Geographic* before he became a noted war photographer, Duncan was the epitome of the talented, energetic, and charismatic photographer that MBG was seeking. So he tried hiring him, but Duncan committed to *Life*, and after that to a distinguished freelance career. MBG vowed that he would not lose the next David Douglas Duncan who happened along.

It was not a war picture but a photograph of a bird that marked his arrival. In 1954, a recently retired GHG, then a frail old man of nearly 80, was at the University of Missouri to accept a lifetime achievement award. While there, he was escorted through some photo exhibits. Abruptly, he stopped to admire a creative photograph of a baby robin, shot from so close it loomed up like a dinosaur, tugging a worm from a bit of sod. An avid birder, GHG stood transfixed. This photographer should work for *National Geographic*, he thought. So he turned to his escort, a journalism student named Bill Garrett, and learned that the cameraman was named Thomas Abercrombie.

Abercrombie was indeed what MBG, who soon became the *Geographic*'s editor, was hoping for—as was Bill Garrett and another Missouri student named Bob Breeden. Within two years he had hired all three.

Bob Breeden would eventually direct the Society's book division. Bill Garrett would go on to become a brilliant editor of the magazine. And Tom Abercrombie would become MBG's new David Douglas Duncan, pioneering a new kind of *National Geographic* photography, one that repudiated the "speak no evil" policy in favor of a "report it as you see it" philosophy. He was the first of a new generation of star photojournalists who made our photographic staff, in my opinion, the best in the business.

That was my generation, and those superb photojournalists were my colleagues and friends. Yet I still see Tom Abercrombie as something special, the last and perhaps greatest of the writer-photographers of the old Foreign Editorial Staff. His odyssey was as much cultural as geographical, since for over three decades, winding through the labyrinths of the Middle East, Abercrombie steeped himself in all things Arabic, mastering the language and adopting the religion.

Each of the four adventurers featured in the following pages contributed dramatically to the success of the magazine. Together they provided that most crucial double star—photography and storytelling—without which the others—enthusiastic audience, editorial vision, technological prowess—could never have aligned to make *National Geographic* the great photographic journal that, for more than a century now, has been bringing the "world and all that is in it" to millions of readers around the globe.

Enjoy their odysseys.

Maynard Owen Williams

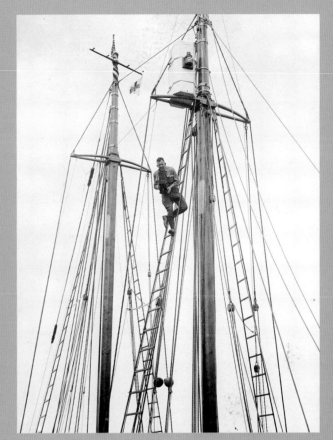

Williams in the rigging, Maine, date unknown

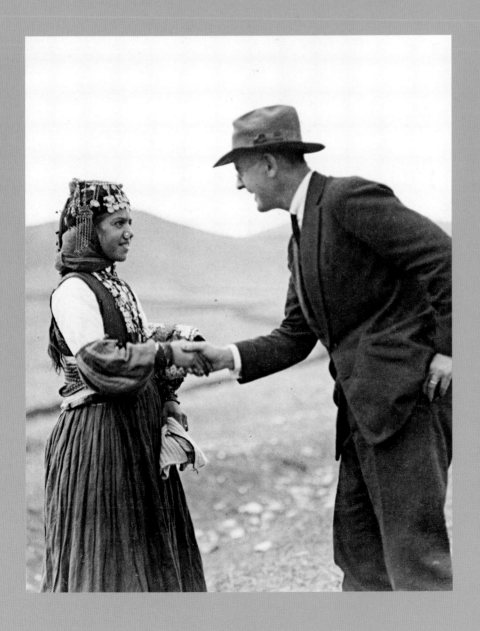

Place and date unknown (opposite)

The little devil-worshipping Yezidi was very generous with her time and her smiles and as we were about to drive away, expressing our regrets that she was going in the opposite direction so that we could not give her a lift, my old friend Hamparian with whom I shared a ruined house in Van, Turkish Armenia, that awful, but happy for me, winter of 1917–1918, suggested that if I would shake her hand and thank her again he would see if he could take the picture. Which he did and this is it . . .

—M.O.W., Armenia, 1931

Maynard Owen Williams
National Geographic Field Man, 1919–1953

by Leah Bendavid-Val

A COINCIDENCE that probably made Maynard Owen Williams very happy was that he was born the same year the National Geographic Society was founded. Wanderlust must have been in his bones from childhood. It surfaced when he was 23: That was when he left his first teaching job in Battle Creek, Michigan, to travel around Western Europe, then on to Turkey, finally taking a job in Beirut from where he explored the Middle East. He met his wife-to-be, Daisy Woods, in Hangchow, China, in 1915 and three years later married her in Natick, Massachusetts. In 1919, at the age of 31, he joined the National Geographic staff and found his calling.

Travel was alluring but also an ordeal in those days. The first editor of *National Geographic* magazine, Gilbert Hovey Grosvenor, devoted himself to the Geographic's declared mission to show the majority who couldn't travel "the world and all that's in it." He had the resources and zest for travel himself and for photography as well. He toted his camera wherever he went and, in addition to taking his own pictures, collected any that looked promising from almost anyone who offered. Contributors included diplomats, scientists, and military personnel, as well as photographers, collectors, and gallery owners. He intended to publish what was immediately of interest and save the rest for possible future use. But by the end of the First World War, much of what he had assembled was already obsolete. The world had changed almost beyond recognition.

His new employee Maynard Owen Williams was of the opinion that National Geographic should create a foreign staff that would write its own original stories and bring back new photography. Restless and gregarious, optimistic and ever curious, Maynard eagerly volunteered to take the job of foreign correspondent. Grosvenor was open to the idea of assigning him stories and publishing them.

In 1923 Maynard and Daisy settled their family in France, and Maynard immersed himself in the still- fledgling technology of color photography. Out of the material he sent back to Washington during the next eight years came fifteen magazine stories and uncounted photographs produced for the files, including many delicately colored glass Autochromes. In addition he followed Grosvenor's example and collected pictures from other photographers, galleries, and organizations he encountered while on his assignments, which ranged widely from northern Europe to the Middle East.

While working on his writing and photographic projects, he moved his family and headquarters from France (only three years after establishing himself there) to Lebanon to Syria to Greece and Turkey. His energy and peripatetic curiosity served his work: The more inaccessible he was the more exotic and romantic the story potential. Maynard was a master at living the romantic life and also at reporting on it. He became a household name at Society headquarters back in Washington.

But he didn't always get his way. In November 1930 he asked permission to cover the dramatic, unfolding story of Soviet Russia, but Grosvenor, caught between National Geographic's commitment to printing only positive stories and the Society's equally strong dedication to the idea of balanced coverage, turned him down:

Mr. Williams:

Referring to your note of November 8, I recognize, as you do, the great interest in Soviet
Russia, but I think it would be extremely unwise for the National Geographic Magazine to pick
out occasional subjects on which favorable notices could be printed regarding Soviet Russia, and
at the same time pass over the numberless subjects regarding which nothing favorable can be
published. The tremendous influence of the National Geographic magazine must not be exerted
to advertise Soviet Russia favorably.
G. H. G.

He turned Maynard down again three years later:

Dec. 28, 1933
M.O.W.
Drop the Volga story. I see by your note you can't write it. But as long as I am editor, the
Geographic won't send you to Russia for an article for us. You are too prejudiced to tell
the Russian story to a Geographic audience.
G. H. G.

But for Maynard that was a minor disappointment in light of his triumph back in November 1930, the month his first pitch to do a Russia story was rejected. To his gratification, Grosvenor had acquiesced to his campaign to establish a Foreign Editorial Staff. He was made its first chief, and for a while he was its only member.

He was ready now for the greatest adventure of his life—the Citröen-Haardt Trans-Asiatic Expedition. French automaker André Citröen supplied the money and equipment, and Georges-Marie Haardt was made leader for what promised to be a dramatic first overland crossing of Asia since Marco Polo's. Preparations for the journey took a year and a half. Two months or so before

departure, French president Gaston Doumergue inspected cars, personnel, maps, and charts of the expedition route. Maynard was in attendance.

Immediately after the inspection he wrote a letter to Washington—he always wrote copious letters to his employers back home and this one was in character:

"Whether by intent or accident President Doumergue gave me a particularly cordial greeting and agreed to M. Haart's suggestion that he is familiar with our Society and its Magazine. I understand that M. Haardt has proposed him for membership and I wish we could make both President Doumergue and M. Haardt Life Members since such honors are more highly appreciated than monetary matters."

Grosvenor, a quintessential builder of relationships, responded in less than a month. He wanted good magazine material from this expedition, and he was always after high-class publicity for National Geographic. He reported to Maynard that action had been taken:

February 20, 1931

Dear Williams:

The State Department on February 18th, through the courtesy of Assistant Secretary of State William R. Castle, sent the following cablegram to Ambassador Edge:

"The Board of Trustees of the National Geographic Society has elected President Doumergue of France to honorary life membership in that Society. At its request, will you please inform the President of this action of The Society's Board of Trustees, which includes ex-president Coolidge, General Pershing and the Chief Justice of the United States among its members. As you are already aware, the French Government is sending certain of its army, navy and other representatives with the Haardt-Citröen Expedition across Asia, with which expedition the National Geographic Society is cooperating."

As the departure date drew closer, the expedition party was divided into two parts. One group would travel west from present-day Beijing, then called Peiping, leaving supplies along the way for the return trip. The second group of scientists, mechanics, film crews, and Maynard—the lone American and only photographer—would travel across Asia in a fleet of half-tracks.

Maynard's group left Beirut on April 4, 1931. Their vehicles made it smoothly through Syria and Iraq, then traveled into Persia, today's Iran. Maynard's letters to headquarters reported everything he saw, heard, and ate. He explained the degrees of difficulty in making specific pictures and described technical challenges involved in the transport, storage, and shipment of fragile glass and film threatened by deterioration. He also commented with relish on his potential photographic subjects:

Pictures in Persia are going to prove difficult. First because the male Persians now wear the pahlavi, the world's ugliest head-gear, and have ideas to fit the hat ... Second, because with the

progress bug everywhere...pictures of native tribes, head-dresses, etc. are hard to get except by contraband methods such as we do not use.

He meant his letters to headquarters to be factual, neutral, textured, and colorful.

...These Kurds have a savage dignity about them, an untamed manliness which contrasts sharply with the slightly effeminate Persian. And some of their dialects, old as time, would well justify a sound recording such as I dreamed would be one of the immensely interesting and valuable SCIENTIFIC results of the expedition.

After Persia the travelers made their way to Afghanistan. "I have fallen quite in love with the Afghan," Maynard wrote in a letter dated May 23, 1931. He meant it, and said so over and over again. He loved their strength, directness, and hospitality.

He covered nearly 700 miles in Afghanistan, visiting the cities of Herat, Kandahar, and Kabul. In Herat he made one of his best photographs ever, of worshippers lit by streaming sunlight filtering into their mosque from above. Perhaps most consequential of all, he photographed the awesome Buddhist statues carved into the sandstone cliffs of the Bamian valley.

Together with a team of ethnographers and archaeologists, he spent four days climbing, exploring, and photographing there. Initially the great statues didn't impress him very much, but he gradually fell under their spell and decided to photograph them in color. He successfully shipped the fragile glass plates back to Washington headquarters and two were published in the magazine. Eventually the color on the plates faded. The photographs still exist, now reduced to black and white.

While still in Afghanistan, and proceeding onward, Maynard wrote a letter dated June 4, 1931, in which he stated:

Now that we are across the last bad river it is apparent to me that the use of the caterpillar thus far has been a vast mistake...My objection to the caterpillar is that it is a time waster...There is not a mile of the course from Beirut to Kandahar which is not more or less regularly made by ordinary cars and trucks...

Despite the fact that those cars and trucks occasionally needed to be assisted over rivers with tedious pick-and-shovel work, Maynard felt sure the caterpillar was unnecessary. He was proven right, in a way, when the expedition reached the mountain ramparts of Karakorum on the Chinese border. The mountains turned out to be uncrossable by caterpillar and, in fact, by motor of any other kind. The explorers, ever inventive, switched to pony and yak.

In Urumchi, the capital of western China's Xinjiang Province, they finally met the first group as planned, but they found themselves in the midst of a rebellion in which the forces of a renegade

general, Ma Chung Ying, forced them to run, which they did for 2,300 miles, traveling eastward into the Gobi's winter winds and the unknown whereabouts of Ma Ching Ying's forces.

The entire exhausting expedition lasted ten grueling months. Maynard loved it. Through it all he was almost always unflappable and upbeat. He never stopped photographing. He saw everyone he encountered as friends.

After the expedition was over, Maynard wrote and photographed for *National Geographic* magazine another 21 years. The Geographic was a family in those days: Gilbert H. Grosvenor was the son-in-law of Alexander Graham Bell, the Geographic's second president. His own son and grandson took over the magazine's editorship and the Society's presidency, in turn. Other staff members were almost like family: Everyone shared the good times and the hard times. As the impact of the Great Depression was spreading across the United States, Grosvenor mentioned his financial concerns to Maynard, writing to him in Paris on February 16, 1931.

Things are going well here but they require constant careful attention from many directions which perhaps even you cannot entirely realize. Authors don't usually realize that books and magazines don't sell of themselves. The effort to get our products sold must be continuous and unrelaxing. Members must be encouraged to renew. In these distressing business conditions, the pilot of our ship of N. G. S. must not be too far away from the bridge.

By 1933 matters had become more critical, but Grosvenor couldn't bear to lose any of his staff. Instead, he reduced everybody's salary, from his own on down. The staff, Maynard among them, rallied to his support. On April 18 that year, Grosvenor wrote Maynard in gratitude:

Dear Williams:
I am very much touched by your kind note regarding the salary reductions which it has been necessary to make. Your thoughtful act has eased greatly the aching heart which I have carried as the result of these reductions. Even after the reductions, the salaries of the staff are, I believe, greater than they were in the boom days of 1928. The National Geographic Society, thanks to the ability and loyalty of the men and women of its organization, has thus far weathered the hurricane of this depression. With trimmed sails we hope to ride it out safely unless some unforeseen cataclysm overwhelms America.
Thank you for your understanding.
Yours faithfully,
Gilbert Grosvenor

The magazine weathered the Depression while many publications went under. Grosvenor had built a powerful and prestigious organization from almost nothing. He was a hands-on editor who

had a proven instinct for what worked. Maybe that had something to do with his reluctance to accept change when the 35mm Leica and the 2¼-inch Rolleiflex came along. He demanded the clarity he saw in in 5x7 negatives, and wasn't seeing it. "I want you to stop this flood of postage stamps and send us some real pictures like you used to do," he told Maynard in a telephone conversation on June 8, 1936. 2¼ by 2¼ are a very bad size for us. They are useful for for only half-page pictures. I am tremendously upset. I knew nothing about this and I want it corrected at once...Just junk your Rolleiflex. We'd rather have 100 good pictures than these thousands that are worthless."

But at bottom Grosvenor was open-minded, ready to be proven wrong, which didn't take very long in this case. He had already supported a great deal of technical innovation, and he proved ready to do so again. His staff, Luis Marden in particular, finally convinced him to embrace the small camera.

Maynard retired on June 1, 1953, 34 years to the day after he was hired. He was finally ready to settle down to a quieter life at home, which was then in Turkey. He had contributed 97 articles to *National Geographic* magazine, a total of more than 2,250 pages of photographs. He kept in touch with goings-on around him and with the Society in Washington and, ever the teacher, he occasionally gave lectures onboard cruises.

One day in 1963, after an offhand good-bye to his wife, he embarked on a solitary day trip to explore archaeological ruins in Antalya, a ferry ride away. At the end of the afternoon he sat down on a bench by the nearby Antalya River. He died alone there, with his camera in his hands. He was 72 years old.

WHAT WAS THE LEGACY OF MAYNARD OWEN WILLIAMS? He was one of a small core of people who literally invented the personality of the National Geographic field man—daring, curious, open-minded, committed to increasing world understanding. Generations of field men followed Maynard. Inspired by his work, his outlook, and his lifestyle, they devoted themselves to the conservation of nature and culture, to doing great work, and to living the exotic life.

Maynard left a photographic legacy, too. He was a problem solver with imagination and a good eye. These pages show the work of a person without prejudices regarding people or photographic technique, a man who had a sense of humor and great affection for his subjects. Maynard could photograph the sweeping vista and the urban street; he experimented with composition, with framing, with mirrors and windows. Best of all, he achieved an intimacy with his subjects. They trusted him. We are left with pictures that are a joy to look at and serve as a record of times gone by, of places changed forever, and of locales that no longer exist.

As for the Foreign Editorial Staff, it lasted a total of 48 years, until new communications and transportation technologies did away with unknown places almost completely and rendered the associated romance obsolete.

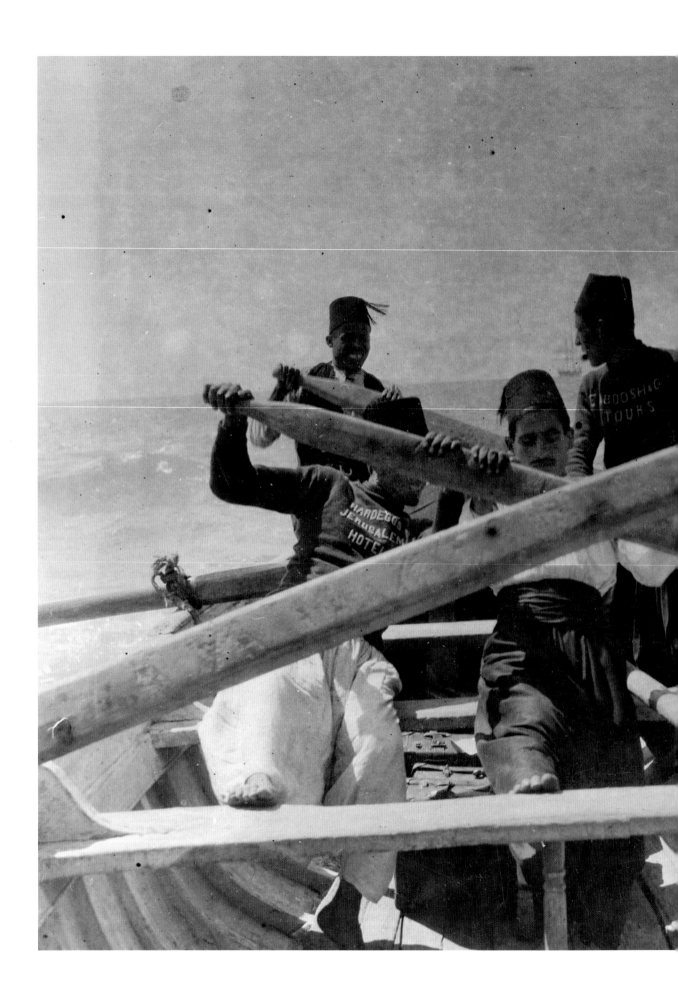

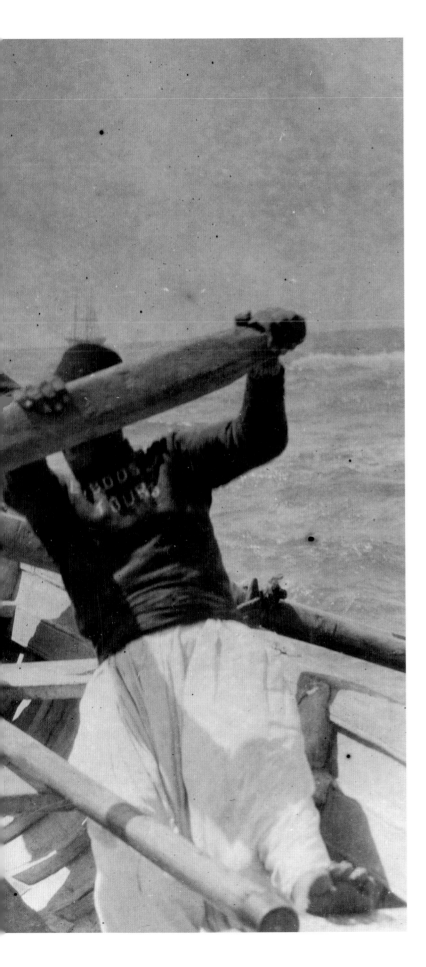

Jaffa, Palestine, 1917

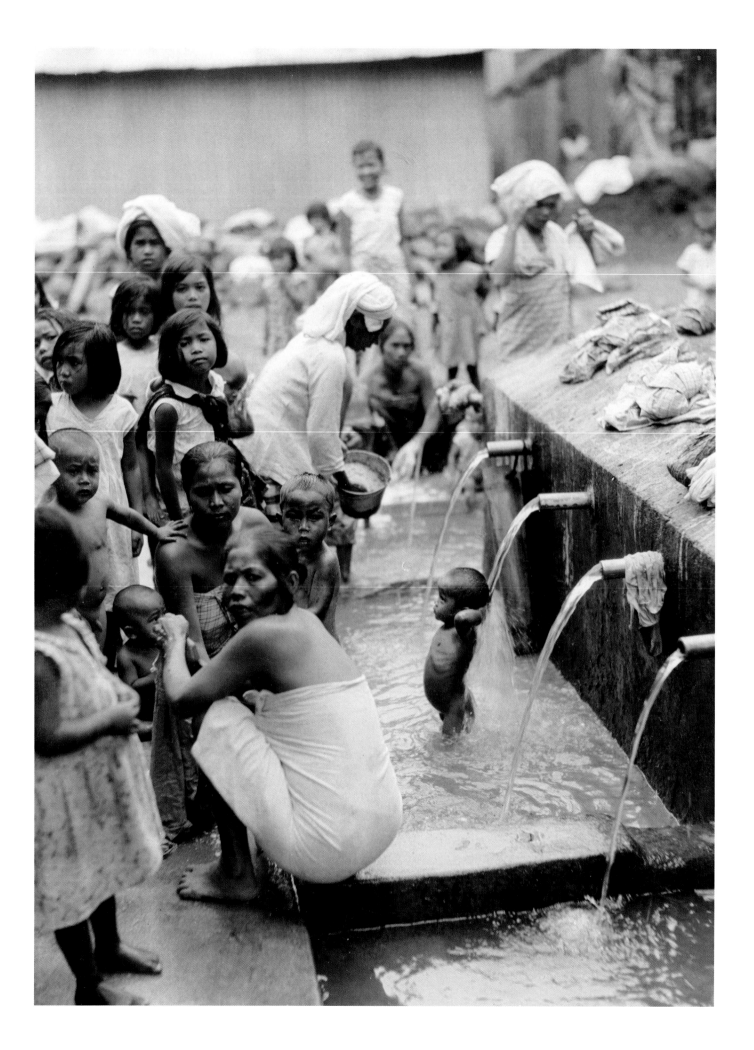

"This is the place of ablutions attached to a mosque for women, also used as a bathing place and laundry.... Notice what a swell time the kid is having."
—M.O.W., Sumatra, 1937 (opposite)

Benares, India, 1921 (below)

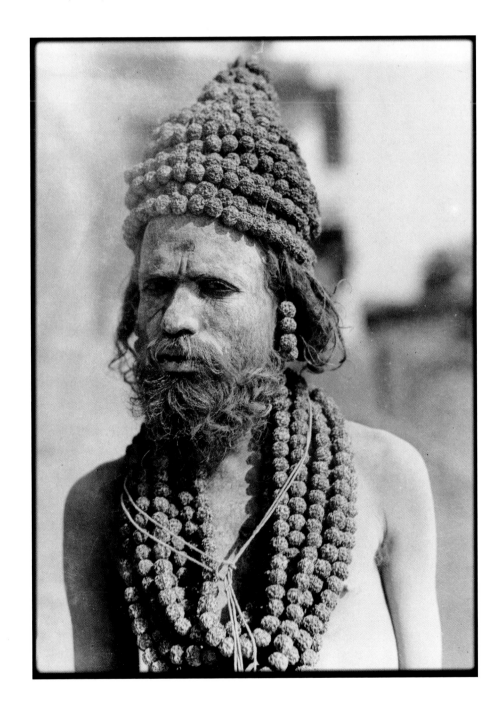

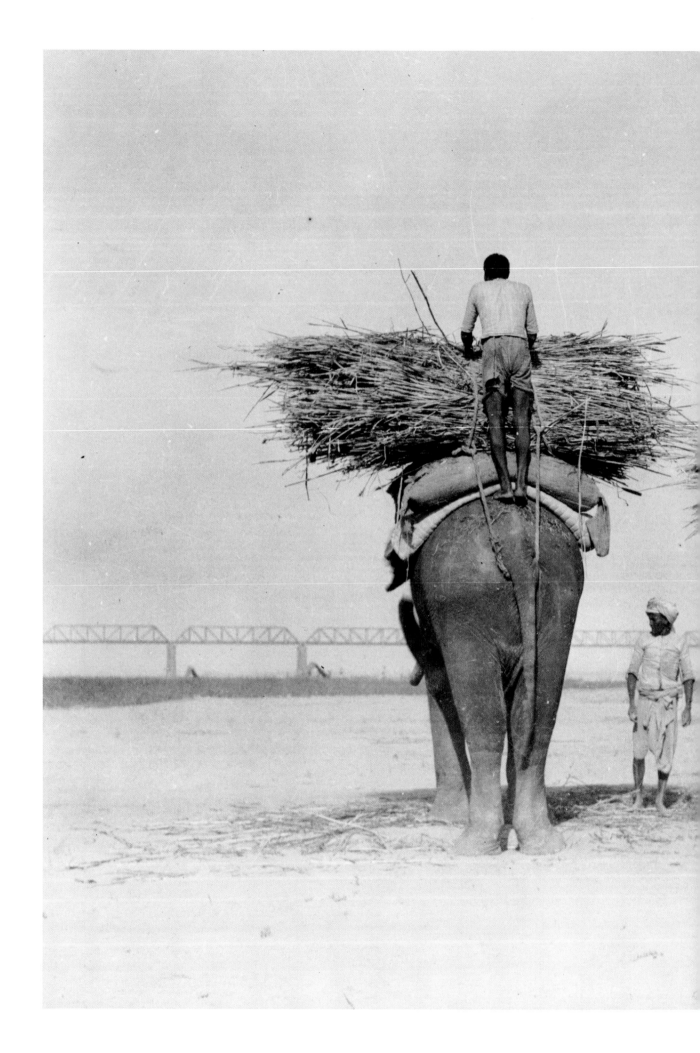

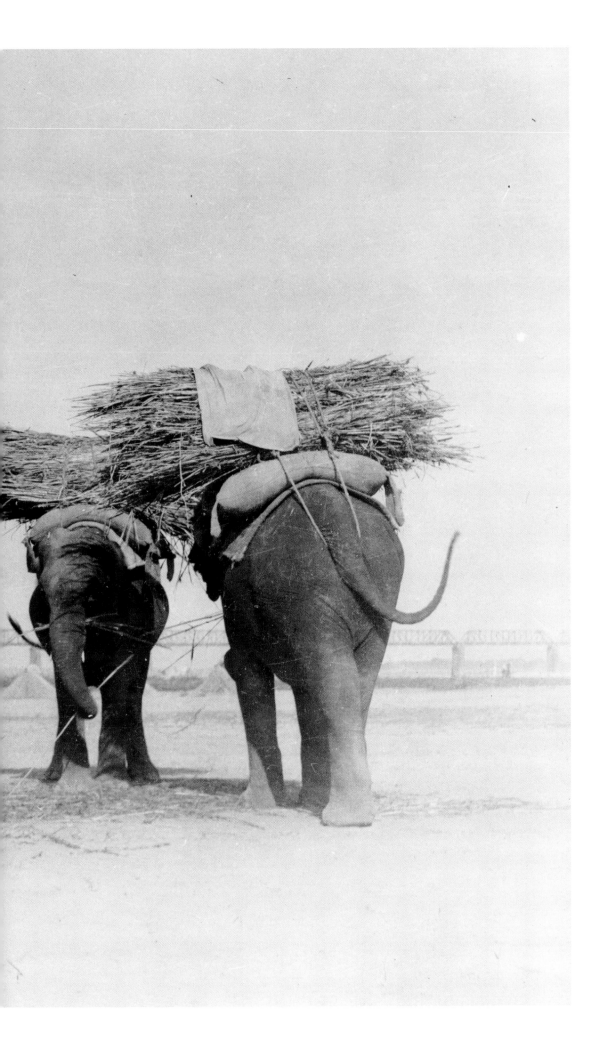

Allahabad, India, 1921

*"Where men wear gowns and women wear trousers and both smoke and chew pan,
it is as well to label them."* —M.O.W., India, 1921

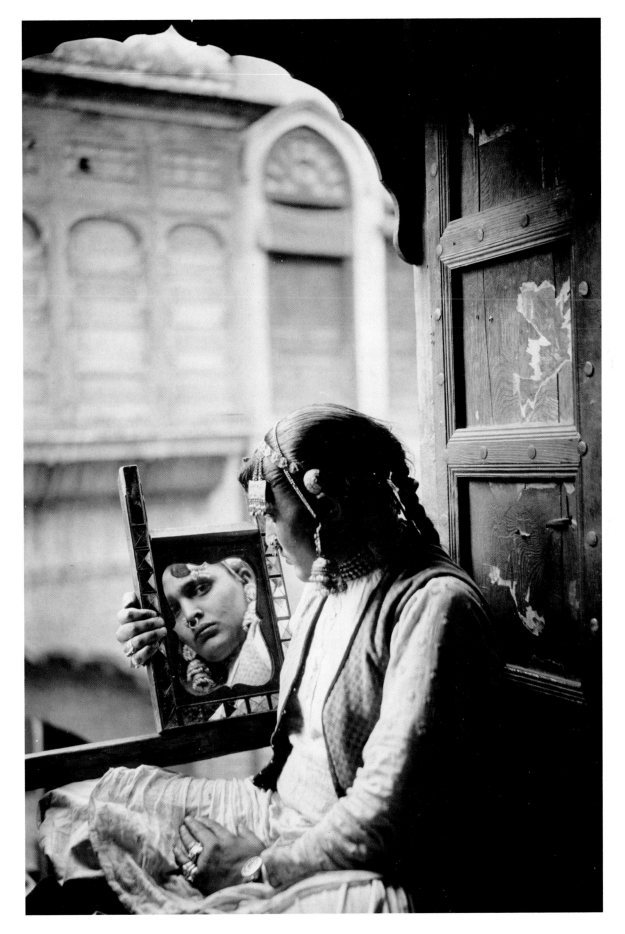

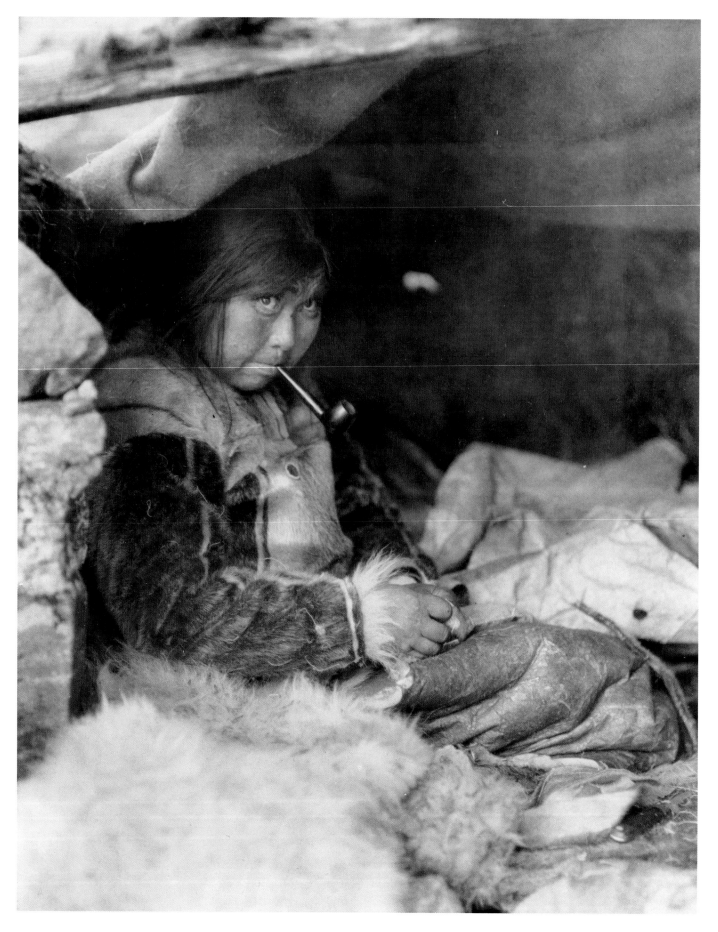

Etah, Greenland, 1925 (both)

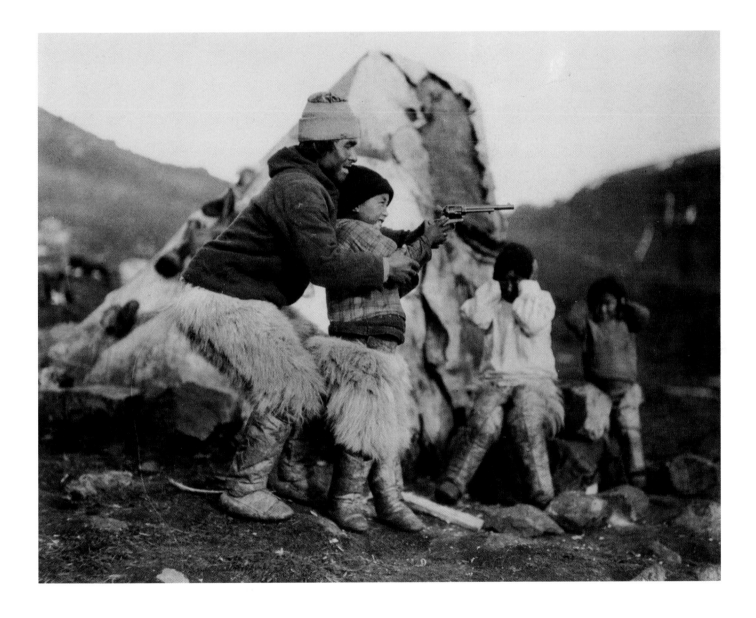

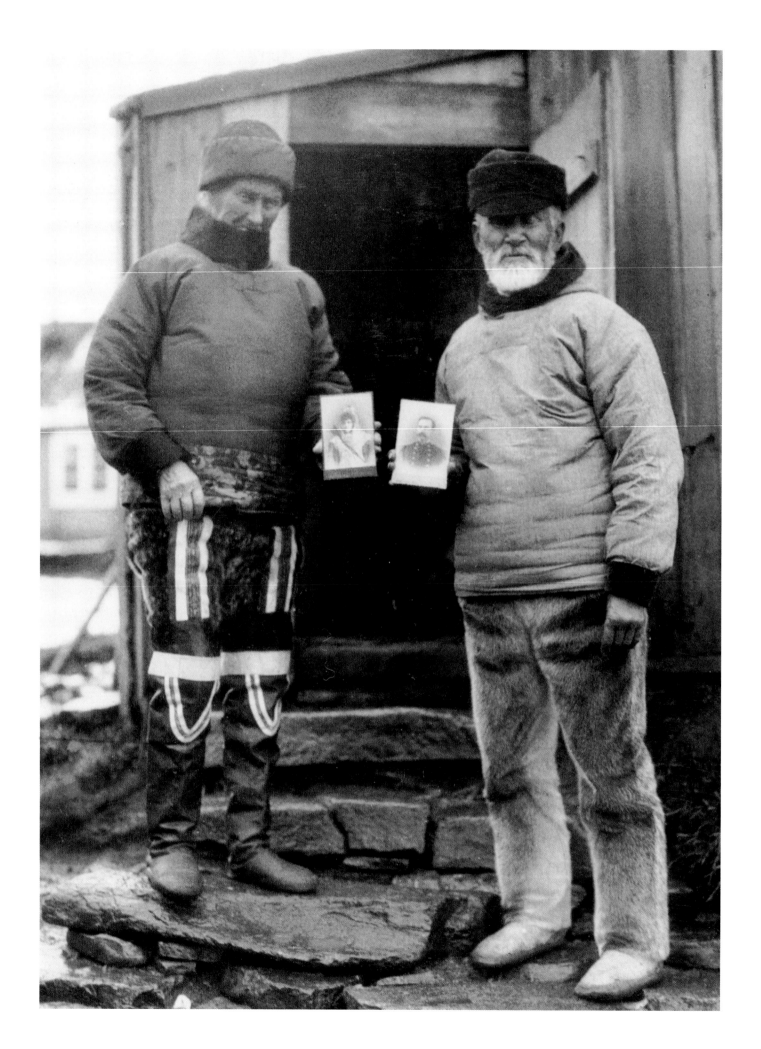

"Two old folks of Godthaab proudly display trophies of former days. When Lieutenant and Mrs. Robert E. Peary passed Godthaab in the early nineties they left their cabinet photographs with these friends. After more than a generation the pictures remain the most prized possessions of these Greenlanders, who well remember the man who carried the Stars and Stripes to the North Pole, Greenland."
—M.O.W., Godthaab, Greenland, 1925

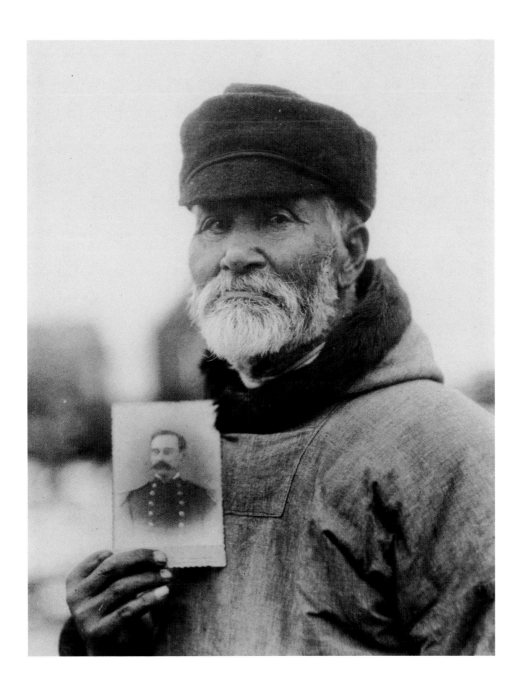

"This picture shows the set up for a daytime autochrome flashlight photograph just before the explosion which flattened the flash-pan tripod to the earth. The children had been warned against the light and noise and were not frightened when the frightful explosion took place. The blast, which might have killed all those present, split wide open the flash-pan, flattened to the earth a strong metal tripod, but no one was hurt."
—M.O.W., Godthaab, Greenland, 1925

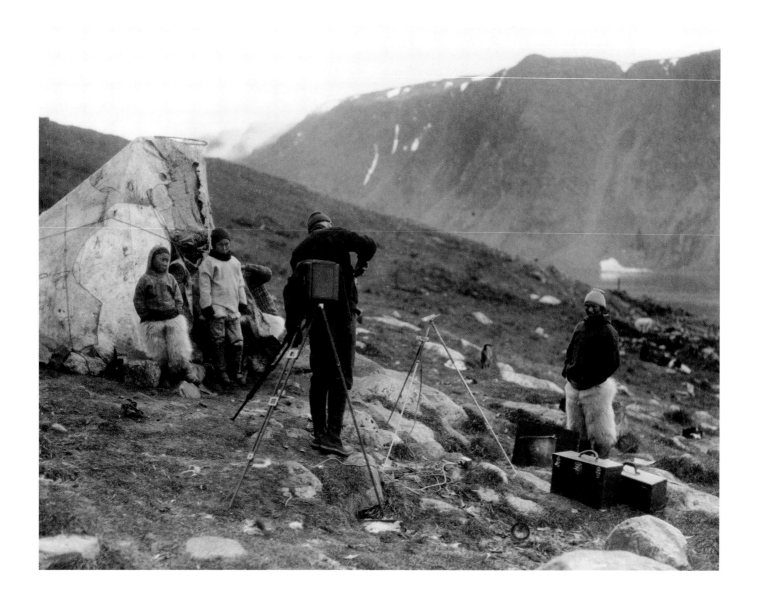

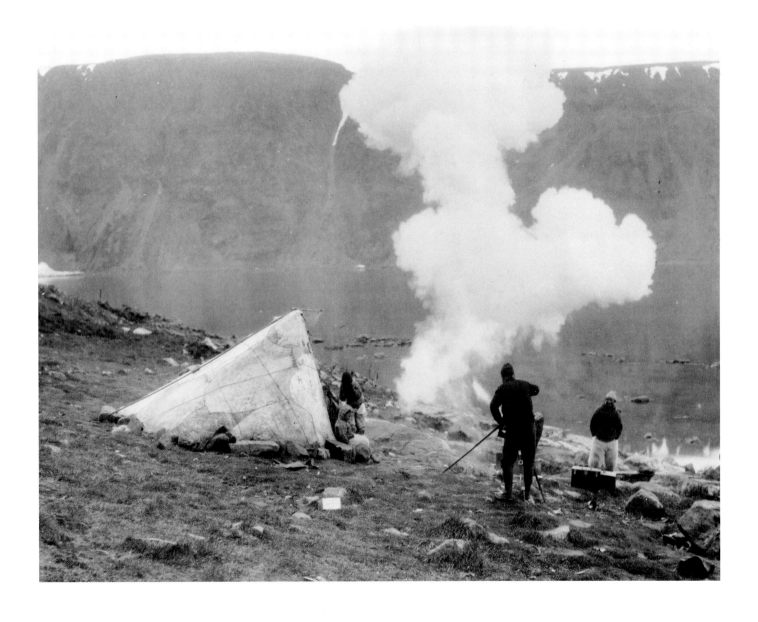

Bastia, Corsica, 1923 (opposite)

Constantinople, Turkey, 1928 (below)

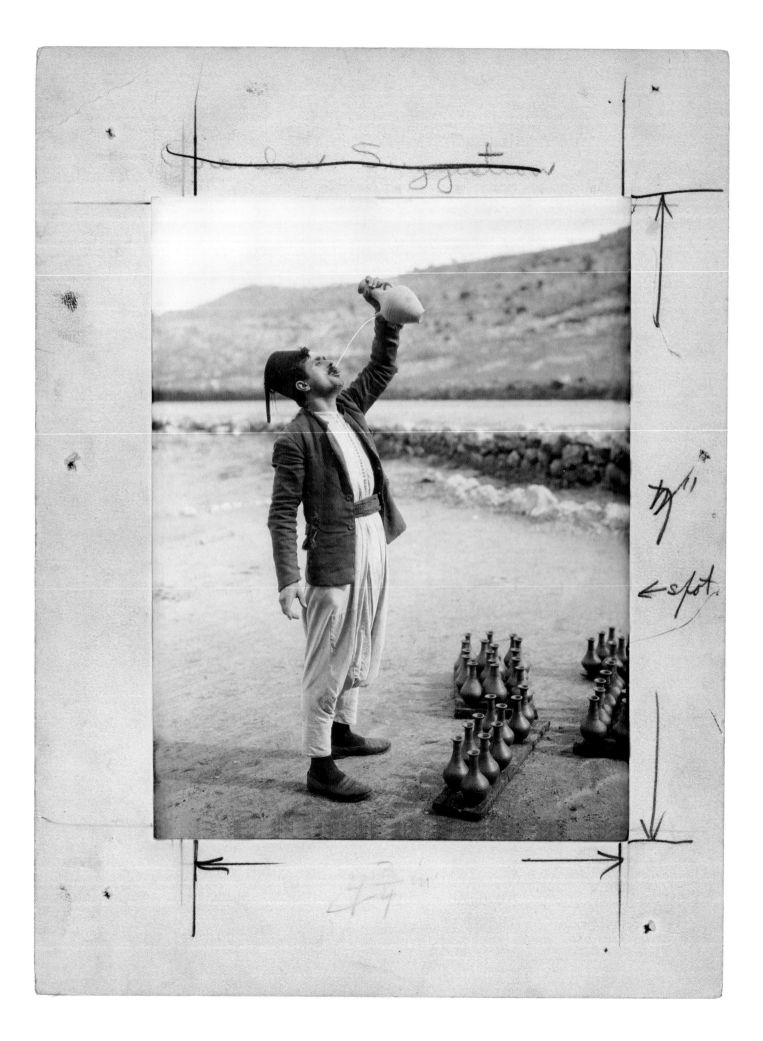

"The way one drinks from a Syrian water jug. This is an early form of sanitary drinking fountain. No man's lip touches the nozzle and Moslem and Christian can use the same vessel without defilement. The cool stream of water, freshened by the evaporation on the outside of a slightly porous jug, hits the tonsils at just the right spot and once one has learned to drink in this manner and not drown his haberdashery, it is an attractive method. Old teachers at Beirut make a point of thus drinking when the new men come out and then have the fun of seeing a tenderfoot swim out of what he intended not as a bath but as a beverage. On the ground are newly shaped water vessels drying in the sun before being stacked in the kiln."

—M.O.W., Beirut-Sidon Road, Syria, 1926

"In Syria, one does not have to seek far for road material, but it is of a poor quality being too soft to wear well. The demands that motor traffic are making on the ancient hills is one of the stories of the land. In many cases, as here, the stones are carried from the fields to the side of the road on the heads of young girls, and the water to wet down the roadway in front of the steam roller is brought in oil tins on girls' heads up from the sea or from some spring or river."
—M.O.W., Beirut-Sidon Road, Syria, 1926

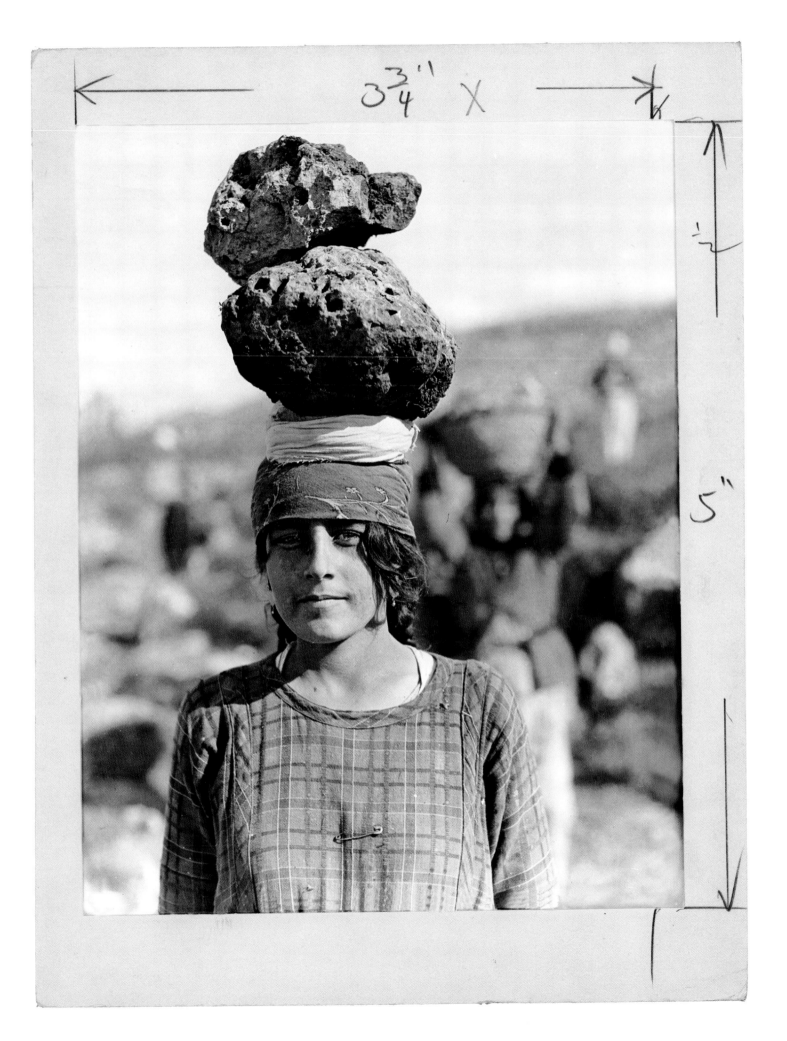

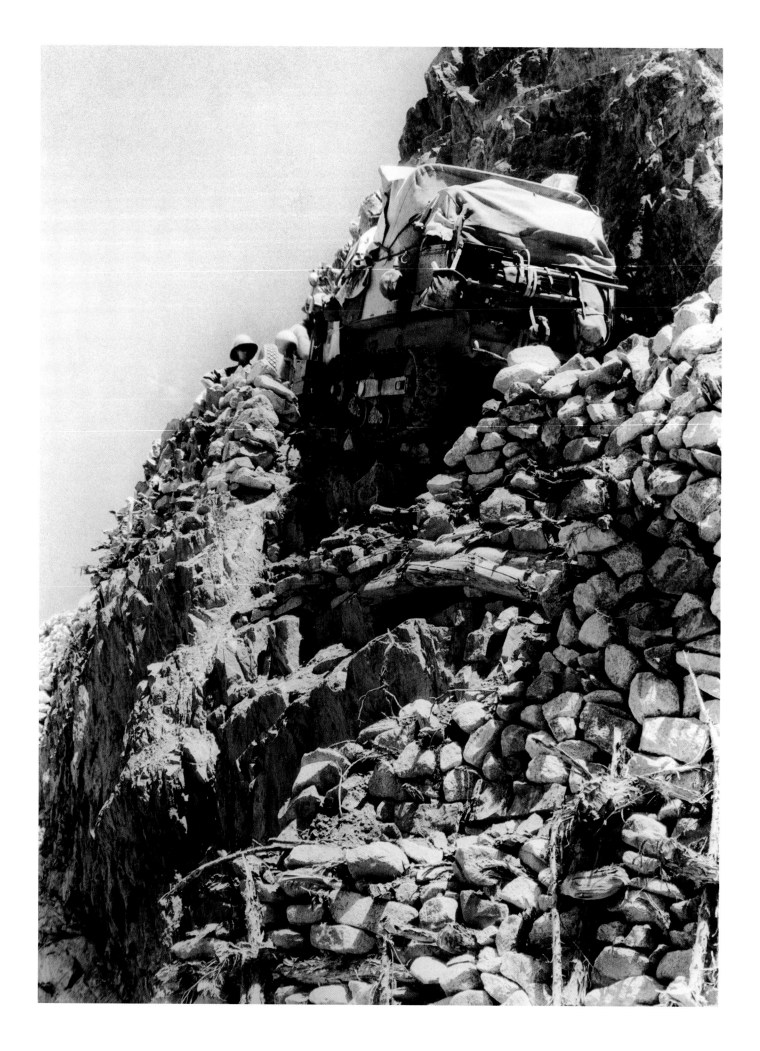

"A portion of the footing dropped way beneath our expedition tractor [otherwise known as the golden Scarab] and it hung precariously on the cliff with its left track in mid-air 40 feet above a mountain torrent. Getting it around the rocky bend involved enough pulleys, cables, and 'fixed points' to give an engineer a headache.... As soon as [we] were past the danger [we} rode through the magic beauty down the valley to Godai. The setting sun still lighted the green slopes to the east, and all around us were such flowers as few gardens can boast."

—M.O.W., Citröen-Haardt Trans-Asiatic Expedition, September 1931

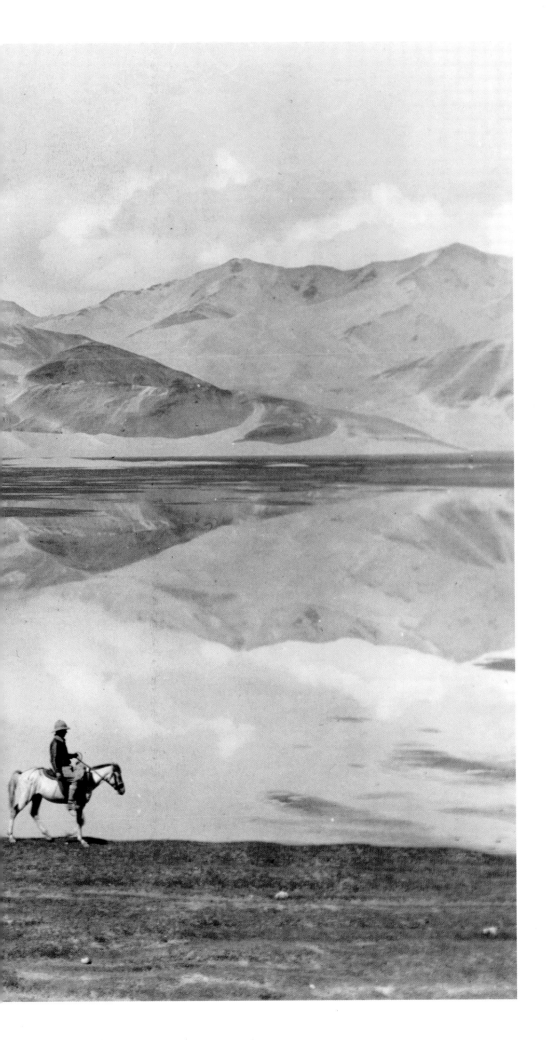

Citröen-Haardt Trans-Asiatic Expedition
Sinsiang, China, 1932

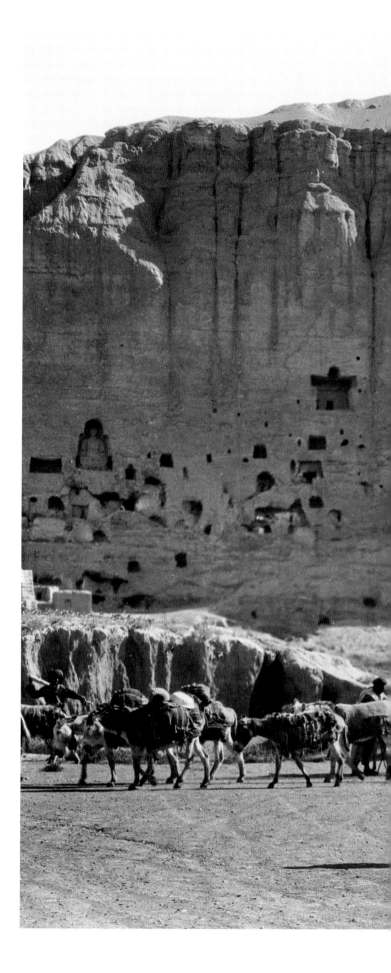

Citröen-Haardt Trans-Asiatic Expedition
Bamian, Afghanistan, 1931

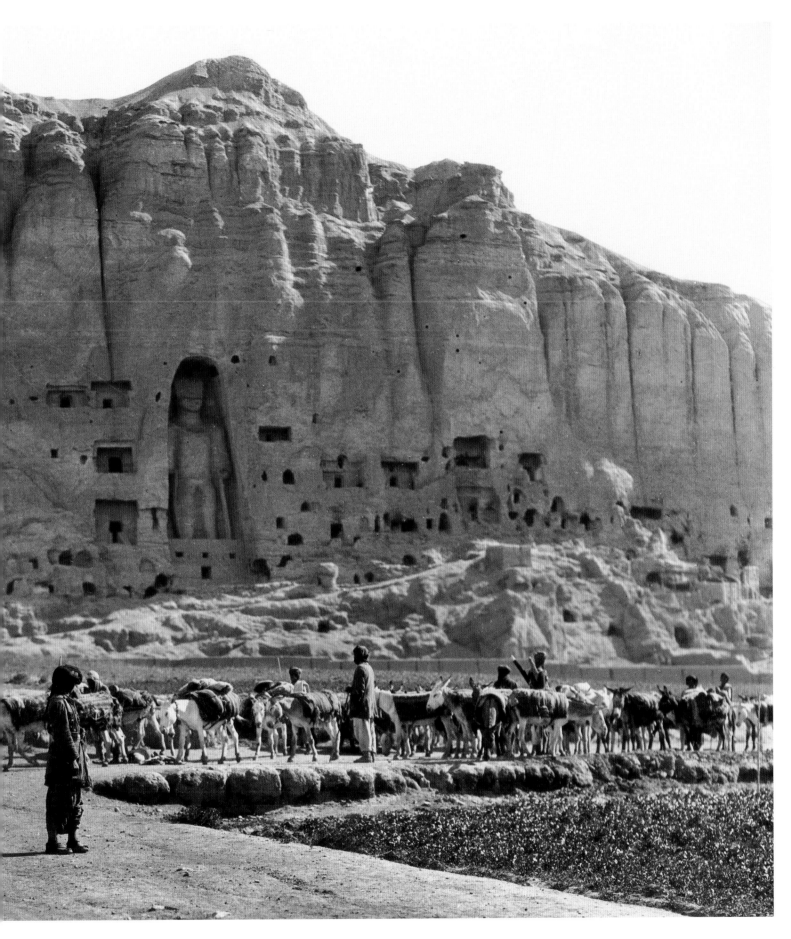

Scene in a dark warehouse, Citröen-Haardt Trans-Asiatic Expedition
Herat, Afghanistan, May 21, 1931

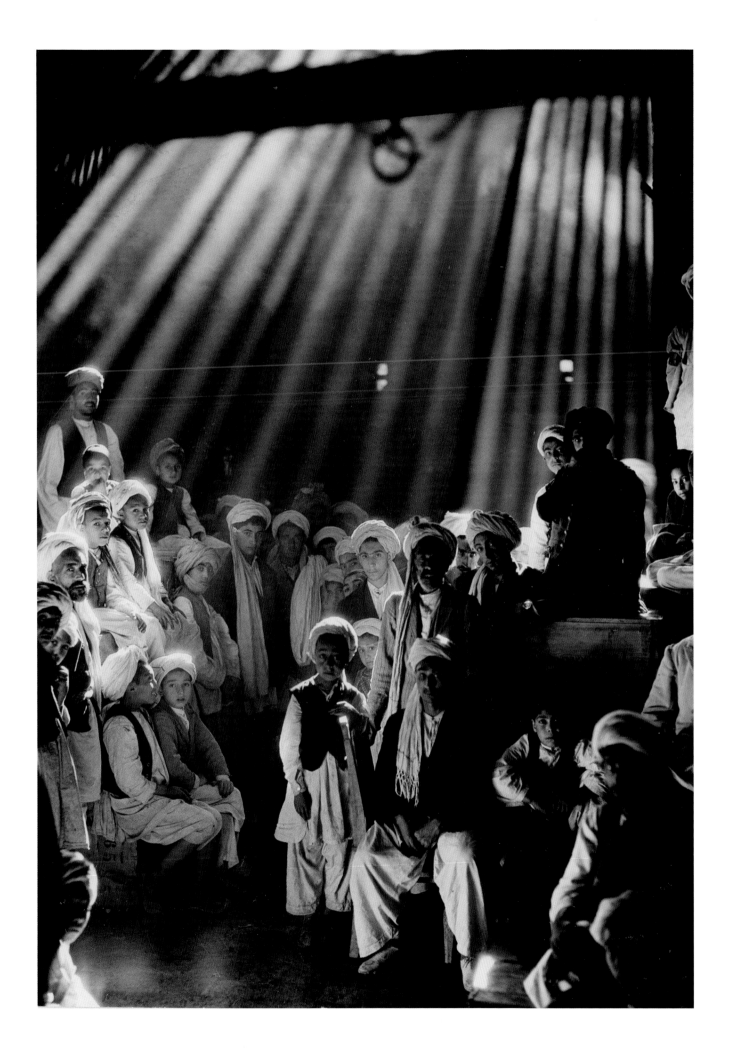

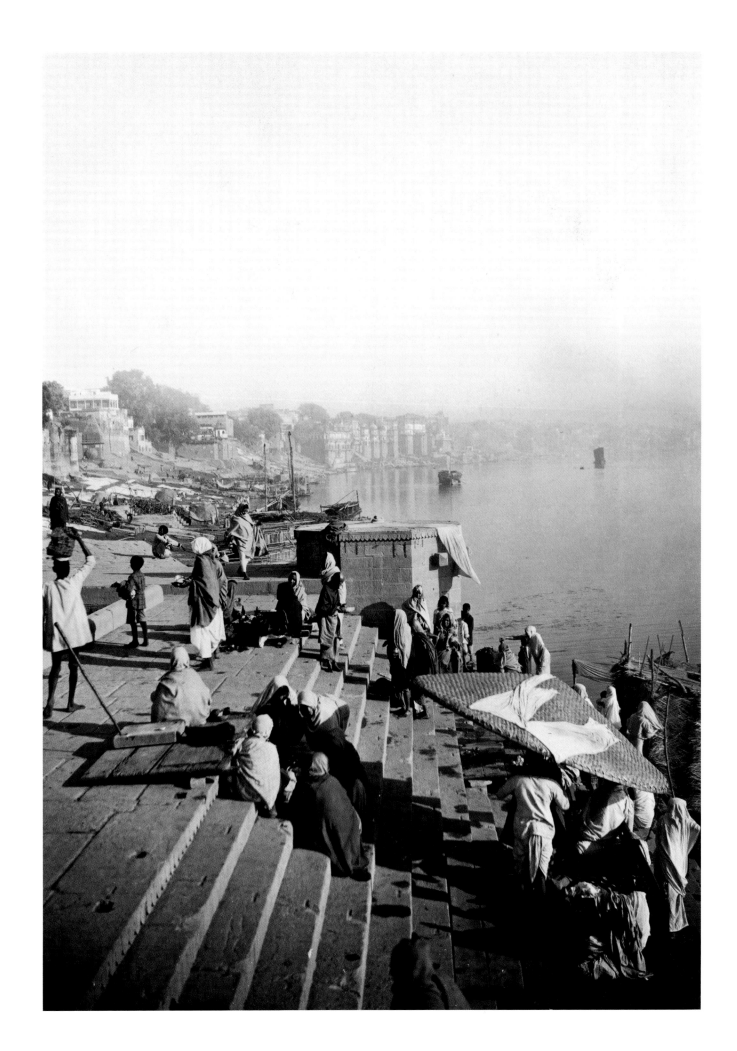

Bathing ghats, India, 1921 (both)

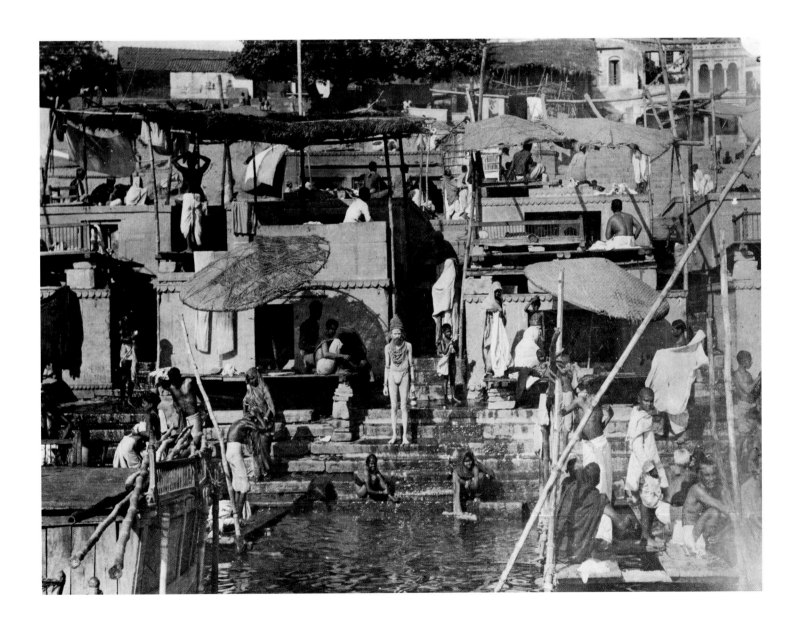

Sheets of rubber hang in the sun in Sumatra, 1937

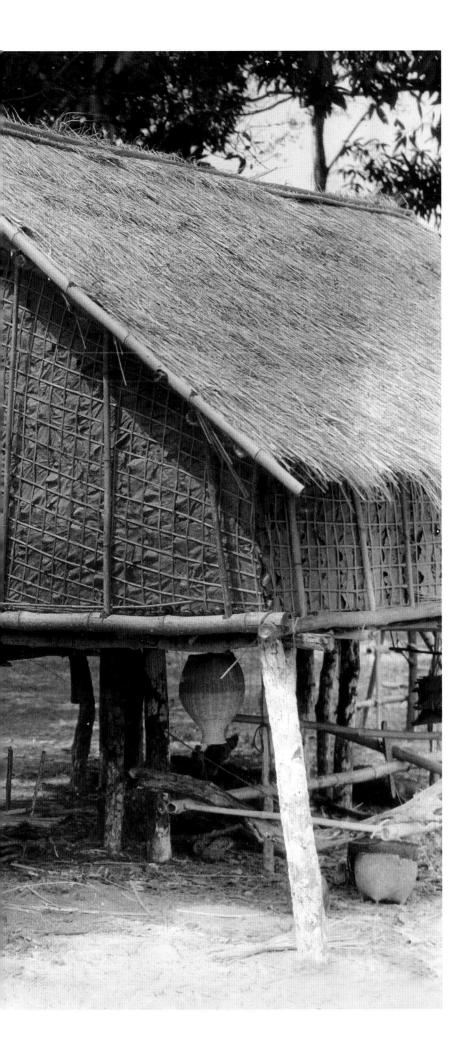

Laos, 1932

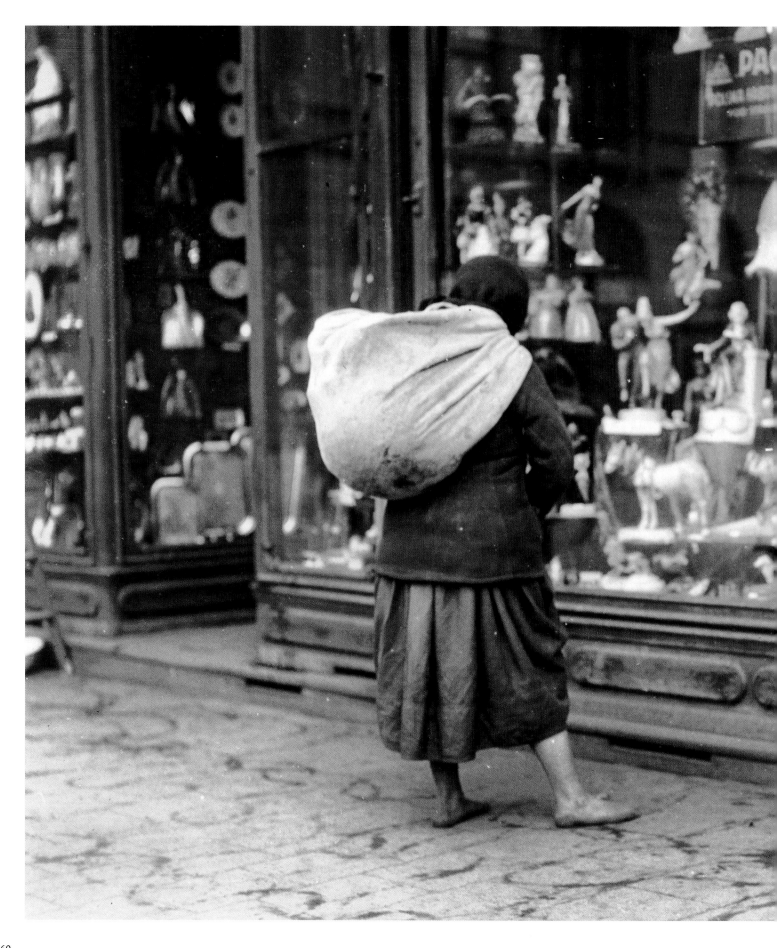

"This is not a good photograph...but it represents one of the great dramas of the region where the barefooted women are coming in closer and closer contact with the women in silk stockings; the sheepskin coat with that of rich fur. All through the barefoot belt, barefooted women are taking a great interest in the goods which are supposed to appeal only to city folks...Throughout a considerable part of Europe, country women are sensing the fact that silk is more alluring than skin. They compromise on artificial silk, let wrinkles show above the tops of skew-heeled low shoes and in general make rubes of themselves.... Some folks read politics to see how the world is moving. When the barefoot women of Europe demand silk stockings, politics will take another swing."
—M.O.W., Lemberg, Poland, 1936

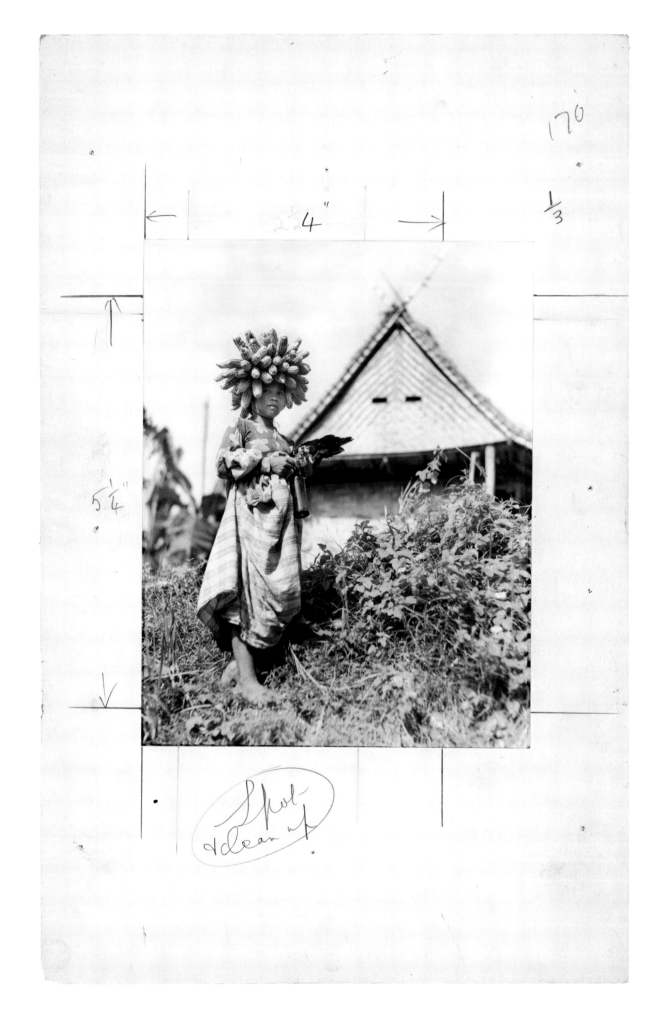

"Carrying a bit of maize and a chicken to market, this girl in Toradjaland has found a way to keep one hand free to manage her sarong. The house, of heavy matting and bamboo poles, is not of the traditional Toradja type and the girl may belong to another tribe."
—M.O.W., Celebes, India, 1937

Scholars in a Persian girls' school, Iran, 1931 (below)

Washington, D.C., 1923 (opposite)

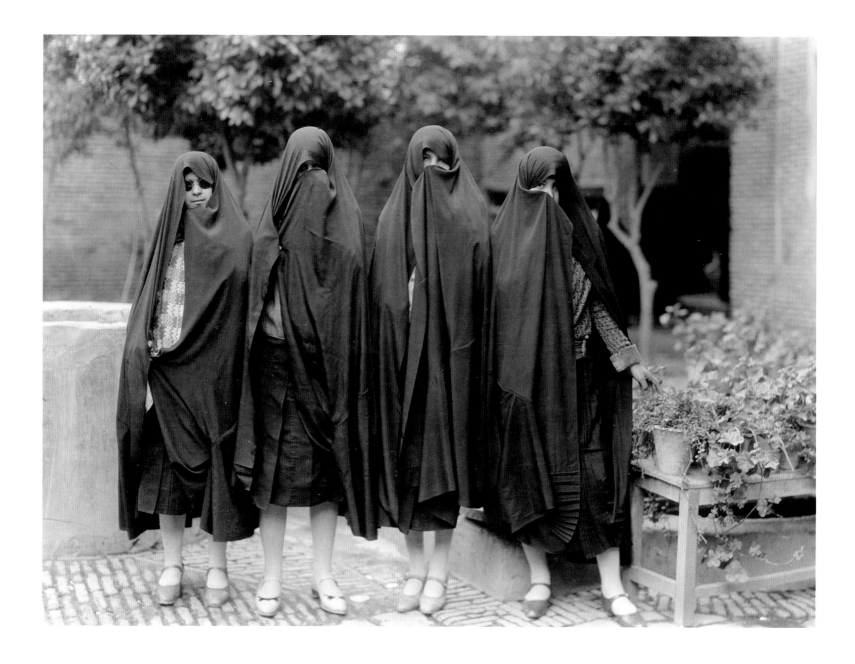

London, England, 1921

TO TULSE HILL

68 VIA
CHALK FARM ROAD
CAMDEN T^{OWN} SEYMOUR S^T
SOUTHAMPTON ROW
WATERLOO B^{DGE} ELEPHANT
CAMBERWELL GREEN
DENMARK H^{ILL} NORWOOD R^D

66
SANITAS
FRAGRANT
COLORLESS
NON-POISONOUS
DISINFECTANT

LMAN'S
STARD

68

LF-8778

PASSENGERS
OFF THE BUS FIRST PLEASE

POWER
PHONES
LIGHTING & c
ELECTRICAL
INSTALLATIONS
27, MARTINS LANE
CANNON S^T
RING UP
CITY 3897

FOR
COMMERCIAL
VEHICLES

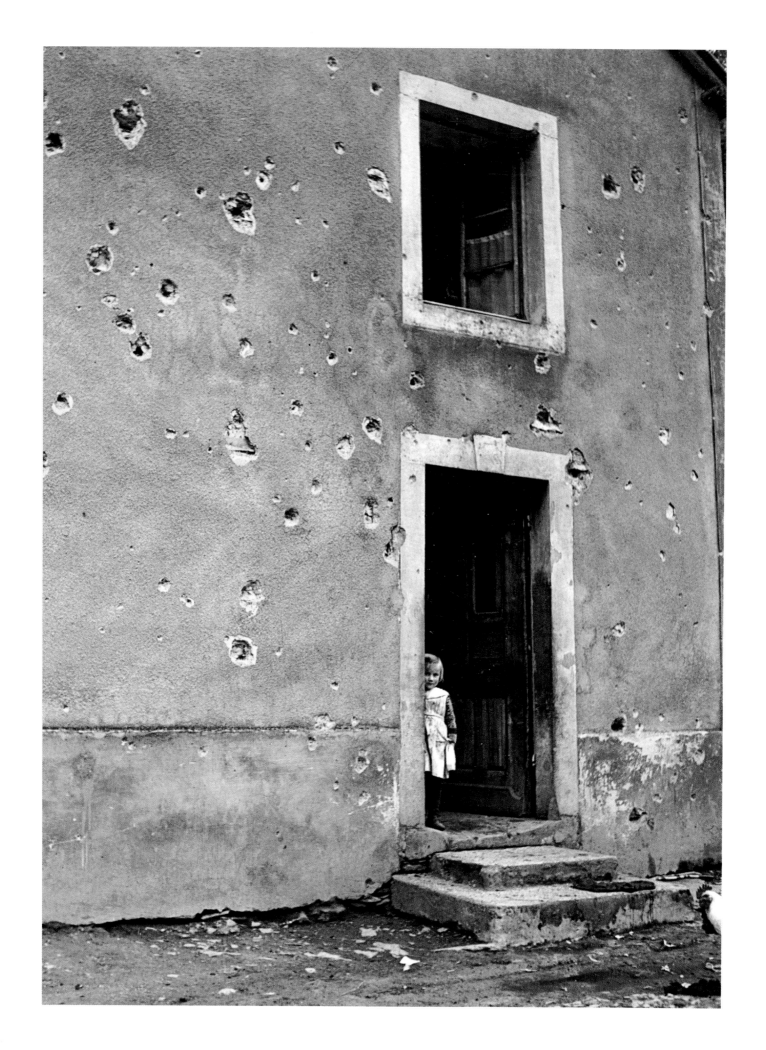

"In general, war hit the heights worse than it did the valleys. But Esch-sur-Sûre is on one of the roads leading to Bastogne so there was more than the shadow of death in this isolated valley. No wonder she uncovers only half her body in peeking out! The walls show why."
—M.O.W., Esch-sur-Sûre, Luxembourgh, 1948

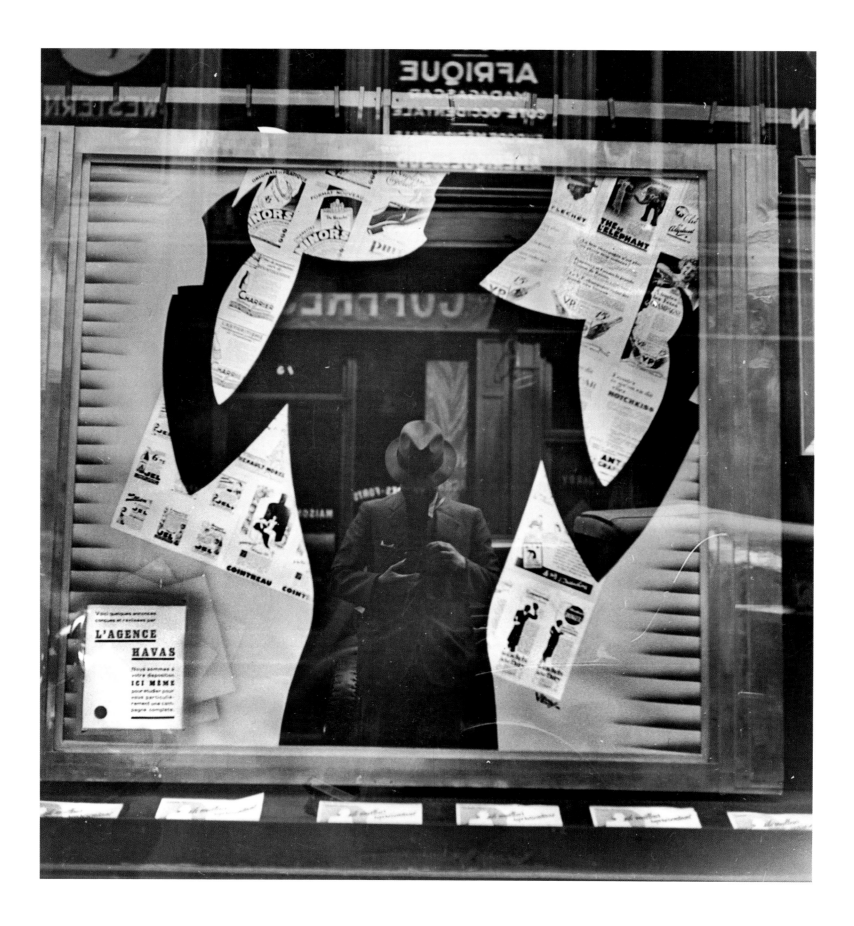

"The eye ignores what it doesn't want to see. Here the camera reveals more than a man sees himself."
—M.O.W. Paris, France, May 1936 (opposite)

Somersetshire, England, 1935 (below)

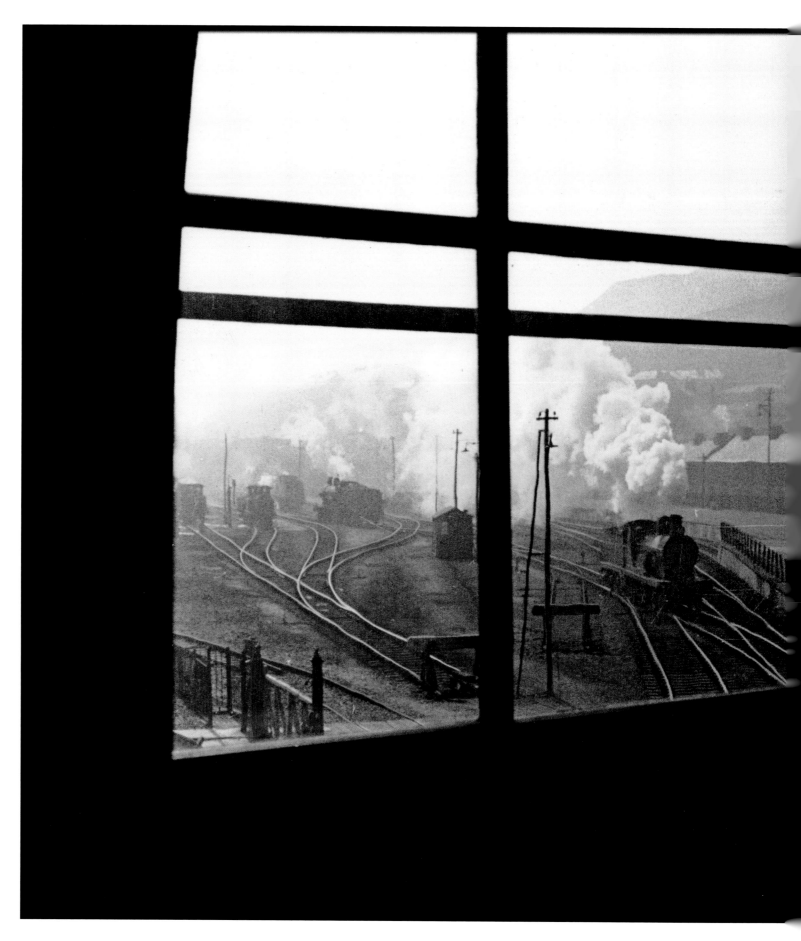

Dover, England, 1934

Paris, France, 1936 (below)

Paris, France, 1946 (opposite)

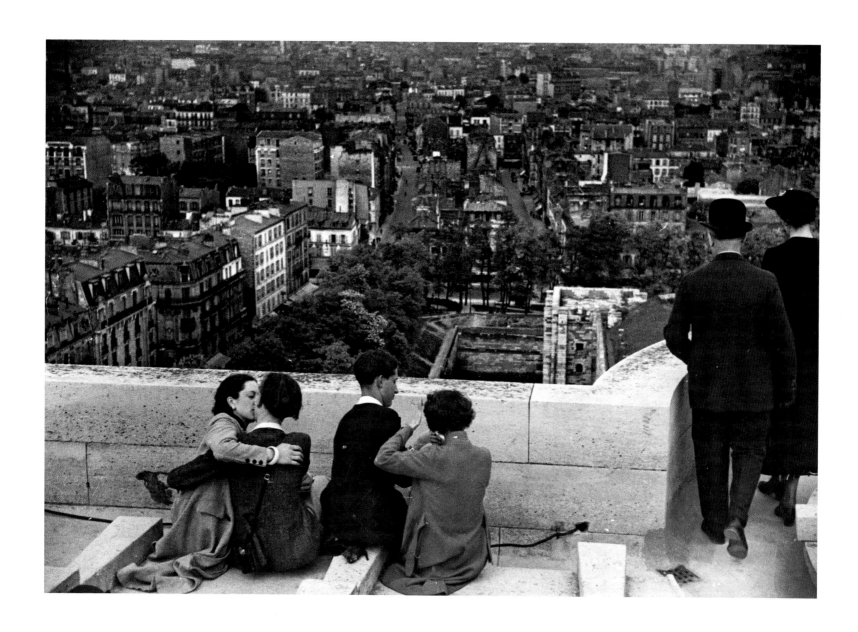

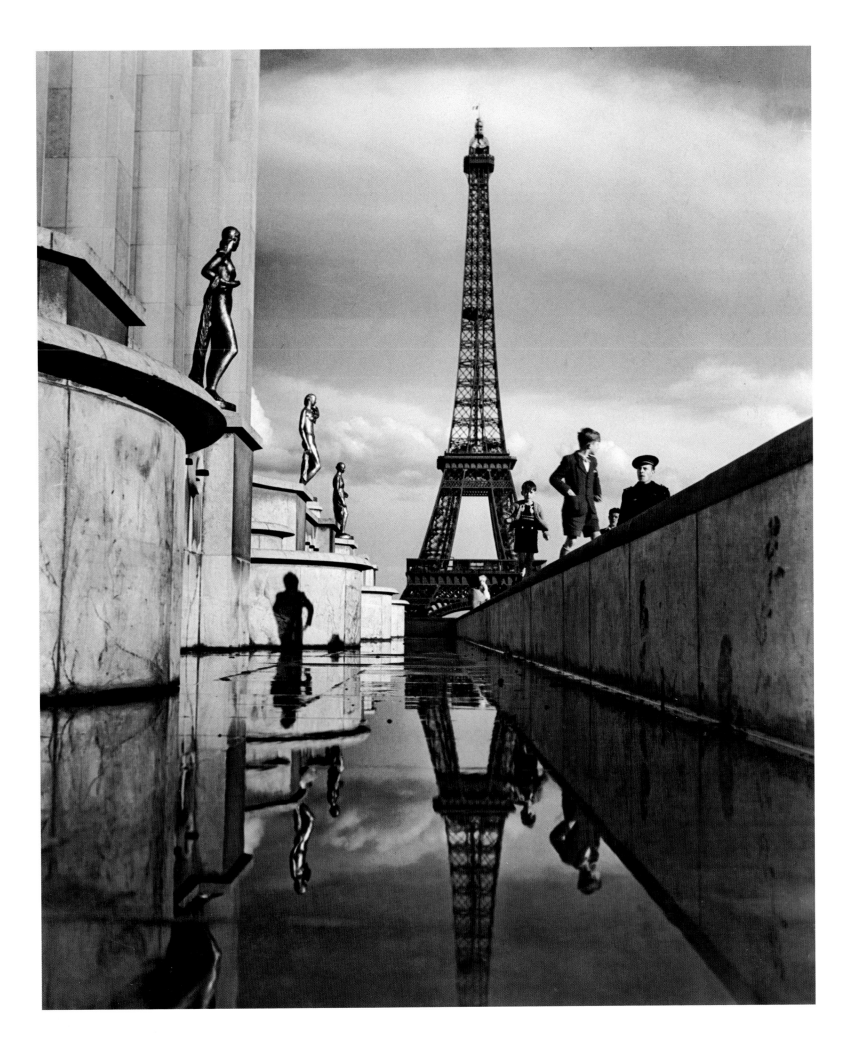

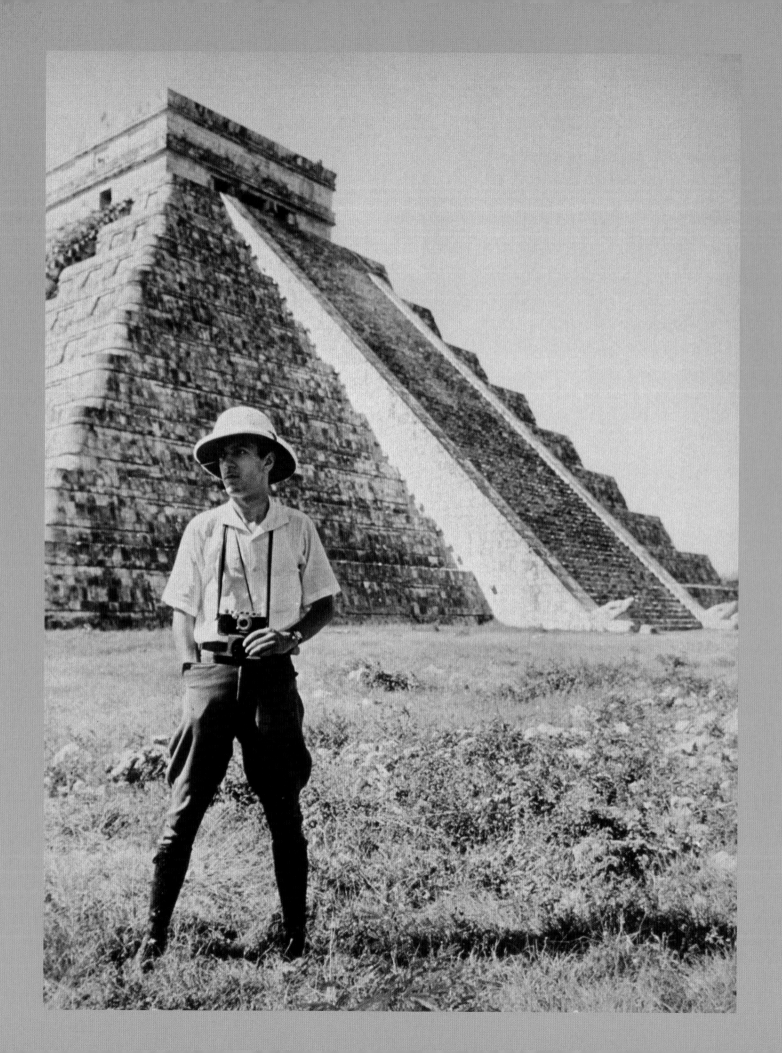

Luis Marden

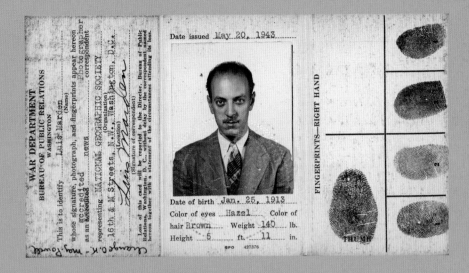

"Incidentally, I was amazed to find how well remembered you still are in Guatemala after all these years since your last visit. I understand in the mountains mothers still tell their children, Luis Marden will get you—but only if you're a good girl." —Peter White, a Geographic colleague, to Luis Marden, April 29, 1958

Chichén Itzá, Mexico, 1936 (opposite)

Ethel and Luis Marden, 1952 (above)

Luis Marden
National Geographic Field Man, 1934–1976

BY MARK COLLINS JENKINS

LUIS MARDEN did not look like a force of nature: Merely an elegantly dressed man of medium height, with a trim mustache, a deferential bearing, and mannerly Old World charm. His business card stated only that he was a member of National Geographic's Foreign Editorial Staff, though his name was long familiar to readers through the 55 stories—ranging from the 1930s to the 1990s—that carried his byline as photographer, author, or both. Yet, like nature, Luis Marden abhorred a vacuum. He filled everything he touched. Not a subject that interested him that he did not soon emerge from its far side; not a delight encountered but he was soon brimming at its top. He filled time, as many of his editors, raising a warning finger, would point out, recalling the chronically late copy, the many months he would overstay his assignments. And he filled space. One wonders what the austere Frank Lloyd Wright, who designed Marden's house, perched dramatically above the Potomac River, would have thought of one of his trademark spare interiors cluttered with thousands upon thousands of books, not to mention globes, antique maps, a brass diving helmet, the football-size fossil egg of an extinct giant bird from Madagascar, broken amphorae from an ancient Mediterranean shipwreck, pieces-of-eight from a drowned pirate city in Jamaica, and copper spikes that once fastened the timbers of the legendary *Bounty*.

Toward the end of his life, Luis Marden would be wreathed with such encomiums as "epitome of the Geographic man" or "spirit of the National Geographic," all of which embarrassed him. Yet those were tributes to his fulfilling of a pattern. Even in 1959, when Marden was at the height of his career, editor Melville Bell Grosvenor declared, "If you stopped someone on the street and asked him to describe what he imagines a Geographic staffer to be like, the description would fit Luis Marden." If that meant the cartoon image of a pith-helmeted, camera-laden, safari-garbed explorer, then from the moment he undertook his first foreign assignment in 1936, posing before El Castillo at Chichén Itzá in new jodhpurs, riding boots, and dazzling white pith helmet, Luis Marden fit the role. Over the years, whether it meant donning top hat and tails or disrobing to the *très déshabillé* look of the *Calypso* crew, he certainly looked the part.

Yet the Marden mystique springs from deeper sources. One was the accumulation of story and anecdote. Mention his name to friends and colleagues and they snapped to attention.

Though he was not naturally gregarious and generally preferred solitude, he was endlessly fascinating and clearly could be fun to be around. And he had a decidedly mischievous grin and a sharp wit. Geographic staffers visiting out-of-the-way places would report that the most unlikely characters would give their best to Luis Marden. It verged on the apocryphal, but he did leave friends around the globe—astronauts, military attachés, fly fishermen, Polynesian chiefs, Argentine tailors, bamboo experts, orchid fanciers, Chinese restaurateurs, treasure hunters, bush pilots, the King of Tonga, King Hussein of Jordan—and each had his own Luis Marden tale to tell. Not that he was always the topic of stories; he could spin them, too. He was a champion raconteur who slipped into one role after another with the dexterity of the born actor and the voice of a former radio announcer.

Then there was his freewheeling sense of adventure. Only it was not adventure as conventionally understood; he preferred quoting G. K. Chesterton's observation that "adventures are inconveniences rightly viewed." His were rather the adventures encountered when chasing his interests wherever they might lead. He balked at nothing. An eyebrow might be raised at his claim that he was never foolhardy. When Jacqueline Onassis, one of her own eyes on her hero-worshiping son, heard how Jacques Cousteau once had to physically restrain Marden from diving with sharks at midnight, she told Luis, "You are a poetic and dangerous influence."

Yet as a close friend once observed, Luis Marden was a unique compound of the reticent and the flamboyant. To those who knew him best, like his wife, Ethel Cox Marden, a brilliant mathematician, pilot, diver, flyfisherwoman, and everything else that he was, the really impressive thing about Luis Marden was his dazzling intellect and that wide range of interests that he filled up and topped out. He had barely scraped out of high school, and yet was a living tower of scholarship. That was what inspired Maynard Owen Williams to dub his younger colleague simply "the Michelangelo of the Geographic."

And he rode a tide of great fortune, one that carried him to just the right place—the National Geographic Society—at just the time in its history—its oak-and-laurel-framed "golden age"—for a free spirit like his to flourish. He had been, he later said, a "round peg in a round hole."

He first encountered the National Geographic in his neighborhood library when, as a youthful photography enthusiast, he pored over its color illustrations. Born in 1913 and reared in the Boston suburbs, eldest son of Italian emigrant parents, his real name was Annibale Luigi Paragallo, Louis Paragallo for short. The kind of boy who read omnivorously yet daydreamed his way through school, young Louis always gravitated to roles with a flourish to them: astronomer, band leader, orchestra conductor, Egyptologist. Studying Egyptian hieroglyphics had sparked an interest in languages, especially Spanish, which he took to so enthusiastically that he began signing his name "Luis Paragallo." Still in high school, he did that stint as a part-time radio announcer, but "Luis Paragallo" sounded a little too Italian for Boston ears. So a stage surname was plucked at random from a telephone book. "Luis Marden," with its touch of Spanish flair, was for him a perfect fit.

Color, then photography's experimental frontier, fascinated him. Few working photographers were interested in color, much less the possibility of color with the new 35mm "miniature cameras." But young Luis's absorption in the technical challenges of iridescence had been matched by an equal passion for a second-hand 35mm Leica camera he had obtained. In his new enthusiasm he was already writing, at age 19, a remarkable little book entitled *Color Photography with the Miniature Camera*, quite likely the first monograph on that unlikely combination ever published.

Overhearing a rumor that National Geographic might be looking for a photographer, on a whim he applied for the job. Surprisingly, he was invited to an interview in Washington, where he proved that he could properly expose and develop a Finlay plate, a recondite British color process that the Geographic had licensed, and so was hired to work in the Photo Lab. He was only 21 years old, and had but a smattering of freelance experience. Tellingly, on the evening before his first day—July 23, 1934—he gazed up at the neoclassical facade of the Society's headquarters and saw not a place of employment but rather a university.

Within two years he had sparked a revolution in those halls. Marden had been hired, quite simply, because he knew something about color photography. His beloved Leica, dismissed as a "toy" by Illustrations Chief Franklin Fisher, had nothing to do with it. Yet in the summer of 1936, friends at Eastman Kodak sent Marden some test rolls of a new 35mm color film called Kodachrome. The rich, saturated, virtually grain-free color was the best the author of *Color Photography with the Miniature Camera* had ever seen. Paired with the small, versatile 35mm cameras, it promised the long-awaited "Millennium" for color photography: the ability to capture action, in all its natural hues, without having to resort to tripods and static, posed pictures. He tried preaching this good news to Fisher and the rest of the Geographic's illustrations hierarchy. But the brash boy who worked in the Photo Lab, whose "hands were in the developer," was merely patronized.

He was not the prophet in the wilderness for long. Kodachrome's superb color was undeniable. It only remained to find a satisfactory means of engraving from the postage stamp-size 35mm negative. Once that was achieved, by 1938, the magazine scrapped all of its considerable investment in other color processes and wholeheartedly embraced 35mm Kodachrome instead. Thanks to Marden's sharp eye, the Geographic was the pioneer; it would be years before the rest of the publishing industry followed suit. Within a few decades, fast 35mm color film would dominate photography everywhere.

That alone would have won him fame had he never left the Photo Lab. But Marden was too resourceful a photographer to mix chemicals for long. He was soon sent into the field as a National Geographic "cameraman," a trade the Spanish-speaking Bostonian learned the hard way, during the 1930s and '40s, while roaming the jungles, coffee plantations, volcanic highlands, and crumbling colonial towns of Latin America. Carrying with him cases of film and a battery of cameras—Linhofs, Graflexes, Rolliflexes, Leicas—he sweltered beneath tropical heat and humidity so intense it could stifle activity and melt emulsions. Nevertheless, editors were quick to praise his well-composed,

well-exposed pictures of the costume-and-fiesta subjects so popular with the magazine's readers. Soon he was also shouldering the heavy 16mm Cine-Special movie camera, and his motion picture sequences made superb travelogues for the Society's lecture series. And his manuscripts—for he had undertaken the writing of articles, too—were witty, pungent, spiced with odd and apt facts, and soon became favorites around the office. He was "cameraman" no longer. Before he was 30, his versatility had led to a coveted spot on the magazine's Foreign Editorial Staff.

The country or regional profile would remain a Luis Marden specialty throughout his career. That did not mean he remained entirely earthbound. His talents began chasing his interests early in his career, and it was not long before they soared into the skies. Marden, a licensed pilot, loved to fly, so it was natural that, aviator's silk scarf wrapped around his neck, he became the photographer who specialized in aeronautical subjects as well. It wasn't just because he had, in one editor's opinion, a "fertile imagination and proven ability to produce technically perfect photographs about unusual subjects." He had also been steeped in the lore of flight and space travel since boyhood, when the Wright Brothers, H. G. Wells, and Mars had been among his many passions, and he remained a lifelong devotee of science fiction and a warm friend of Arthur C. Clarke's. So, again, it was natural that soon after NASA's establishment in 1959 he became the Geographic's photographer of choice to document the heady, exciting days of Project Mercury, shooting rocket launches and tearing around Cape Canaveral with astronaut Gus Grissom. Years later, when rumors surfaced that a journalist might be permitted into space, Marden, though in his fifties, quickly volunteered.

Not that he never explored new worlds—he did, and whenever he recalled it in later years his eyes kindled with the remembered enchantment. Marden was an early convert to scuba diving. "Those were halcyon days," he would recall, "when the undersea world was new and lay all before us, waiting to be discovered. Every dive was like a visit to a new planet." Captivated by the world of the coral reef in particular, he resolved to find better means of photographing it in color. Yet undersea color photography was in its infancy; equipment was still crude and technique haphazard. Plunging in anyway, he devoured everything he could find on the subject, experimenting with various combinations of cameras, lenses, filters, and watertight housings. Then, in 1955, he secured a berth on Jacques Cousteau's *Calypso* for a long, difficult voyage to the gorgeous, unspoiled reefs of the Red Sea and Indian Ocean.

While Cousteau (and a young director named Louis Malle) filmed what became the Academy Award-winning documentary *The Silent World*, Marden dove with his makeshift equipment and tried making underwater stills. Hoping to balance the watery blue with the rich colors of the coral reef, he used ordinary daylight flashbulbs. But they often imploded under the water pressure, lacerating his hands and once, when a bag of them blew, knocking him nearly senseless in the deep. It was all an exercise in blind improvisation. Yet when the February 1956 *National Geographic* was published, it was clear he had succeeded. Never had the tropical glories of fish or reef appeared so beautiful. The images revolutionized the taking of underwater color pictures, influencing an entire

generation of undersea photographers. Marden had taken something experimental and by dint of hard work and ingenuity made of it an accomplished art.

Yet photography alone cannot explain the Marden mystique. While one hand held his camera, the other gripped his pen. His love for words transcended any professional requirement. It approached hieroglyphic veneration: "I should have been a philologist," he once wrote. In Latin America, Spanish had helped him become *muy simpatico* with dictators, aristocrats, campesinos, and Indians alike. Similar fluency in French, Portuguese, German, and Italian ("the language of my heart") opened doors in the Mediterranean, on the *Calypso*, in the Brazilian hinterland. He made inroads on Arabic and Japanese as well, studied various Polynesian dialects, and once, during an exceptionally rainy season in Papeete, recorded an entire Tahitian vocabulary.

The camera's real rival, however, was "that superb instrument, the English language." Good English was wine to his tongue; and his diction was so precise that his articles were cited six times in *Websters Third*—the landmark 1961 dictionary that Marden, believing it too permissive, called "an abdication of scholarship." He would instead pat the enormous bulk of his worn *Websters Second,* published in the '30s and stuffed with linguistic proprieties, as a priest would his Bible. Without standards in discourse, he pontificated, we should be reduced to the primitive, to the "palatal clicks and grunts."

He was a man of strong opinions. "I intensely dislike the term photo-journalist," Marden once wrote. "Why not just journalist?" That was only partially a linguistic cavil. His journalist was a journalist with a twist, the mythical "Geographic man," who stood above and to one side of the hard-bitten, news-oriented foreign correspondent. A man on Geographic's Foreign Editorial Staff traveled first-class, stayed in the finest hotels, and always, because he was expected to be a gentleman, carried a black tie. That was a role with a flourish, and it perfectly suited the mannerly Marden. The world was his oyster, and he went about savoring it. He made his assignments, whenever possible, gastronomic tours, and his own wine cellar was always stocked with the finest Grand Crus burgundies—Musigny, Richebourg, Romanée-Conti. His sharp eye, precise diction, and discriminating tastebuds lent his Geographic articles sensuous detail, evoking the look and feel and flavor of a place.

Because he was alone in the field, pictures and text both being his sole responsibility, his was above all a role that gave him freedom. Marden always craved freedom; it was a *Life* magazine article describing a Frank Lloyd Wright dwelling as being a "pattern for a freer life than you could possibly live in the conventional house" that inspired him to contact the famous architect. Freedom from convention and editorial constraint alike allowed him full rein to chase his interests, to live out boyhood dreams. Like Captain Cook, he studied navigation beneath the billow and boom of sail. Like Charles Darwin, he played at being a gentleman naturalist of the old school. He collected freshwater sharks from Nicaragua; samples of breadfruit and sandalwood from the tropics; and not one but two of those rare fossil eggs of the giant extinct *Aepyornis* bird from Madagascar. And then there are

his namesakes: a small pink orchid *(Epistephium mardeni)* he discovered in a Brazilian forest and a tiny sand flea *(Dolobrotus mardeni)* he recovered from the Atlantic surf.

He pushed that freedom to its limits, though, sometimes disappearing for months at a time. He chased the "golden dream of everyman," an idyll in Tahiti, to the point where he nearly lost his job. He usually turned up, however, not just with an egg or a plant but with the story—or several of them. Eight months covering Franco's Spain in 1949 resulted in three articles and a lecture film. And he always managed to carry his editors and readers along for the ride. That was never more true than when he carried them to a lonely speck in the vast Pacific called Pitcairn Island. He had embarked on a quest to discover the remains of the storied *Bounty,* the ship whose decks once rang to the shouts of the most famous mutiny in history, when Fletcher Christian seized the vessel from Captain Bligh, and sailing her to remote Pitcairn, scuttled and burned her.

Marden got it into his head to go there, if only because, at the dawn of scuba, no one else had thought to search for the *Bounty*'s remains. Some editors weren't ready to indulge him this one. But he prevailed, and just happened to be the right man at the right time and that distant corner of the world was the right place. In January 1957, after weeks spent diving in the treacherous currents and pounding surf of Bounty Bay ("Man, you gwen be dead as hatchet," a Pitcairn Islander liltingly warned him), he found what fire and coral and wave had not destroyed: an oarlock, some copper spikes, a rudder pin, hull fittings, and scores of small sheathing nails. It did not amount to much, but that didn't matter. Those were the tangible fragments of a burnished romance, and when the story "I Found the Bones of the *Bounty*" was published in the December 1957 Geographic, it appealed to people the world over. It was quintessential Luis Marden, a compound of imagination and pluck and derring-do—and not a little stubbornness. More than any other of his achievements he came to be identified with this most quixotic of quests. At the end of his tailored sleeves, his cufflinks were made of *Bounty* nails.

The myth endured because he endured. Retirement in 1976 came and went and still he kept at it. With Ethel he twice sailed across the Atlantic, once being shipwrecked on a Bahamian reef. He pedaled an ultralight aircraft (while in his seventies) high in the sky; his subsequent article was the most popular one he ever wrote. He replotted the route Columbus must have taken to the New World, adding for the first time the effects of current and leeway. For decades he continued to maintain a desk at Society headquarters. Though photography had long passed him by, the halls he trod back and forth to that desk were practically paved with millions of 35mm Kodachrome slides that were the foundation of Natoional Geographic's pictorial success. Soldiering on, increasingly stooped, increasingly frail, to the ultimate rendezvous, he kept arriving well into his eighties, his pin-stripes and cufflinks flinging defiance at "casual Fridays." After all, he once said, with that conspiratorial grin, "I was practically born here."

Texas, 1938

Buenos Aires, 1939

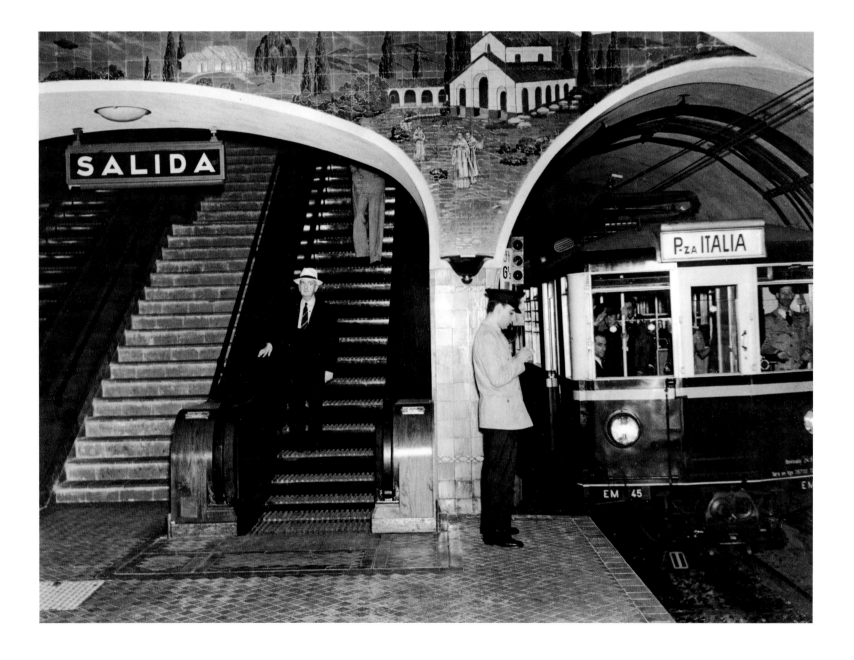

Guatemala, 1936

Yucatán, 1936

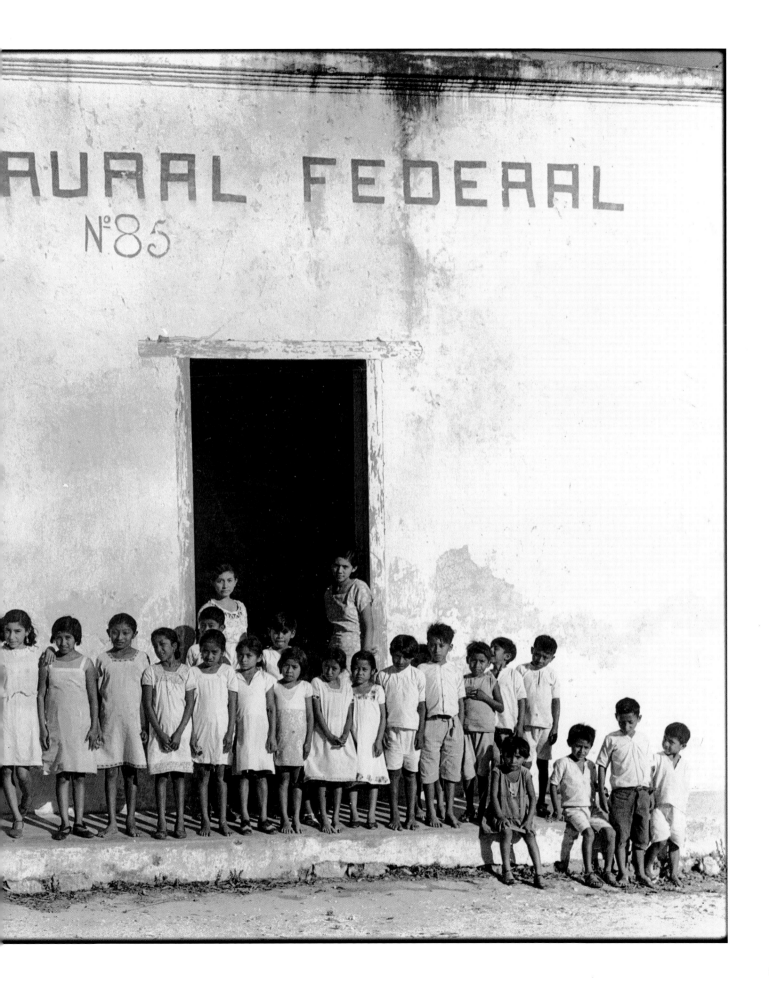

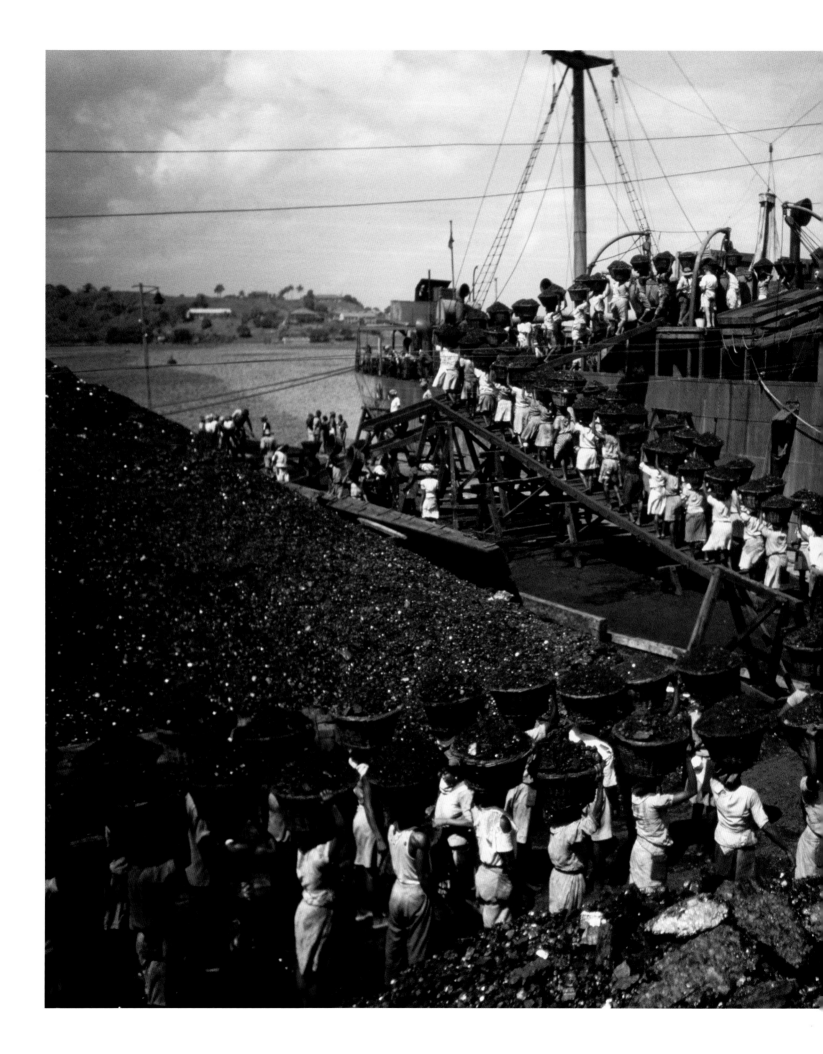

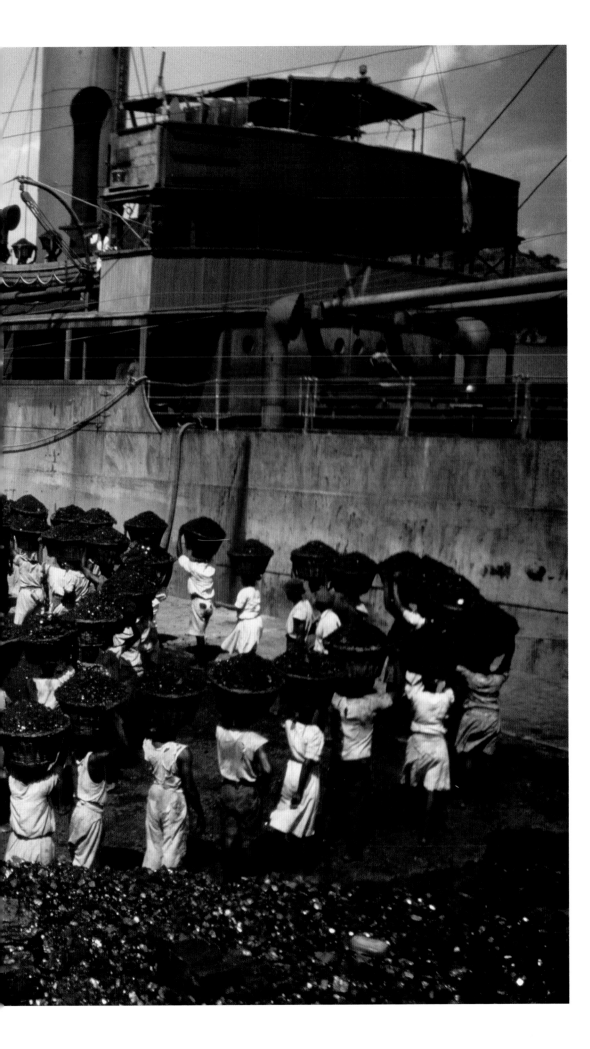

St. Lucia, 1941

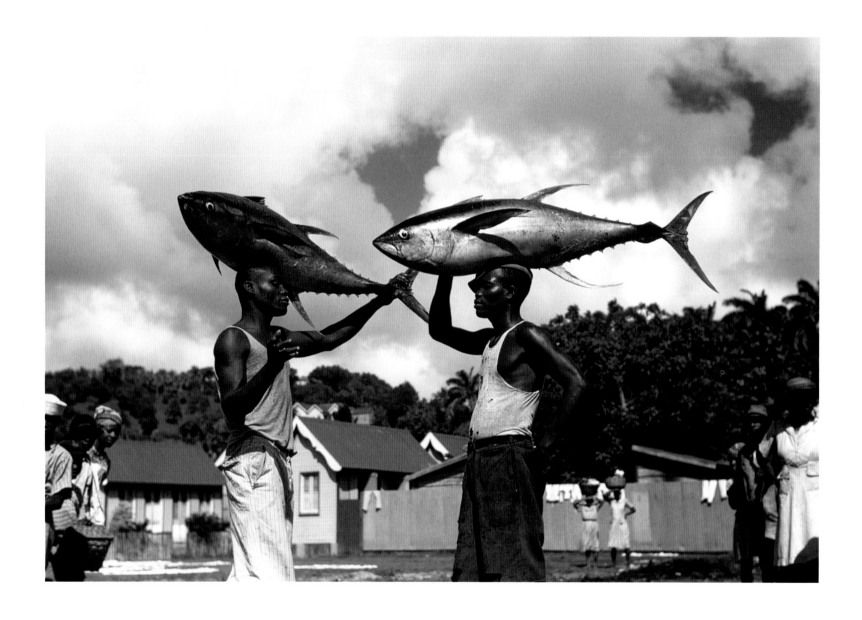

Panama, 1941

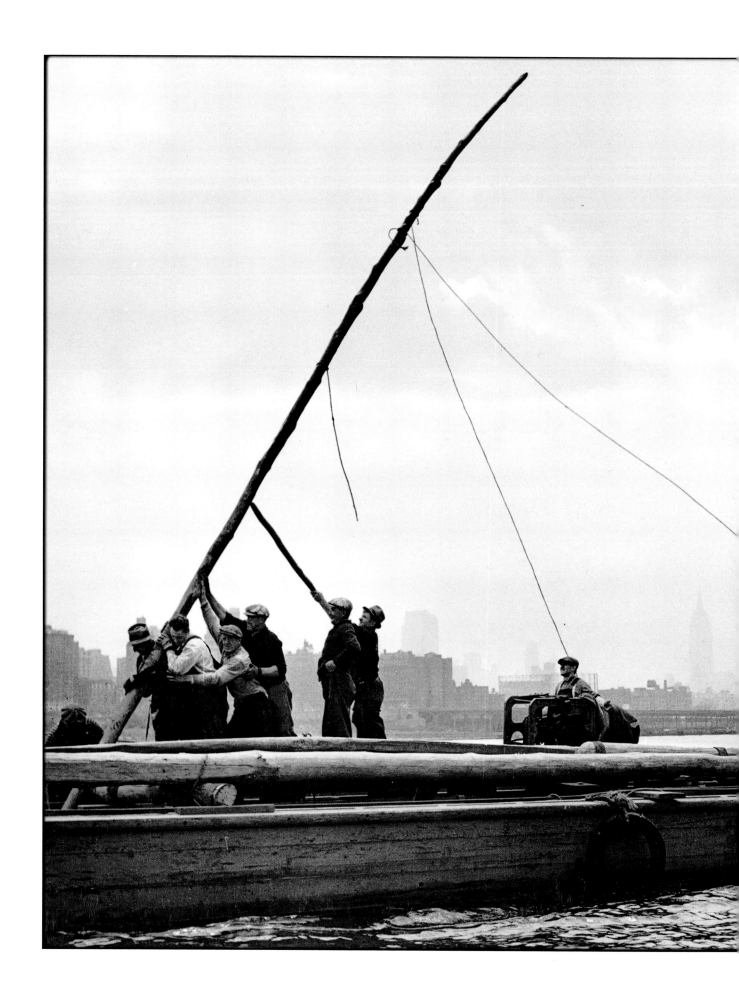

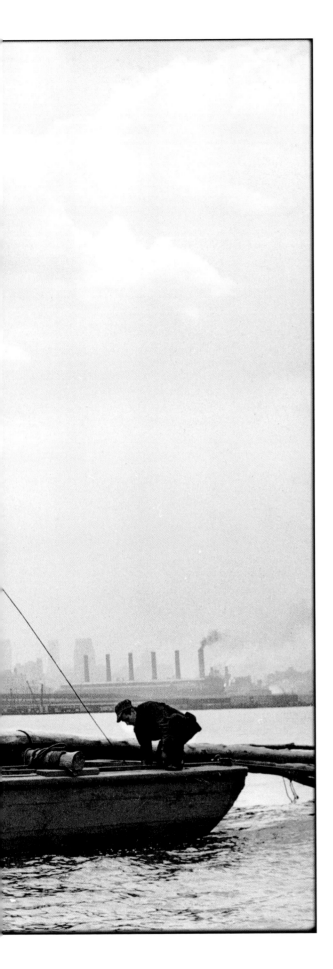

Shad fishermen, New York Harbor, 1942

Nicaragua, 1943 (both)

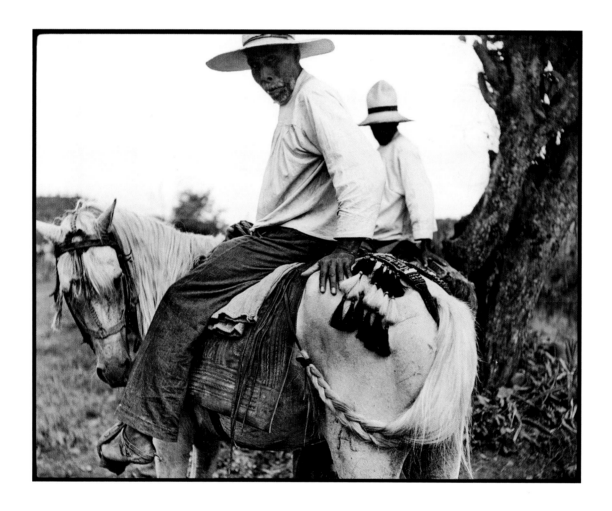

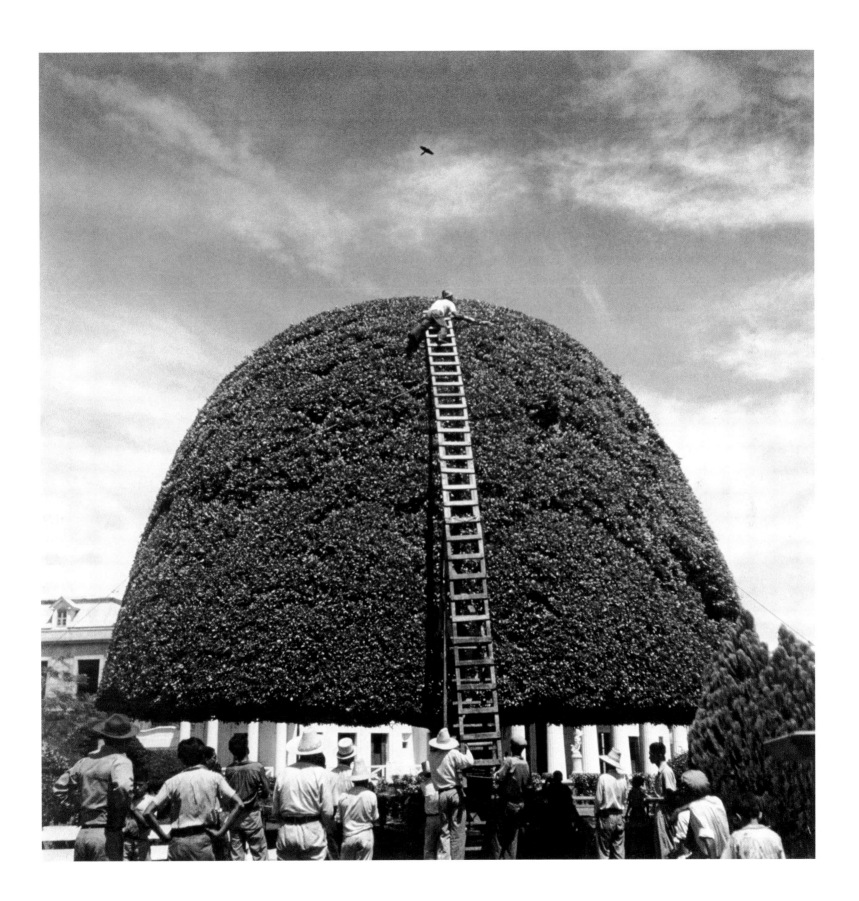

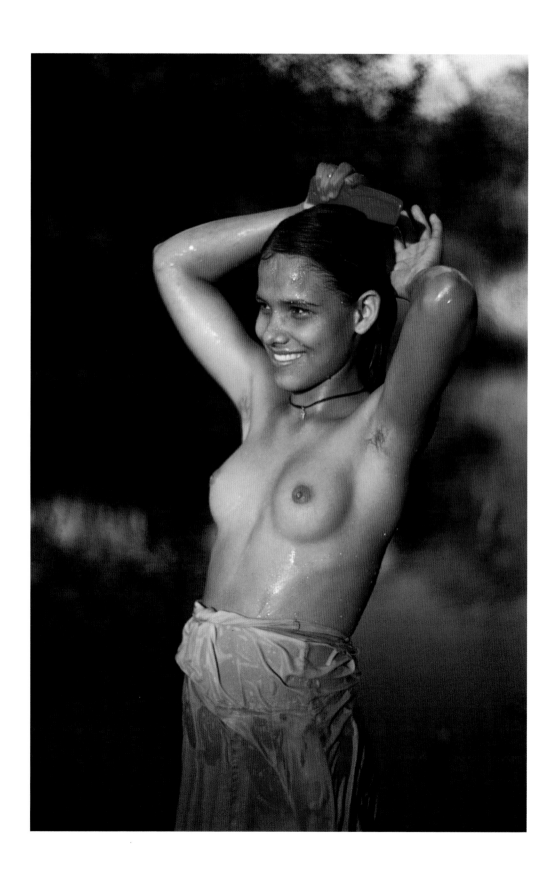

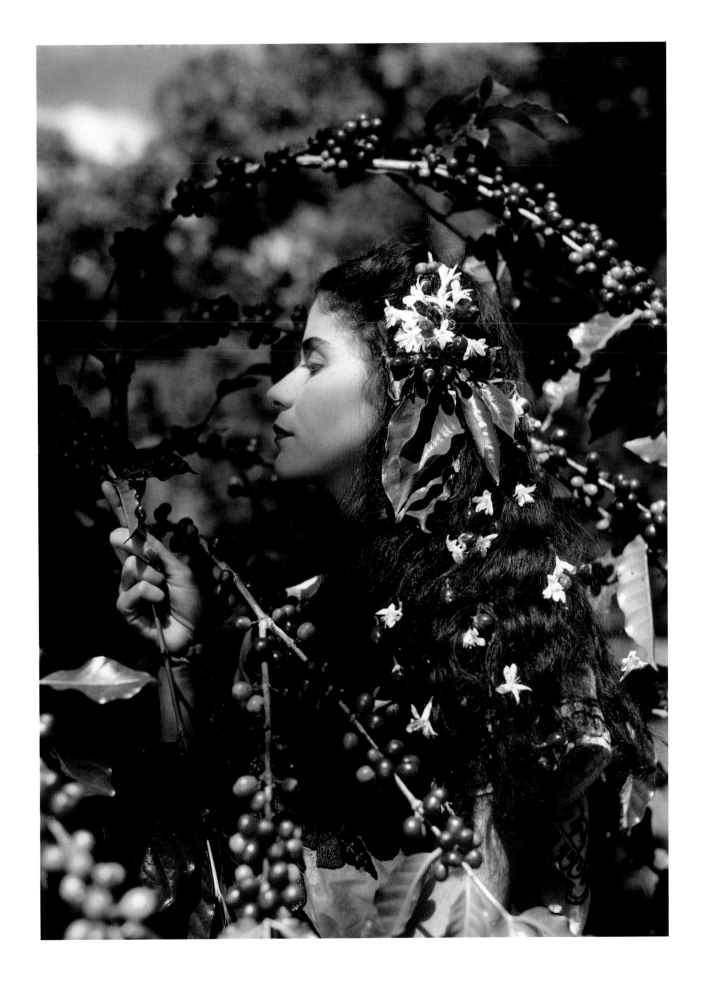

"When Luis Marden dropped in by air from São Paulo, he demanded gauchos..."
—Maynard Owen Williams, Argentina, 1939

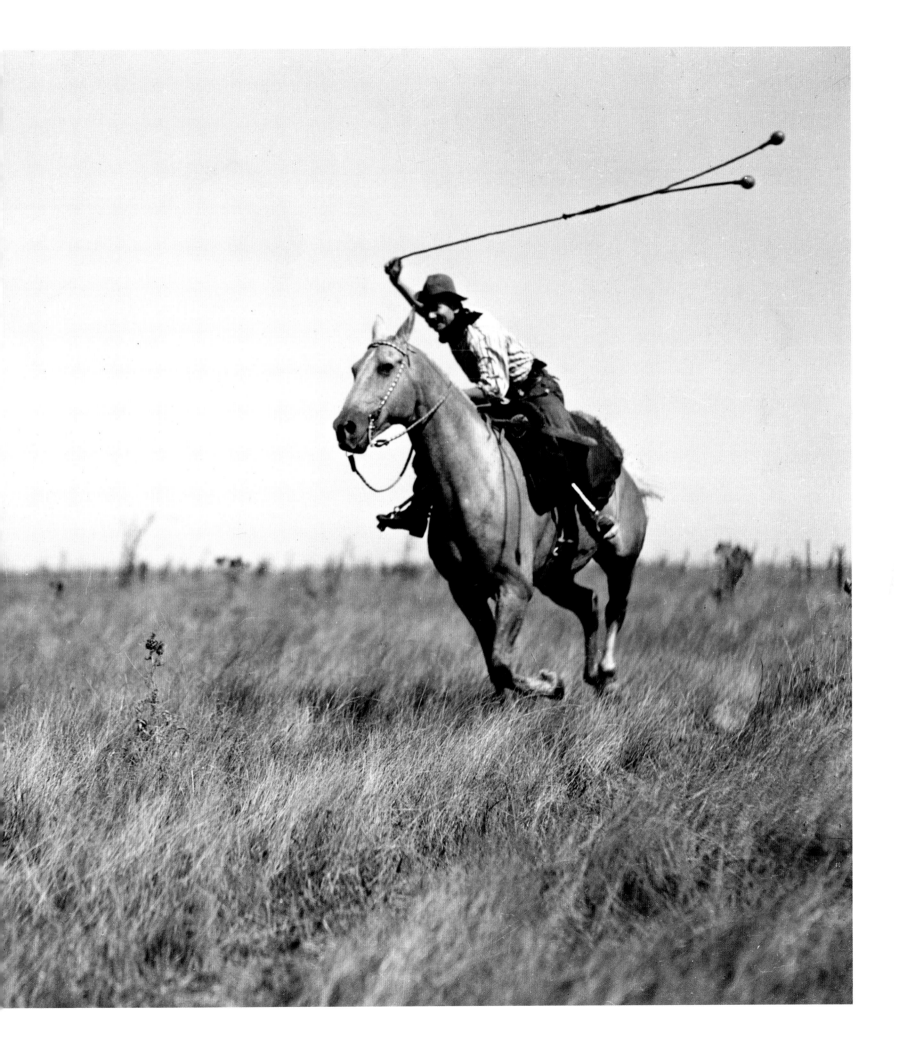

"I have had the good fortune through the years to be almost without exception in countries where I knew the language, and don't ever let anyone tell you it doesn't make any difference."
—L. M., Costa Rica, 1944 (all)

Maine, 1952 (below)

California, 1955 (opposite)

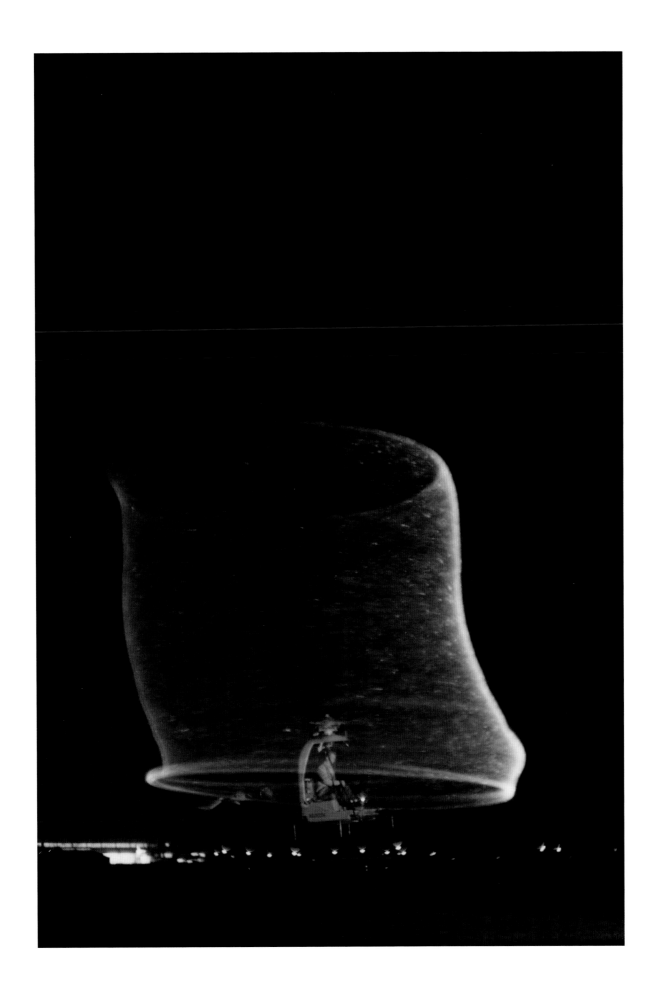

"No one who was born in New England is a man without a country."
—L. M., Maine, 1951

The Mbengga Fire Walking Ceremony, Fiji, 1954

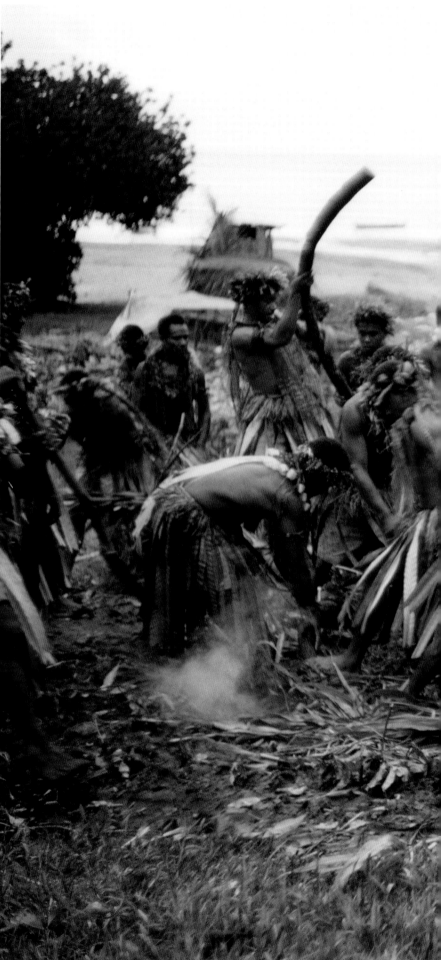

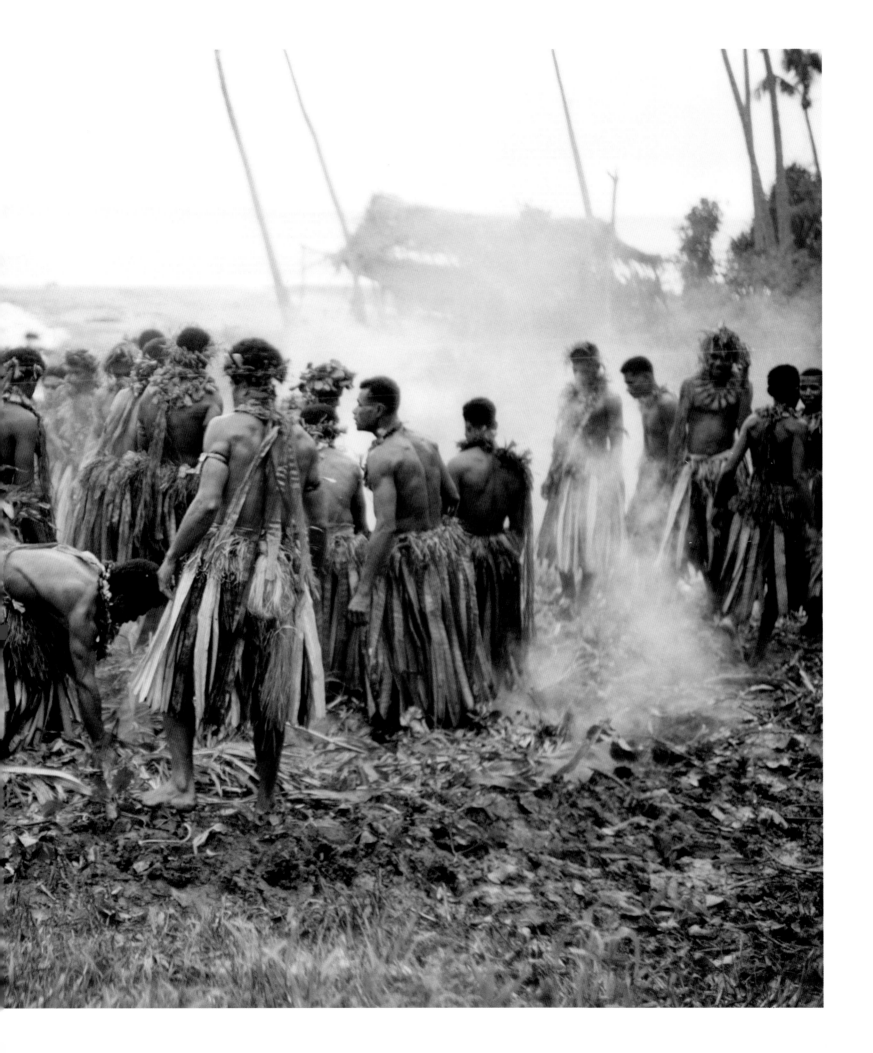

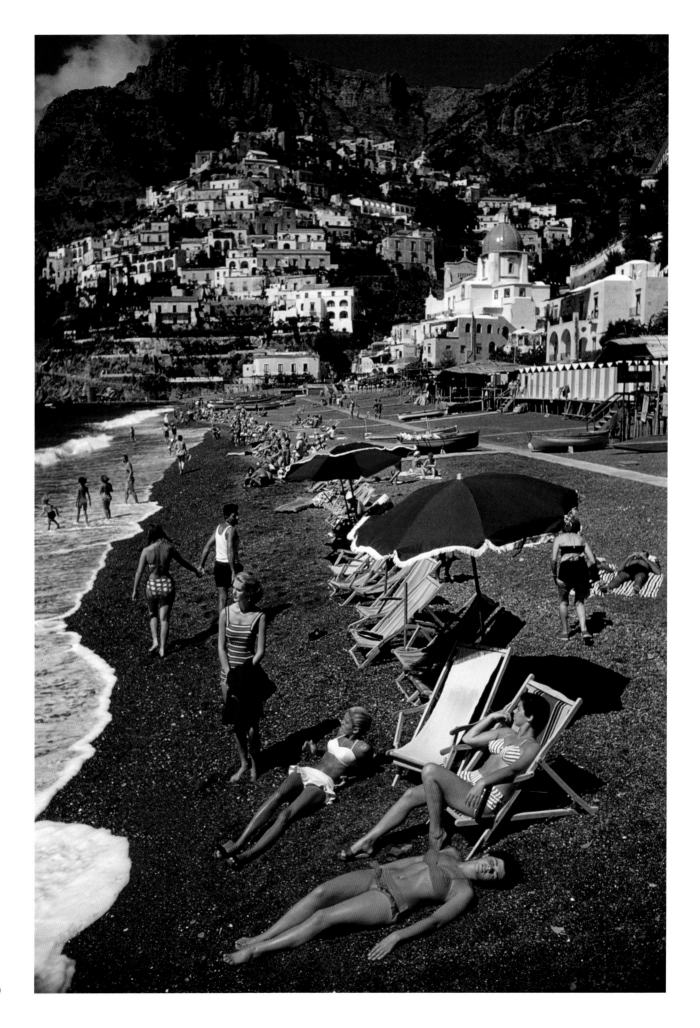

"Positano has something for everyone, including the lotus-eaters. As it becomes fashionable, the town attracts more and more of the conventionally unconventiional set, who circulate from watering place to watering place round Europe and the world, greeting each other with delighted little cries as their paths cross."
—L.M., *NGM*, October 1959

Positano, Italy, 1956

Japan, 1970 (both)

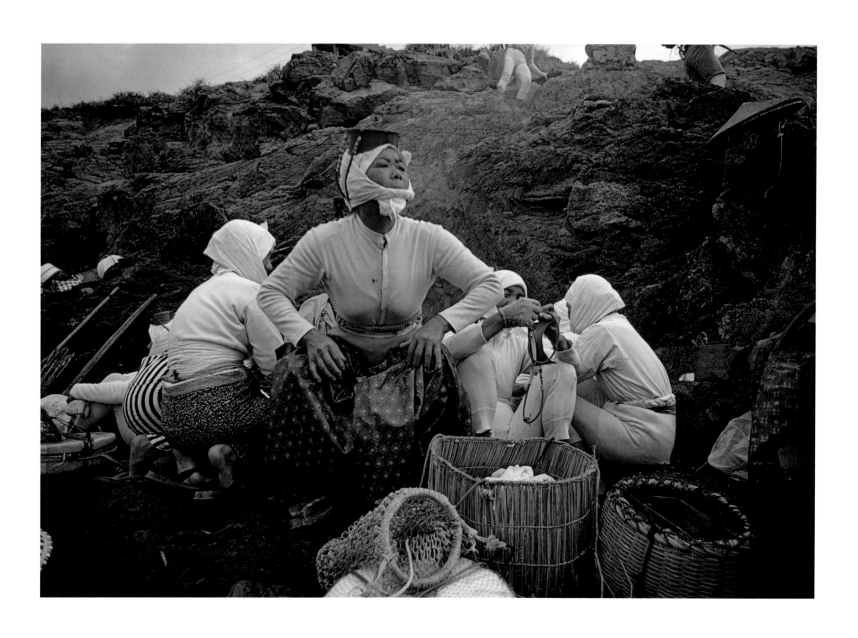

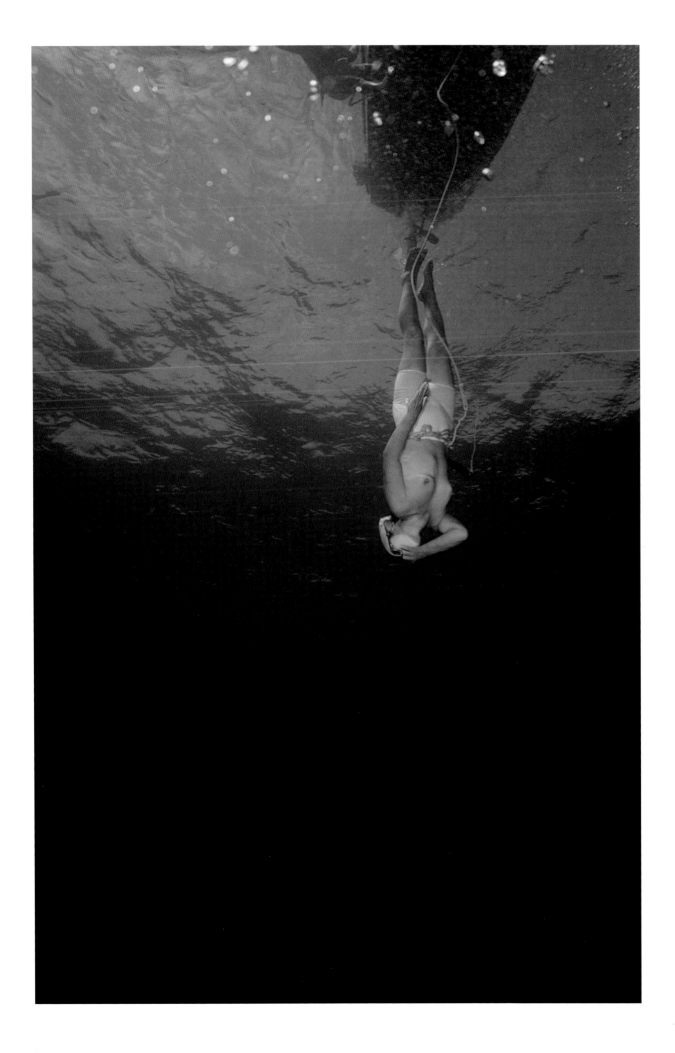

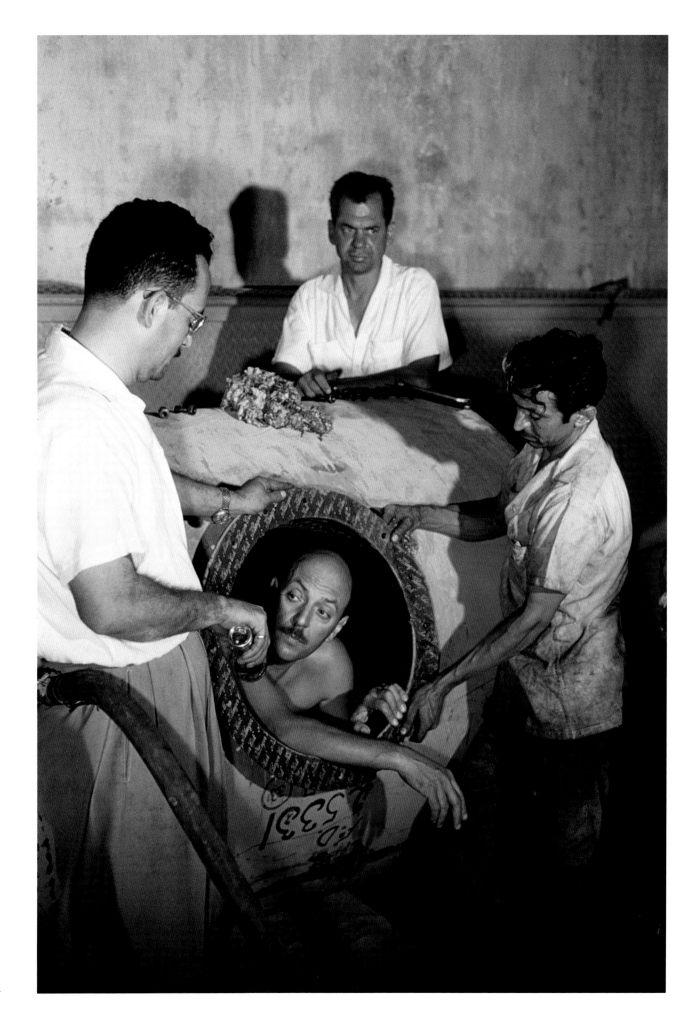

"My time in that steel coffin was one of the least pleasant experiences of my life. I would not recommend it to anyone with claustrophobic tendencies...When, after centuries of time, I heard the six-blow hammer signal, 'We're bringing you up,' I felt as though I were emerging from a dungeon in which I had lain for years."
—L. M., 1959 *NGM*, January 1959

Emerging after seven hours in an emergency recompression chamber,
Dzibilchaltun, Mexico, 1958

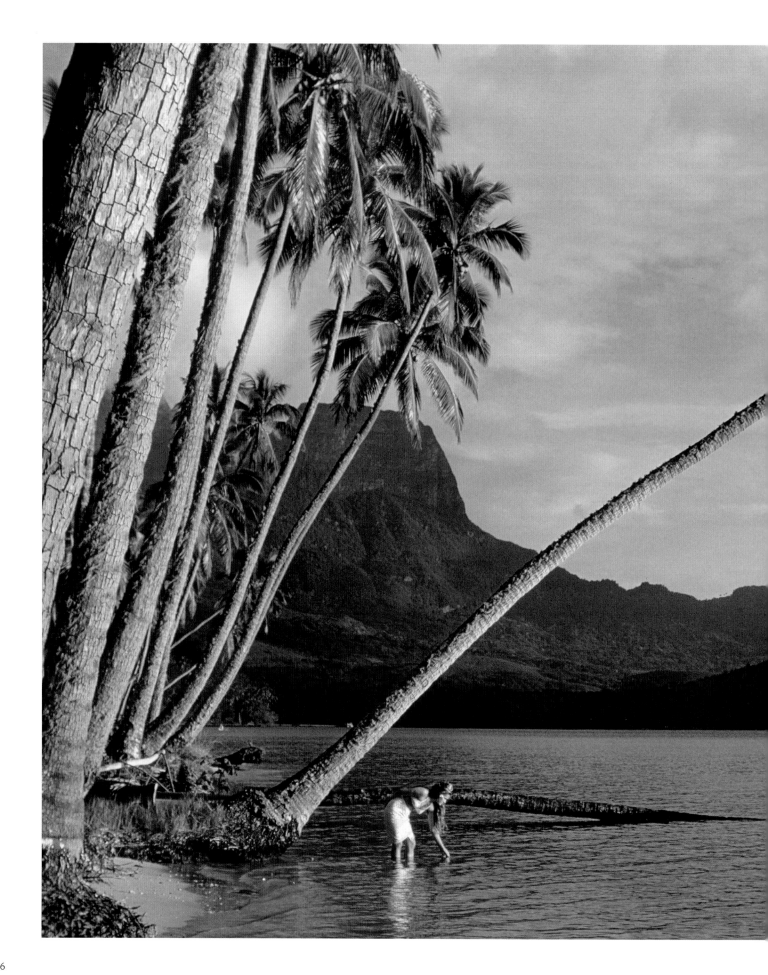

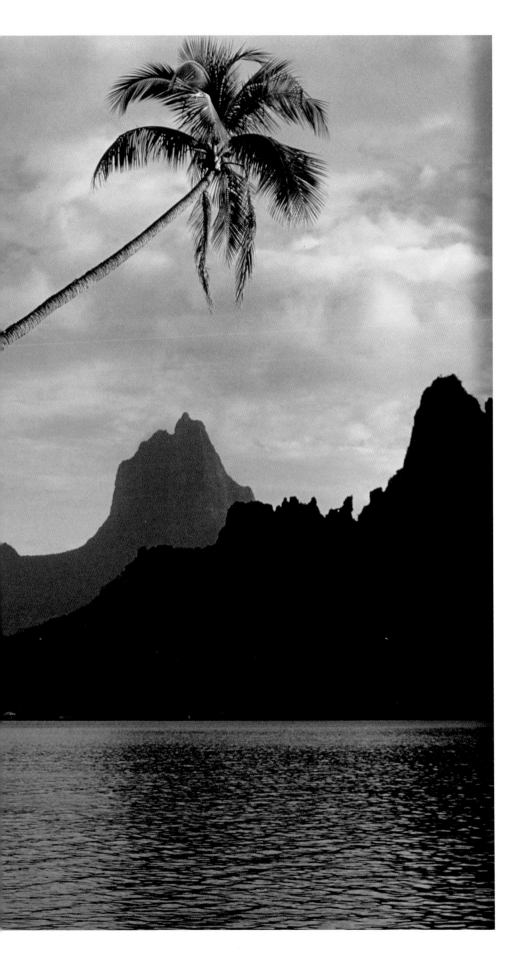

"*No matter if one never set out for Tahiti, the Isle of Illusion was always there, somewhere beyond the horizon, far away and approachable only by sea, the golden dream of everyman.*"
—L. M., *NGM*, July 1962

Tahiti, 1961

*"If anyone asks me officially, it is a
triumph of the cinematic art; actually,
it was a great disappointment to me,
particularly in Brando's acting and in the
contrived and vulgar ending. However,
if you have a chance to see it, by all means
do so for the scenes showing the ship,
which is the real star."*
—L.M. to a friend,
 November 1962 (right)

Two stars on the set of MGM's
Mutiny on the Bounty: the
reconstructed ship, and
Marlon Brando, Tahiti, 1961,
(opposite)

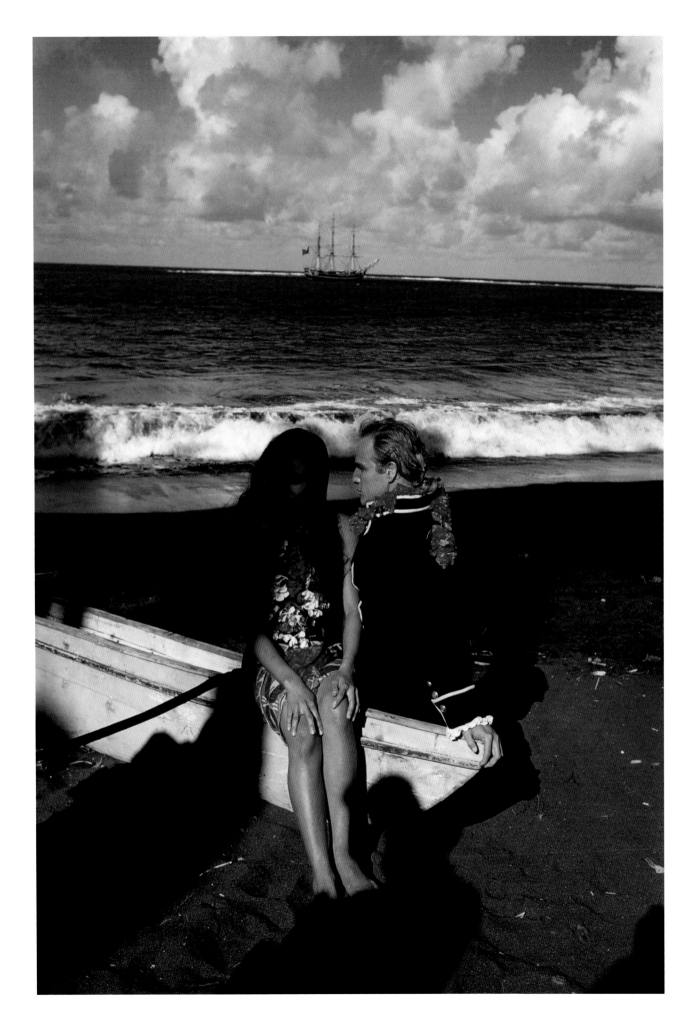

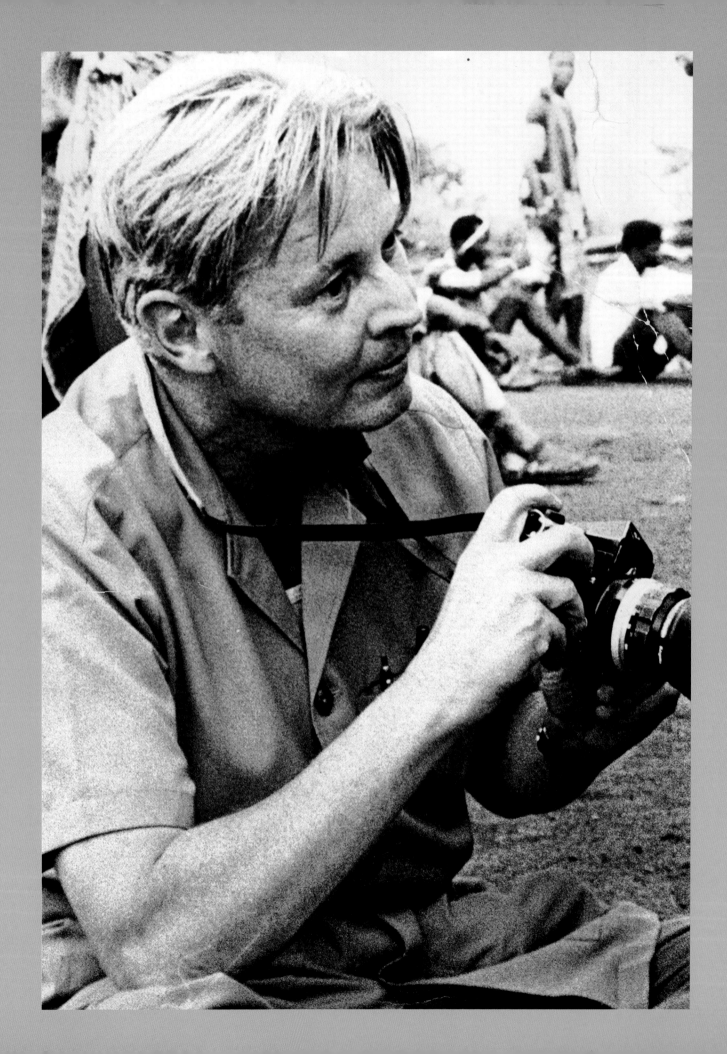

Volkmar Wentzel

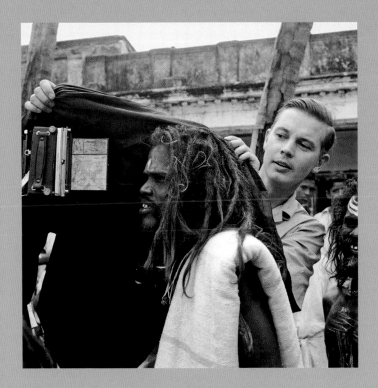

Madras, India, 1948

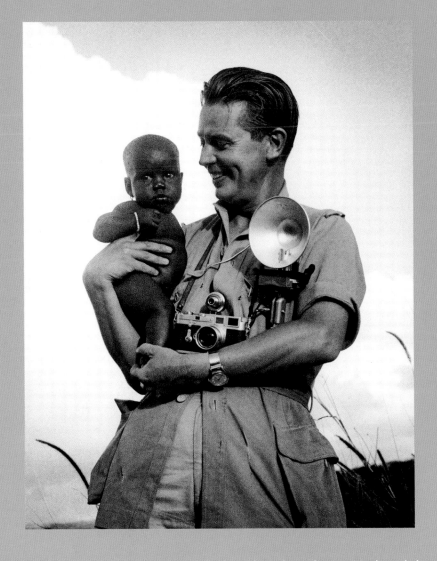

"A few days ago [your boss] Ted Vosburgh and Mrs. Vosburgh have been here with us. Very fine friends. And good news for you: Ted advised to make a letter for the National Geographic Society asking them for a grant for a big expedition, and, he added, they then would send a photographer with me. I said only the word Volkmar."

—Harald Schultz, Brazilian ethnologist and explorer, to Volkmar Wentzel, February 17, 1959

Belgian Congo, 1955 (opposite)

Volkmar Wentzel
National Geographic Field Man, 1937–1985

BY Viola Kiesinger Wentzel

Volkmar Kurt Wentzel was born in 1915 in Dresden which was, as he liked to put it, still in the Kingdom of Saxony. In 1926 the Wentzel family escaped the political unrest and ever rising inflation by emigrating to the United States. Volkmar's father, Dr. Fritz Wentzel, a respected photo chemist, was offered a position with Agfa-Ansco in Binghamton, New York. In 1932 his dear wife, Verna, died of pneumonia, leaving Fritz alone with four growing boys—a hard task for him.

The boys missed their mother terribly. Dr. Wentzel, though a brilliant scientist, was introverted and somewhat rigidly teutonic. His wife had provided communication and laughter in the family. Now there was only an endless succession of housekeepers. After a while, Volkmar could not stay at home anymore. He and a friend, Bill Buckley, decided to go on a "Good Will Tour" from New York to Rio (New York sounded better than Binghamton). They even wrote to President Roosevelt. The tour came to an abrupt end in Washington, D.C., when Bill discovered cockroaches in their room in the YMCA and went home to his mother. The year was 1935. Young Wentzel found himself standing in front of the White House without a place to stay or a job.

In his short life Volkmar had already had to adjust to many changes. It left him with a strong sense of the mutability of the world around him, a feeling that would stay with him all his life and make him want to hold onto, record, and explain what was disappearing. It made him a passionate photographer and an equally ardent, often lonely advocate for the preservation of historic photographs.

In 1963, at a lunch at the German Embassy, I sat next to a handsome bachelor with very fair blond hair, pitch-black eyes, and charming dimples when he smiled. He had been introduced to me as a photographer/writer of *National Geographic* magazine, who had once been told by his editor to "do India." He did India for two years, from 1946 to 1948, a time of great change. I was intrigued. A year later we were married. We had three children and 42 wonderful years together. Volkmar died in May 2006 at the age of 91.

Getting back to the failed explorer in front of the White House, Volkmar did find a room— actually more of a closet with a window—on the top floor of 716 Jackson Place. The window had a magnificent view of Lafayette Square. He also found a job mixing photographic solutions for

Underwood and Underwood, a portrait studio on Connecticut Avenue. In his boarding house, he met Eric Menke, a somewhat eccentric architect, who became a lifelong friend and mentor. Eric loved Washington and knew the city and its history. When Volkmar finally got hold of an old Speed-graphic, Eric introduced him to a little book by Brassaï, *Paris á Nuit.* The night pictures enchanted Volkmar and inspired his magnificent black-and-white images of Washington by night. Roaming the city by night he caught the mysterious alabaster beauty of its monuments, but he also photographed with empathy ordinary people he encountered. Many years later my husband wrote, "I am still fascinated by the silver mystery of black-and-white photography. It can capture scenes in a way that color cannot and is the equivalent of abstraction in painting or sparse prose in literature." This is indeed how he captured Washington for us.

He printed his own pictures on Underwood's best portrait paper and marched with them to the National Geographic Society. He got a job. His 48 years with the Society had begun.

His first photographic assignment was West Virginia. He loved its windswept highlands and deep valleys. He photographed farmers, miners, quilting parties, applesauce-making, quaint traditions, hardship, courage, and poverty. Here began a lifelong love affair with this beautiful mountain state and its people. We have a farm now near Aurora, West Virginia, where we restored a 150-year-old house, much of it with our own hands.

Shortly after Volkmar returned from the war, where he served in the photographic division of the Air Corps, his editor at the magazine spoke the famous words: "Do India." India was then a subcontinent in transition. He was given a letter of credit for $2,000 and told to keep his nose out of politics.

Volkmar set off by boat toward Bombay. Upon his arrival he was able to buy, for $600, an old war ambulance that had to be hand cranked. It would give him mobility, house his 18 suitcases of photographic equipment, and serve as lab and hotel. He was ecstatic; not so the accountants at home. A sharp reprimand noted that the letter of credit was intended for small withdrawals only. Volkmar was crushed, but just then a telegram arrived from Gilbert H. Grosvenor, president of the Society and editor of the *Geographic*, congratulating him on acquiring an ambulance for his photo survey of India. God was in heaven and all was well with the world again.

Volkmar had the ambulance painted with a map of India and the words "National Geographic Photo Survey of India" in English, Urdu, and Hindi. As he drove his vehicle through the streets of Delhi, it attracted the attention of Pandit Nehru, at that time an activist working for India's independence from colonial Britain. Nehru sent a messenger to invite Volkmar to lunch. When Volkmar asked his host where he should go first to photograph, Nehru answered without hesitation, "Go see the Ajanta and Ellora caves," in the state of Hyderabad. Volkmar took the advice, even though he was not convinced that this was *Geographic* material. I am glad he did.

Both caves are actually temples and monasteries carved out of the living rock. The Ajanta walls were decorated with exquisite frescoes portraying the life of ancient India. For reasons unknown,

the monks abandoned Ajanta about 900 years later and moved to Ellora, only about 50 miles away. The jungle took over Ajanta, and the temples were forgotten and only rediscovered early in the 19th century. The Ajanta frescoes and the Kayhash temple sculptures of Ellora are from what is often called the golden age of Indian art. Over the next 300 years, the Buddhist monks were joined by Hindus and Jains. All contributed to a priceless heritage.

To photograph these treasures, Volkmar and his Sikh assistant had to build scaffolding in the temples. They also had to sleep in the caves. The Sikh, who was of the Indian warrior class, did not like this and left Volkmar alone at night. Volkmar had just received some of the new Ektachrome film. He wanted to photograph the frescoes in color with his Linhof and develop the film right on the spot. He worked for three days. It was very, very hot. Finally the time came to develop the film. Here is a description, in his own words:

I set up all the solutions, I think it was 11 or 12. I had also sent for a block of ice to cool the solutions down to 65 degrees. All this was done with a green bulb in my flashlight; there were no darkroom lamps. I began to process the film. It was quite scary in the temple. Huge Buddhas (satraps) towered over me. From the outside I heard the night coming in. I heard the river splashing through the valley and owls hooting. Bats kept flying around my ears. At last the moment came to turn on the white flashlight: good pictures!. As I lifted them up all the images slid off. The solutions had not been cool enough. I had to photograph it all over again, with more ice brought in from Orangabad. Finally I got a good set of 3¼ or 4¼ Ektachromes of these beautiful 5th- and 6th-century frescoes. I was very proud. The irony is, at home the editors did not like my pictures because there were no people in them pointing at the frescoes. None were used. And all my work was in vain.

Not quite. The Indian Embassy in Washington had a splendid exhibit of his temple photographs.They certainly represent an inspired, extraordinary record of India's most treasured art and history.

The National Geographic Photo Survey Ambulance opened many doors for Volkmar, even among the maharajas of Rajputana. Rajputana comprises 23 Indian states. Volkmar explored five of them. After I had met him at the lunch I decided to read up on India. Here is what he wrote:

"In the oasis of the Indian Desert and in the uplands of India's ancient Aravalli Range, knighthood still flowers. There the resplendent maharajas of Rajputana, descendants of a lusty warrior race, dwell yet in the Age of Chivalry, surrounded by lavish oriental pomp and circumstance…. My most lasting impressions of Rajputana are of the incomparable pageantry and splendor in the courts and palaces of the maharajas. How long will this way of life continue?"

Volkmar went tiger hunting by elephant with the Maharaji of Bundi. He was allowed to see the treasure chest and jewels of the State of Jaipur and received an invitation to the wedding of the

third son of the Maharaja of Jodhpur to a princess of Jaisalmer. His story reads like a fairy tale, and he caught the essence and splendor of it in his pictures.

There was more to see. On the 9,000-foot-high Banihali pass, the tired ambulance acted up. Its fan belt was shredded to pieces. Volkmar had no choice but to coast for about 60 miles down to Srinagar, the capital of Kashmir. He learned that it would take a month to get a new fan belt. Never one to waste time, he set off on foot, and sometimes pony, for the stony wild desert of Ladakh. along with a Muslim cook/guide and his Hindu assistant. It took them a week to reach Leh, the capital. Volkmar politely drank salted yak butter tea with the Buddhist monks at Hemis and took breathtaking pictures of Bob Kharbu at 11,000 feet and the fortress-like monastery of Lamayuru. What struck me most, however, were his studies of faces: monks, a queen, the child High Lama, poor people, and the "leading citizen of Leh."

Our children listened often spellbound to tales of Volkmars's explorations. One very frightening experience happened in Ladakh. One evening he had stayed behind his two companions to photograph at dusk. His pony did not like to be separated from the other horses, who were on their way home to food and rest. The pony set off at a lively trot. To his horror Volkmar realized they were approaching a simple wooden plank bridge with no railings swinging high above the Indus River. The pony did not slow down. Volkmar closed his eyes; he had never been so frightened in his life. One wrong step and he would never have made it to Nepal, his next adventure.

Nepal at that time was still the forbidden kingdom. Very few outsiders had ever been there. You had to walk in from India. There were no roads, let alone airports. Volkmar was told to accompany Dillon Ripley, the ornithologist from the Peabody Museum, who was leading an expedition into Nepal in search of a rare bird, the Ophrysia Superciliosa. Mr. Ripley never found the bird, but came back with many other interesting examples of Himalayan bird life. Nepal was fascinating. Volkmar took a very amusing photo of a big Mercedes being carried by 60 bearers out of Nepal to Calcutta. It was to be exchanged for a new car that could only be driven in Katmandu, since only the capital had paved roads. At the expedition's camp at Mangelbare he was lucky to shoot a really beautiful view of Mt. Everest. It turned out to be the first time that the whole Everest massif had been photographed directly from the south. Sir Edmund Hillary is said to have used this picture to plan his Everest expedition.

Much more could be said about this interesting adventure. One of my most treasured possessions comes from the Mangelbare camp: Volkmar's Sherpa portraits. According to Webster's dictionary, Sherpas are "Tibetan people living high on the Southern slopes of the Himalayas and skilled in mountain climbing."

Volkmar took these pictures for himself. They are truly exquisite studies of human faces. Only one or two have been published. When he returned from India, he printed them himself. He was a master at that, too.

He was given many tasks during his 48-year odyssey with National Geographic. He pho-

tographed all over the world, not only in India and Africa but also in Europe and Mexico—the whole Atlantic Ocean coast down to Tierra del Fuego. He made movies in Nepal, French Cameroon, Angola, and Mozambique, and even recorded African music. He visited Albert Schweitzer in Lambarene and took what is certainly one of the most likeable photos of the doctor. He followed the salt caravans from the Danakil Depression in Eritrea through the desert to the fabled City of Timbuktu in Mali. He was fortunate in the three assignments of Angola, Mozambique, and the mother country, Portugal, again all three countries in a state of transition. He photographed the Moorish villages of the Algarve, now hidden by high-rise condominium buildings. He took pictures of the last Douro river boats with their lateen sails carrying the wine casks to Porto. Now the boats have been replaced by railroad and trucks.

Both Angola and Mozambique suffered from revolution and war. When Volkmar saw Angola, it was still a huge unknown part of Africa. The lead picture of the Angola story—a lonely, nomadic Kuvali tribesman sitting on a rock with a hazy mountain range as background—evokes all the mystery and beauty of this vast country. I love his photos of the Murila women and their decorative hairstyles, each depicting a different stage in life. Volkmar also had a great eye for catching touching ordinary scenes—a father playing with his son, a baby peeking out from under his mother's legs.

On Mozambique Island, Volkmar came upon a strange beauty regime among the women. They grind a root with astringent properties into a paste and then they paint their faces with it. It seems to be somewhat counterproductive that they never wash the white paint off. He took many pictures of the ladies. One is almost reminiscent of a Picasso painting; others are comical, such as the one of a woman smoking a cigarette from the wrong end.

The last two articles that he wrote as well as illustrated show his full talent but also the fun he had doing them. The first article is about Swaziland's celebration of independence from Great Britain. Surely there can't be a more splendid picture of King Sobhuza II in all his tribal finery. On the same trip Wentzel had great trouble photographing a witch doctor treating a sick little boy. The man wanted no part of it until he discovered Volkmar's little tape recorder. Finally he asked, "Can I have that?" Volkmar was surprised: "What for?" "I can hide it in a big gourd and then I have a talking calabash." Volkmar got the picture.

The second Swazi story dealt with the wedding of beautiful Princess Mantfombihe to the Zulu King. I was allowed to come along. The Swazis are a handsome friendly people and welcomed us to their celebration. Volkmar's story and photos show all their pageantry and exuberance. At one of their festivities I sat next to Chief Buthelezi, the Zulu king's uncle, who explained the meaning of the various rituals to us. As the princess danced into the kraal followed by her maidens and warriors, holding a large blade held upright in her hand, he said, "This blade is a symbol of virginity, and when you are royalty it works retroactively."

One of Volkmar's great passions was photographic history. He had an extensive library on the subject and spent many a weekend going to secondhand book sales. Bins of old photographs

fascinated him; so did old glass plates. He would develop the plates, and we would get a glimpse of a passed age. I remember one particular example that intrigued our girls in which elegant ladies in white dresses with frilly parasols took tea on a 19th-century hotel porch and enjoyed the salubrius mountain air. The children and I tried to steer him away from secondhand bookstores, estate sales, and photo bins but we did not often succeed. Many a time he told us how lucky he was to be working for the National Geographic Society, which represented among other things 100 years of photography and therefore 100 years of uninterrupted photographic hstory: Autochromes, Finlay plates, large-format nitrate film, Dufay transparencies, glass plates, and finally the safety film. It is the most extensive pictorial documentation in existence of the customs of mankind and of the physical features of this world. Imagine Volkmar's shock when he learned, more or less by accident, of "Project Negative."

Project Negative, according to a Photographic Services Memorandum dated February 18, 1967, was to remove all nitrate films from the files. Actually, Project Negative goes back to the 1960s and justified its destruction by a need to create space and therefore the need to get rid of material of no editorial value. All in all, 200,000 unpublished nitrate, safety base, and glass negatives as well as Autochromes and Finlay plates had been systematically destroyed.

There was some resistance to Project Negative and this is how Volkmar became aware of it. Judy Slifer of the Photo Lab, after having made many objections, was finally ordered to get rid of the negatives and prints. She threw it all in the trash and then called Volkmar, knowing of his interest. He took the treasure out of the trash and brought it home. This arrangement went on for a while. Volkmar rescued about 3,000 negatives and a few Autochromes and Finlay plates. Among the Autochromes were 11 taken on the 1908 Peary North Pole expedition. The Lumiere Autochrome plate came on the market in 1907.

Volkmar went on a crusade. He had very few comrades in arms and the frustrations were many. Just as things looked hopeless, he suggested the Society establish the Melville Bell Grosvenor Image Library, which would preserve its photographic trust. In 1980 Volkmar becme the Society's first archivist.

Shortly before his death Volkmar told me, "I don't want to be known for my photography but for my efforts to preserve the National Geographic archive that documented our changing world for nearly a hundred years." My husband was a modest man, and I was a very lucky wife.

Washington, D.C., 1935–1936

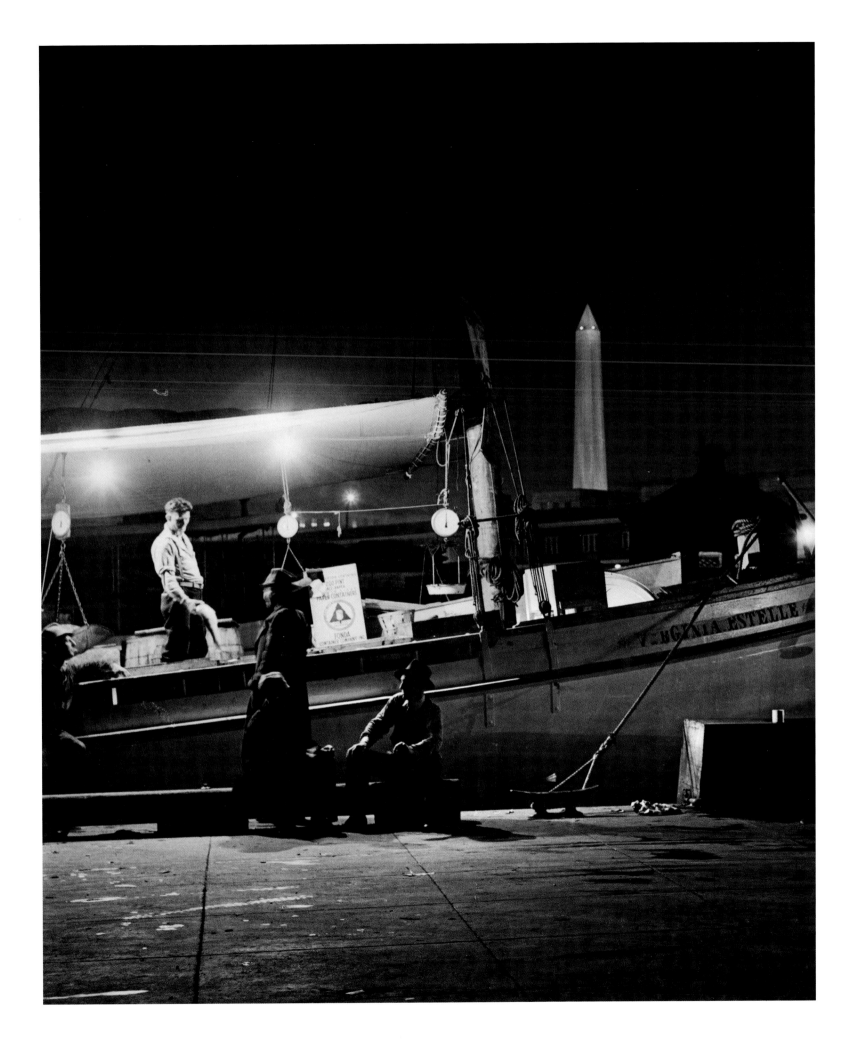

Washington, D.C., 1935 or 1936

West Virginia, 1939 (below)

Kentucky, 1940 (opposite}

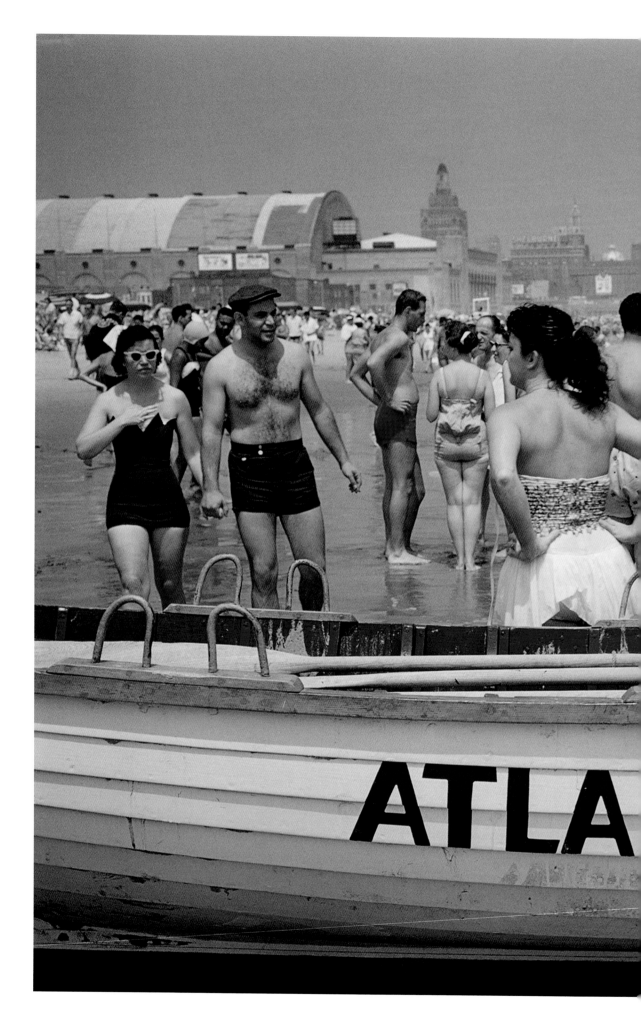

New Jersey, 1958

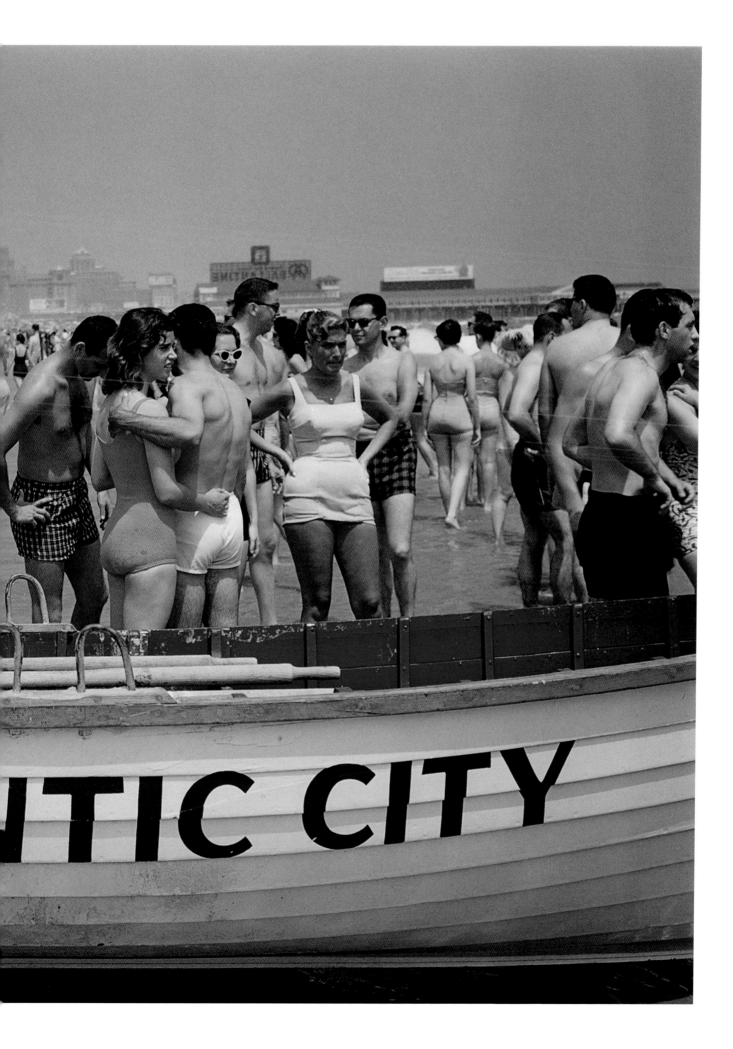

New York, 1953 (below)

Oak Ridge, Tennessee, 1953 (opposite)

"In the evening we would sit at a long table. It looked like the Last Supper, with Schweitzer in the middle.... After the meal, he would play the piano, which was totally out of tune, and that was a disappointment. But he liked to hold forth on almost any subject, and there's no doubt that he was a wise man and a man who knew about many things.... I got a very nice picture of him playing with two little kittens, because he had this reverence for life."

—V.W., Lambarene, Gabon, 1952

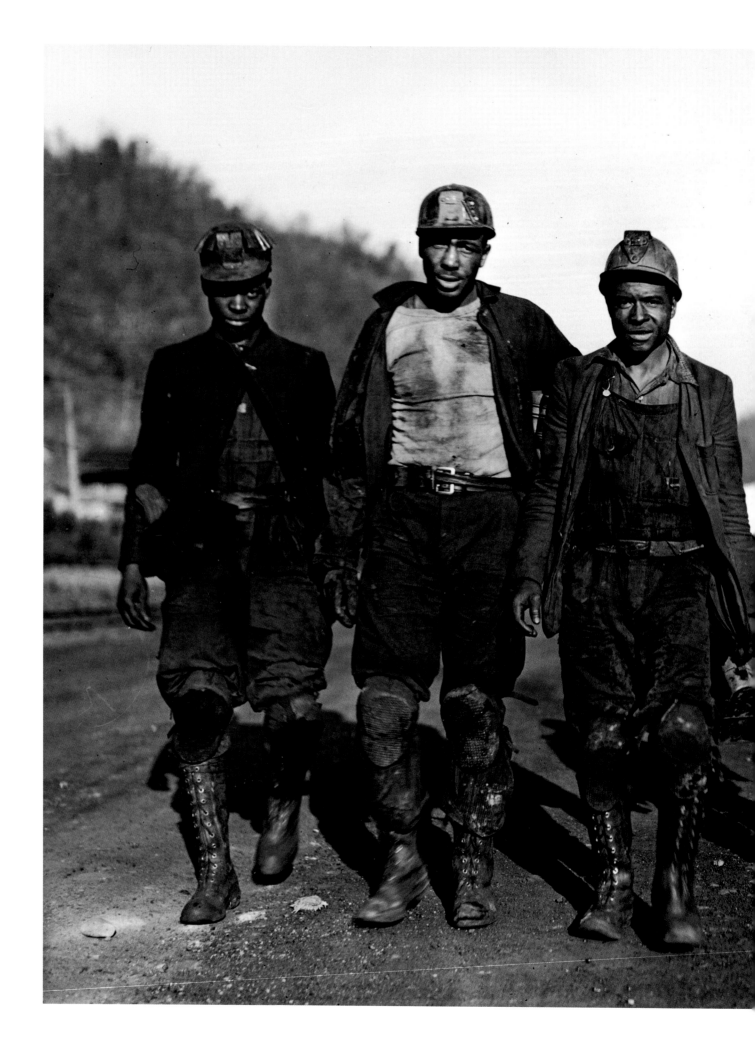

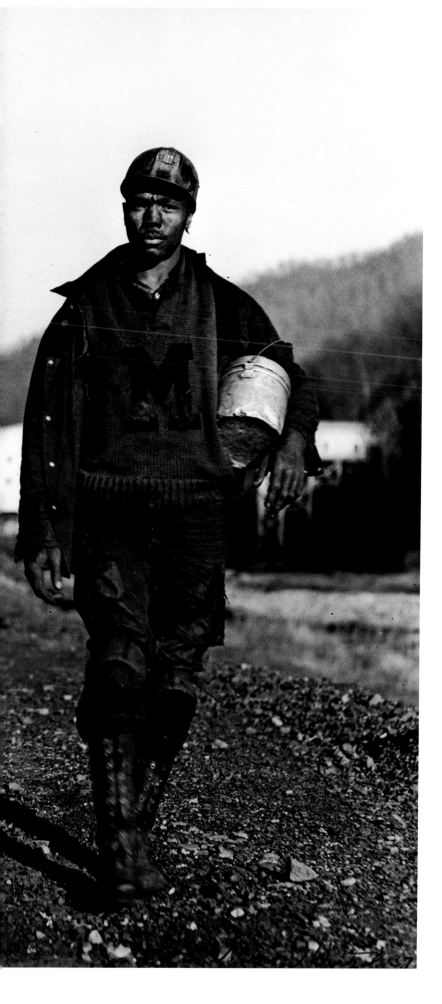

Miners in West Virginia, date unknown

India, 1946

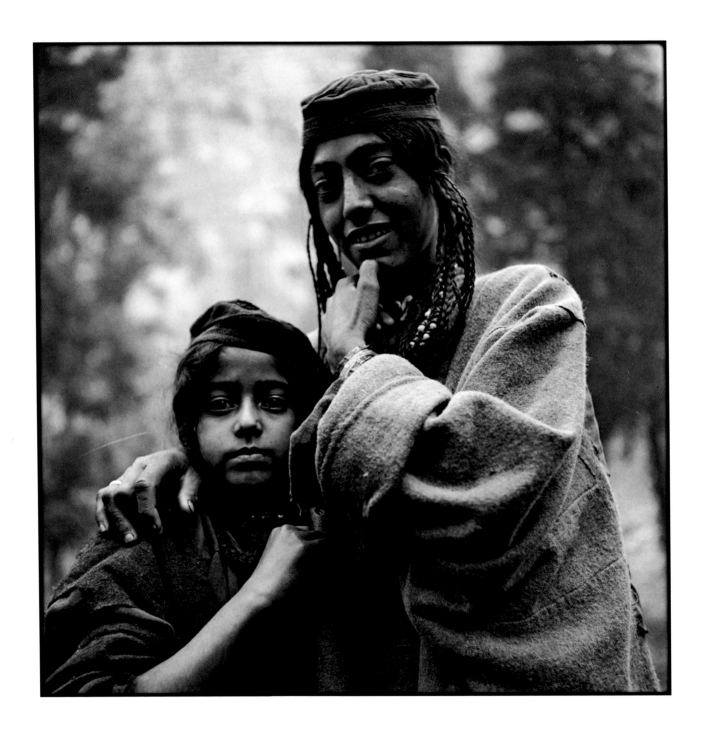

India, 1948

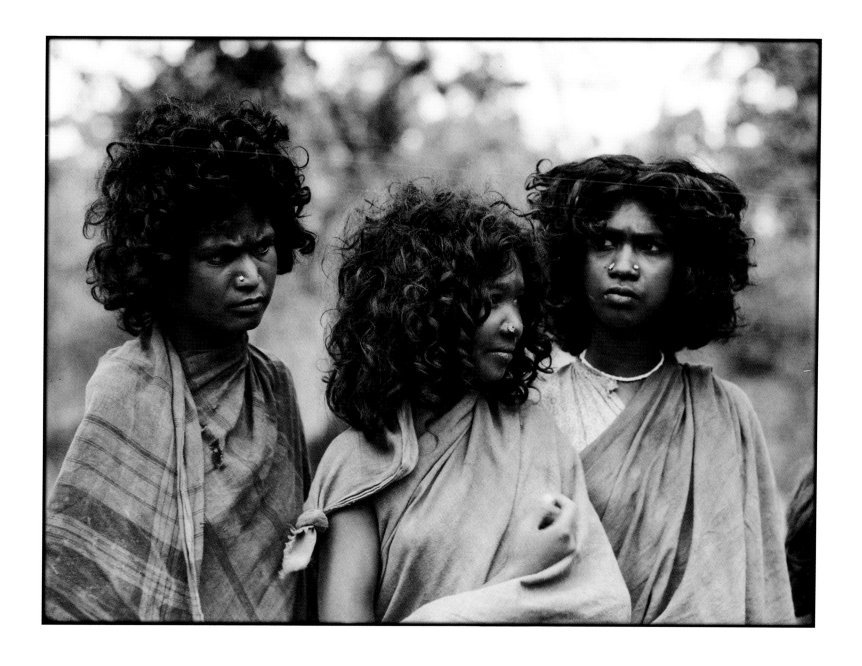

Near Bombay, India, 1948 (below)

Madras, India, 1948 (opposite)

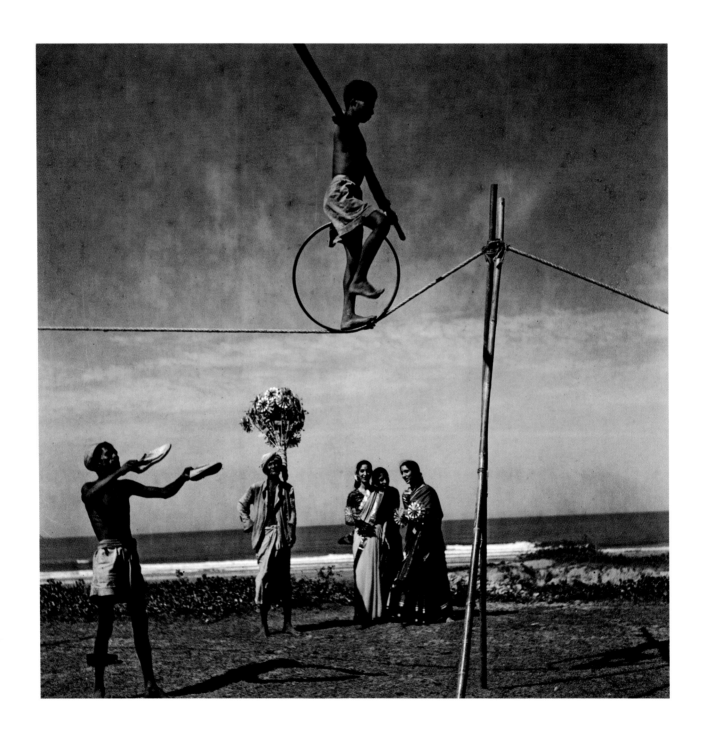

Bombay, India, 1948

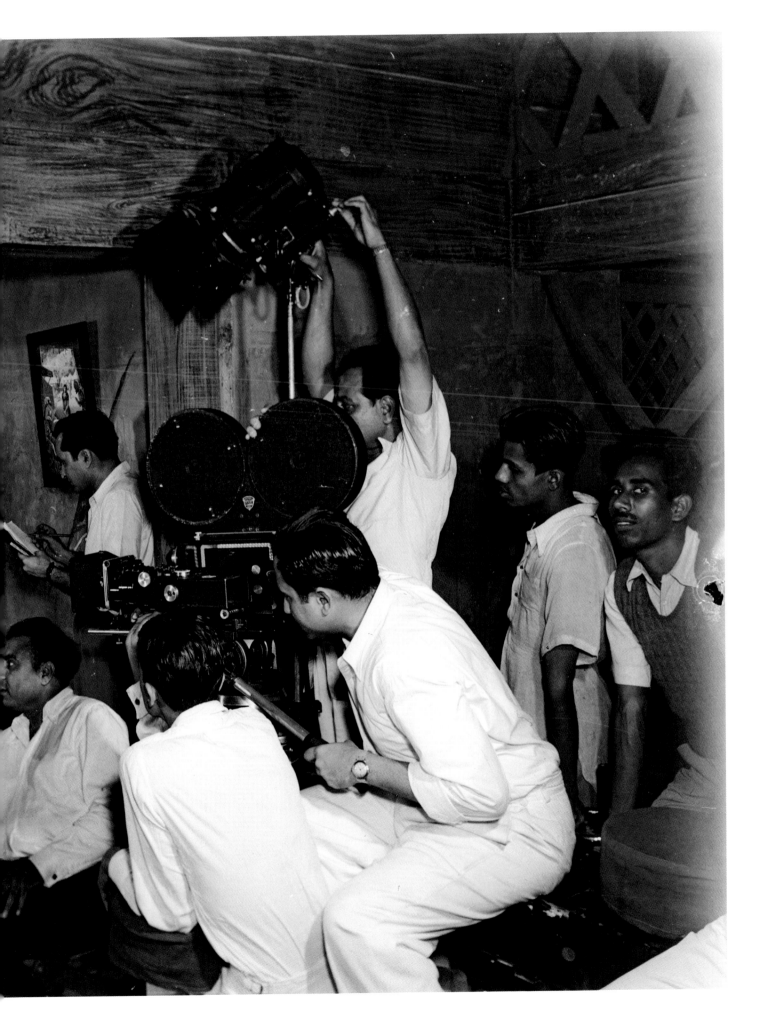

India, 1948 (below)

Bundi, India, 1947 (opposite)

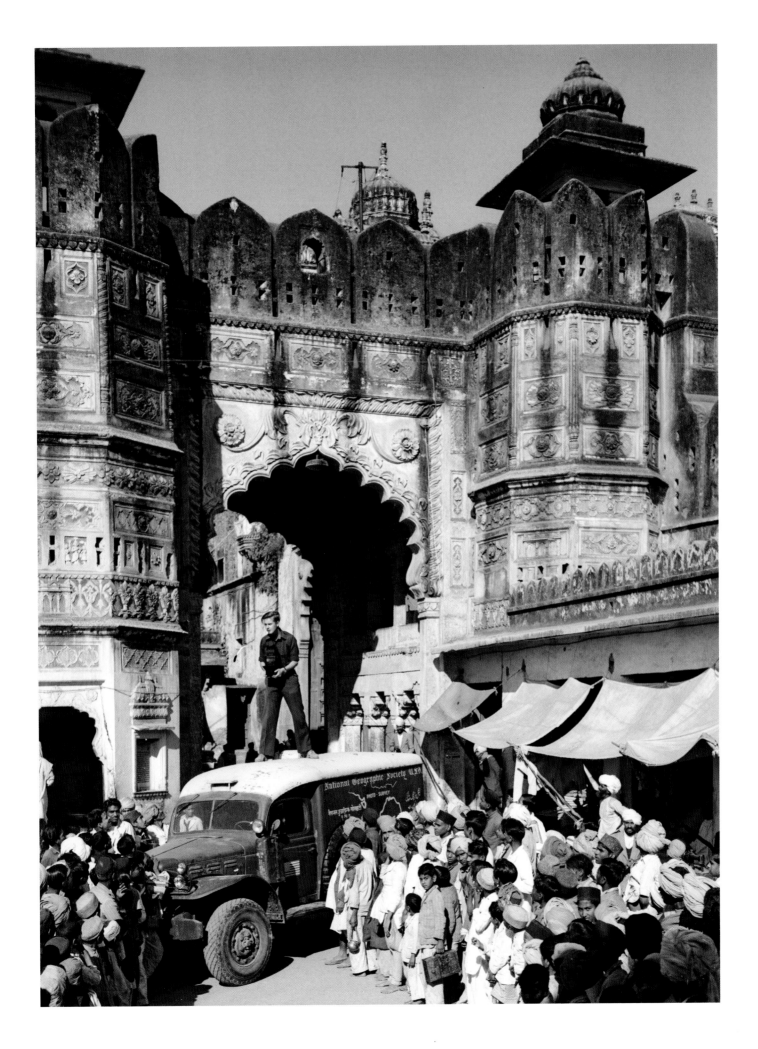

"Watching closely from my machan, I saw the tiger, which apparently had leaped out of nowhere, on the flank of the young man's elephant, clawing its way upward behind the frightened beast's ear. Quicker than it takes to tell, the rider shot the ferocious animal at close range. It dropped to the ground. Examination later showed it was a female about to give birth to five cubs."
—V.W., Rajasthan, India, 1947

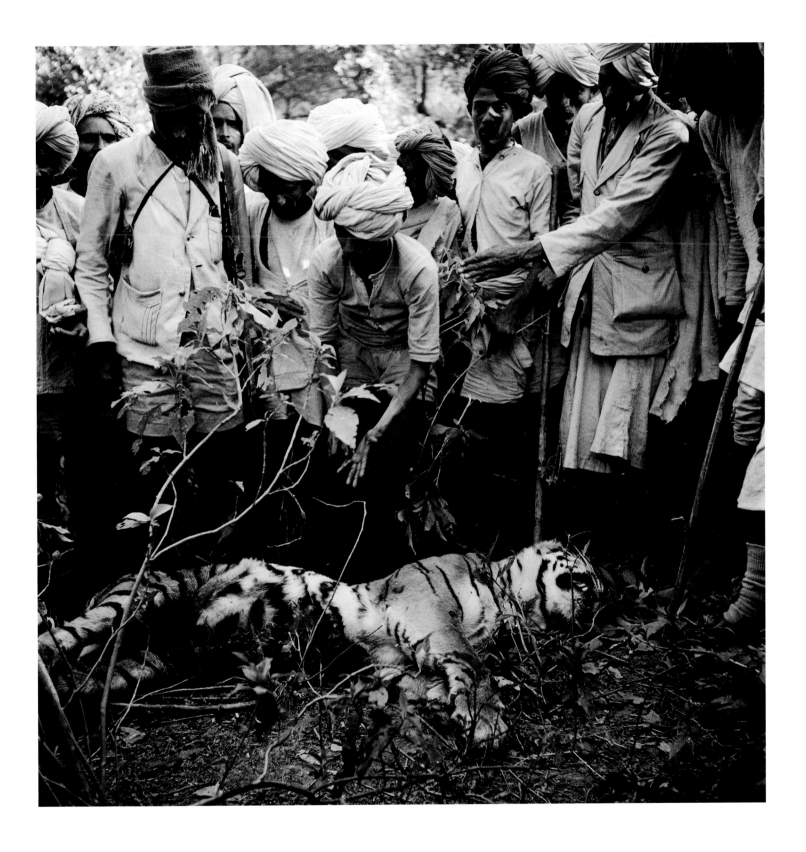

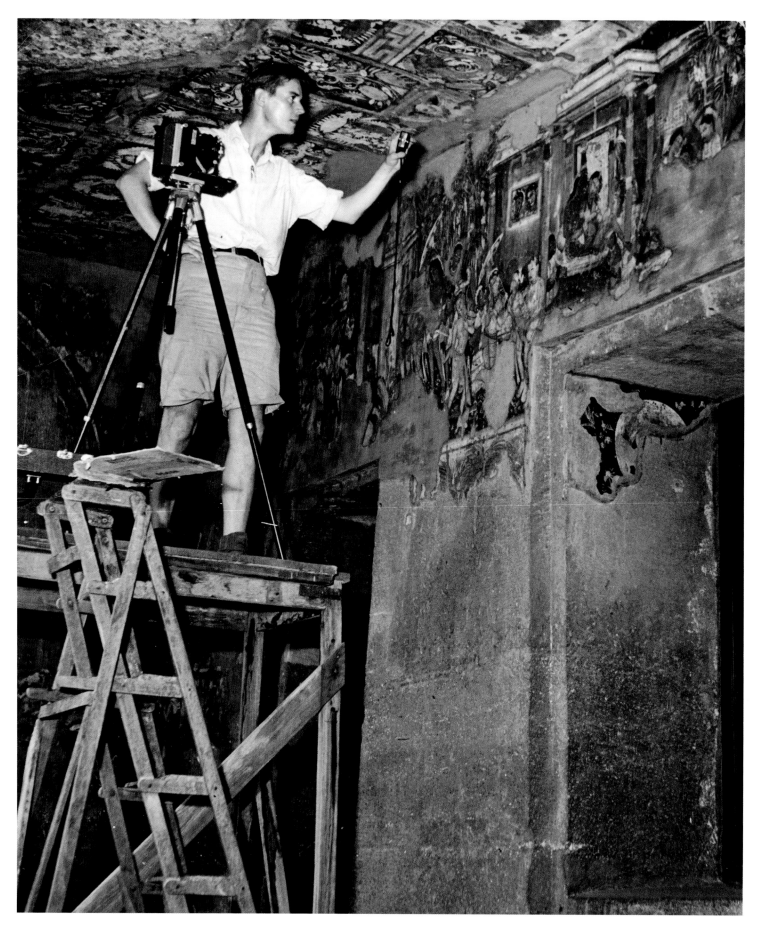

Ajanta, India, 1947 (opposite)

India, 1947 or 1948 (below)

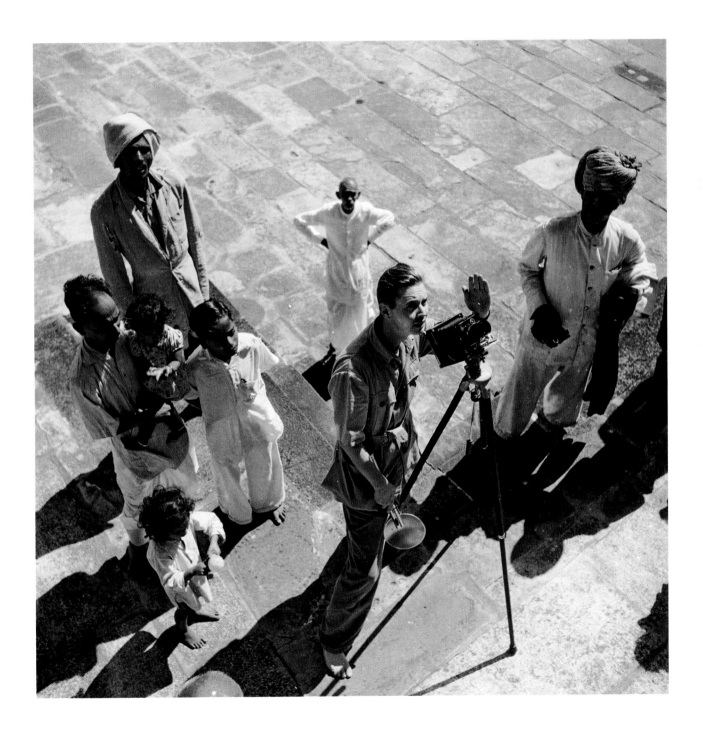

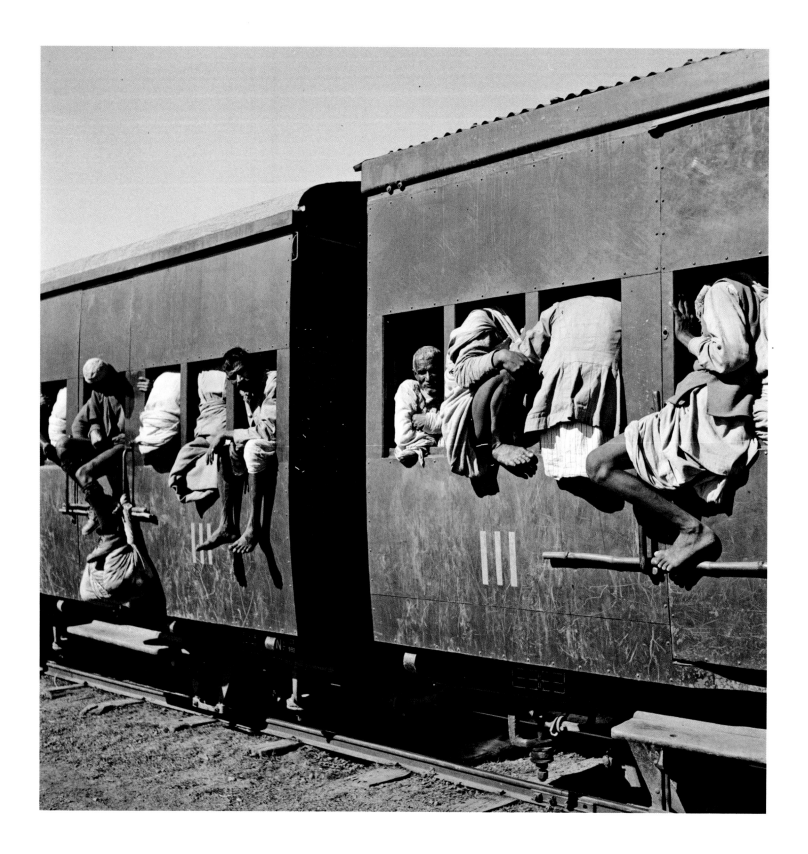

"The whistle blew. The station master and a dozen vendors competed in a final burst of shouting. As the cries 'All aboard!' 'Coconuts, Lemonade, Soda, Gingerale, Oranges, Figs' died, the steady, monotonous clicking of the rails tuned in. Balmy spring air came through the shutters and with it an occasional burst of cinders and smoke. Inside the dim and dreary light was not suitable for work on my diary and expense accounts, both weeks in arrears. For a while I watched the palm trees, jute fields, and thatch-covered villages roll by. After they faded out in darkness, I fell sound asleep."
—V.W., unpublished manuscript, 1949

Nepal, 1948–1949 (all)

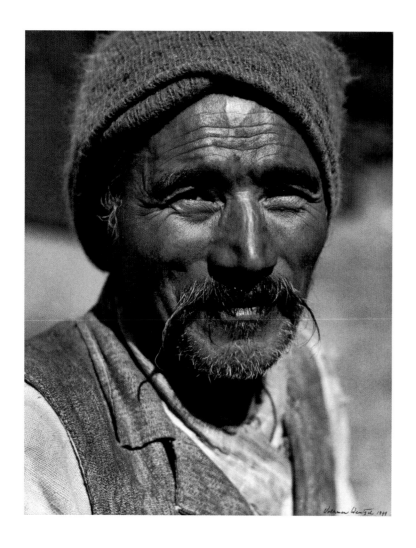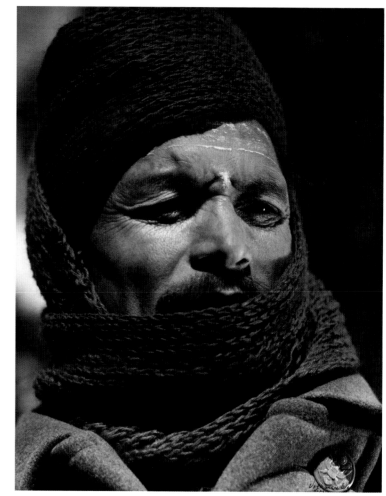

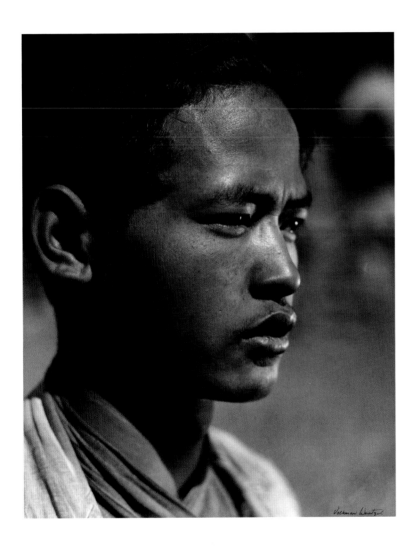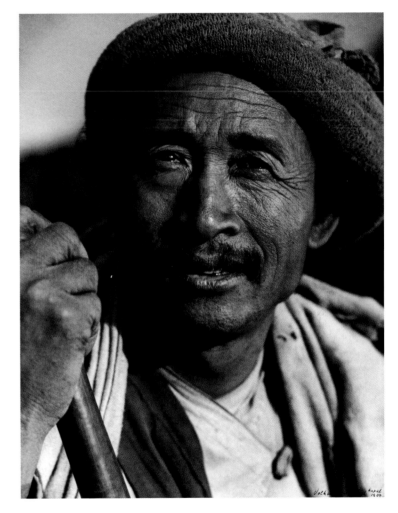

Ladakh, India, 1946 (below)

Italy, 1950 (opposite)

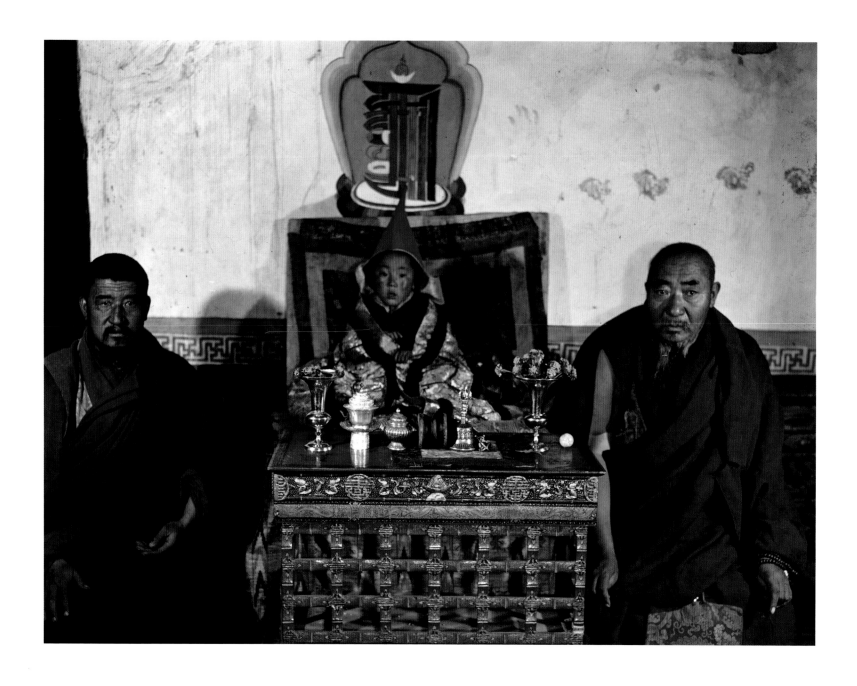

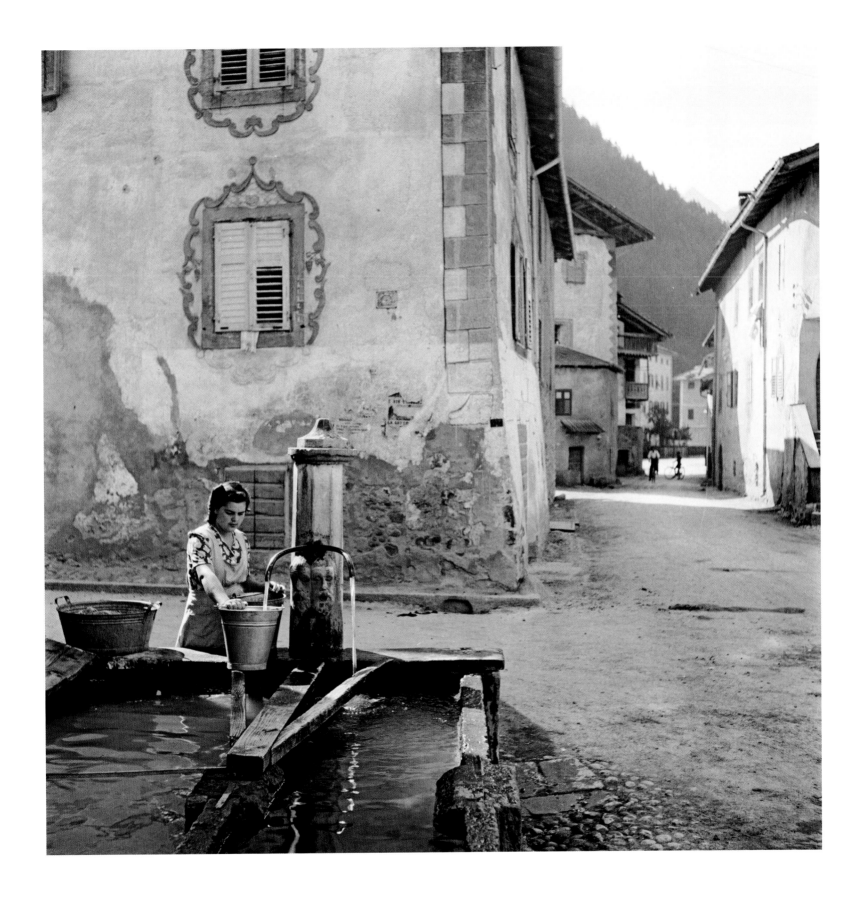

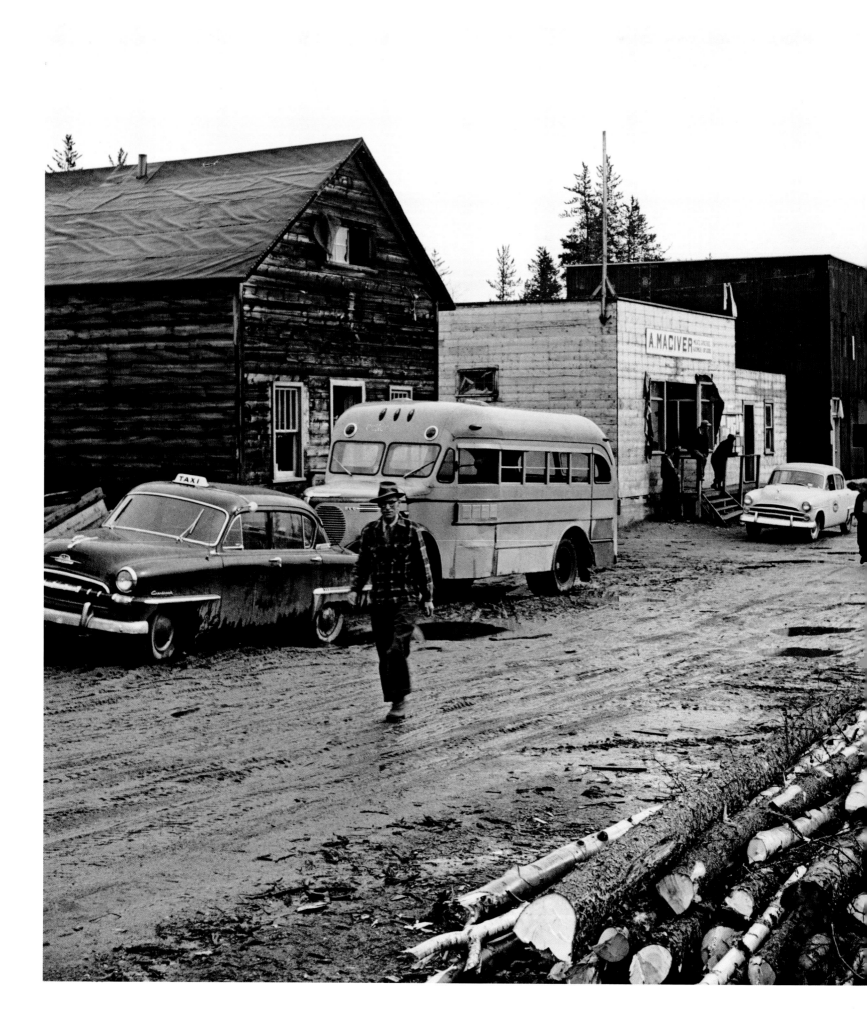

Uranium City, Saskatchewan, Canada, 1953

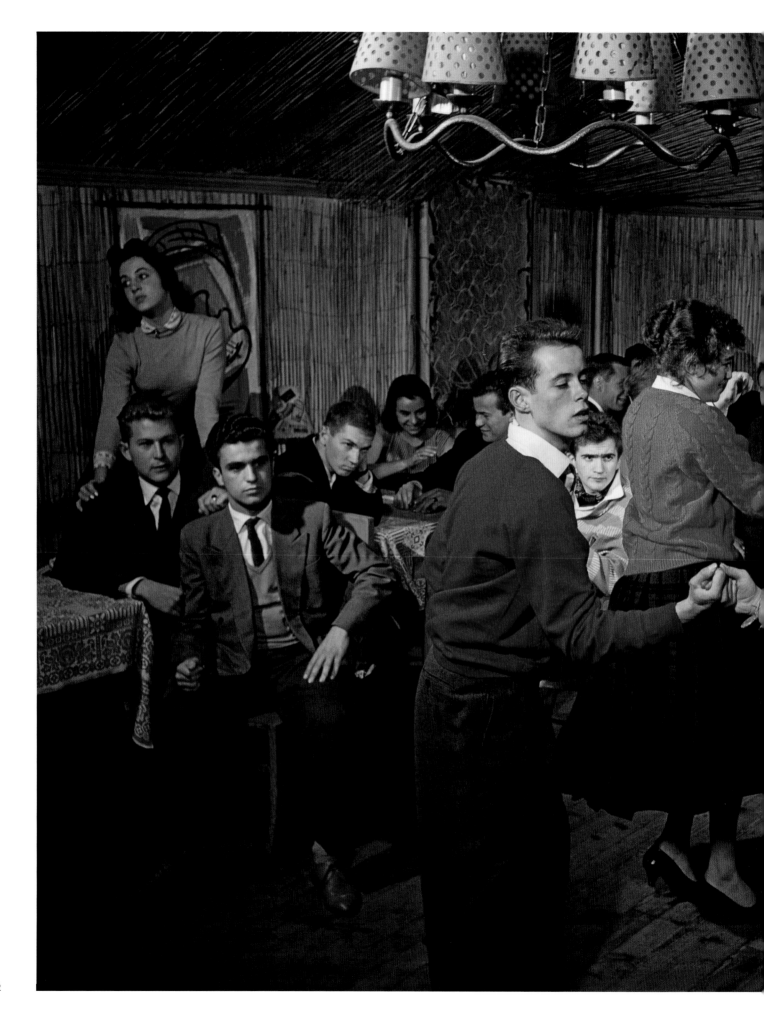

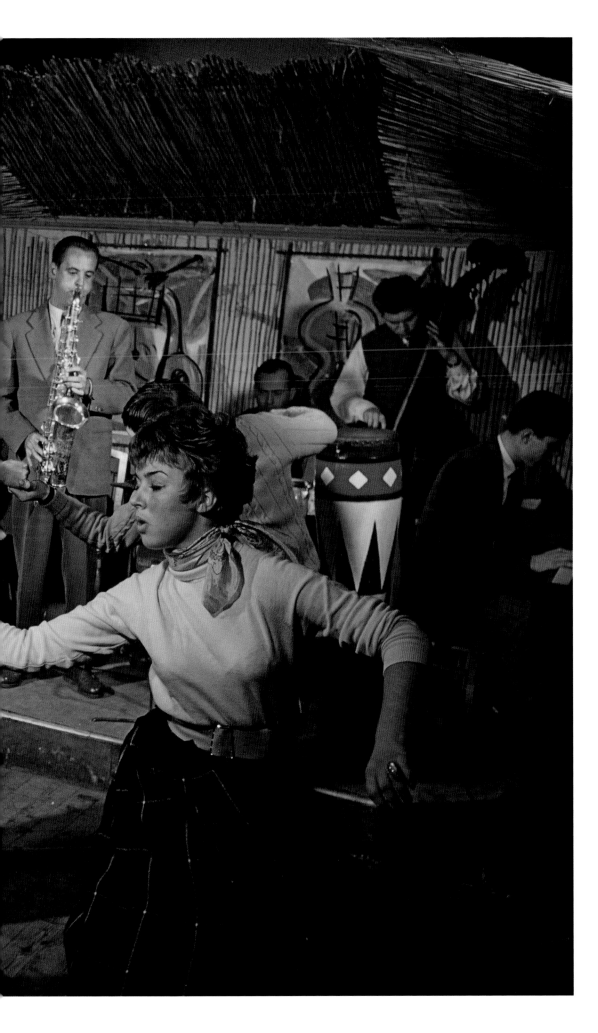

Austria, 1957

"Our mutual friend, Volkmar, incidentally, has recently added a brilliant new achievement to his splendid record by getting exclusive photographs of the world's longest parachute jump. Through his enterprise, the National Geographic Society had an automatic camera in the gondola from which Capt. Kittinger of the United States Air Force jumped at an altitude of nearly 103,000 feet. If it had not been for him, this dramatic moment in which the parachutist stepped into space for his record jump would not have been preserved for posterity."
—Letter from associate editor Frederick G. Vosburgh to Jose Fenykovi,
 August 31, 1960

In the skies above New Mexico, 1960

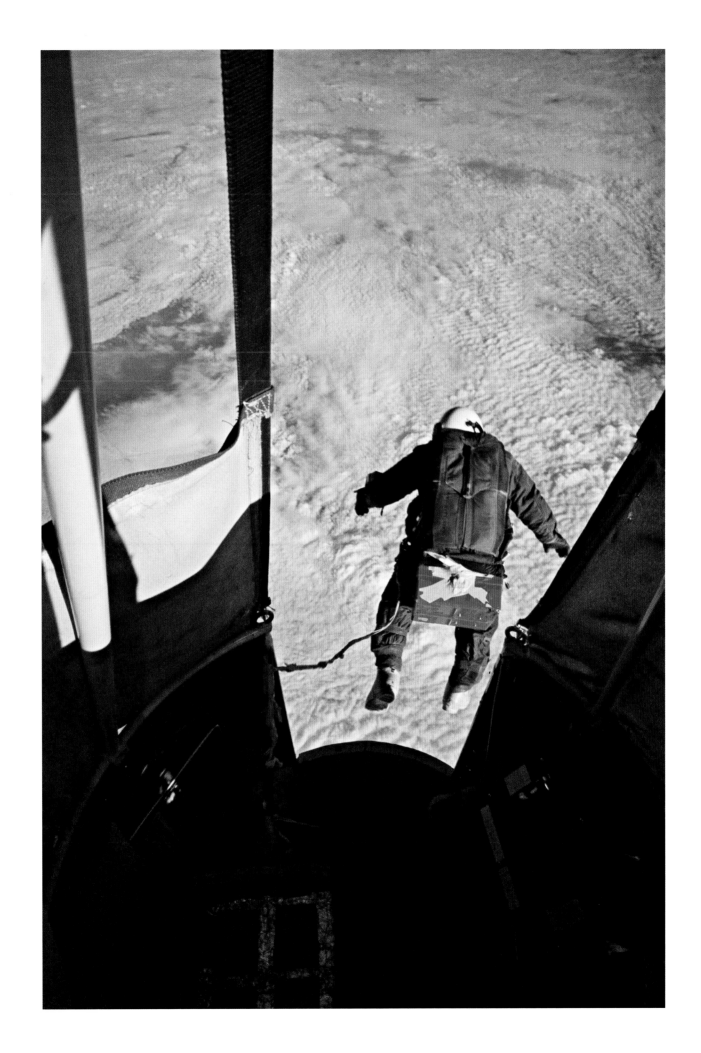

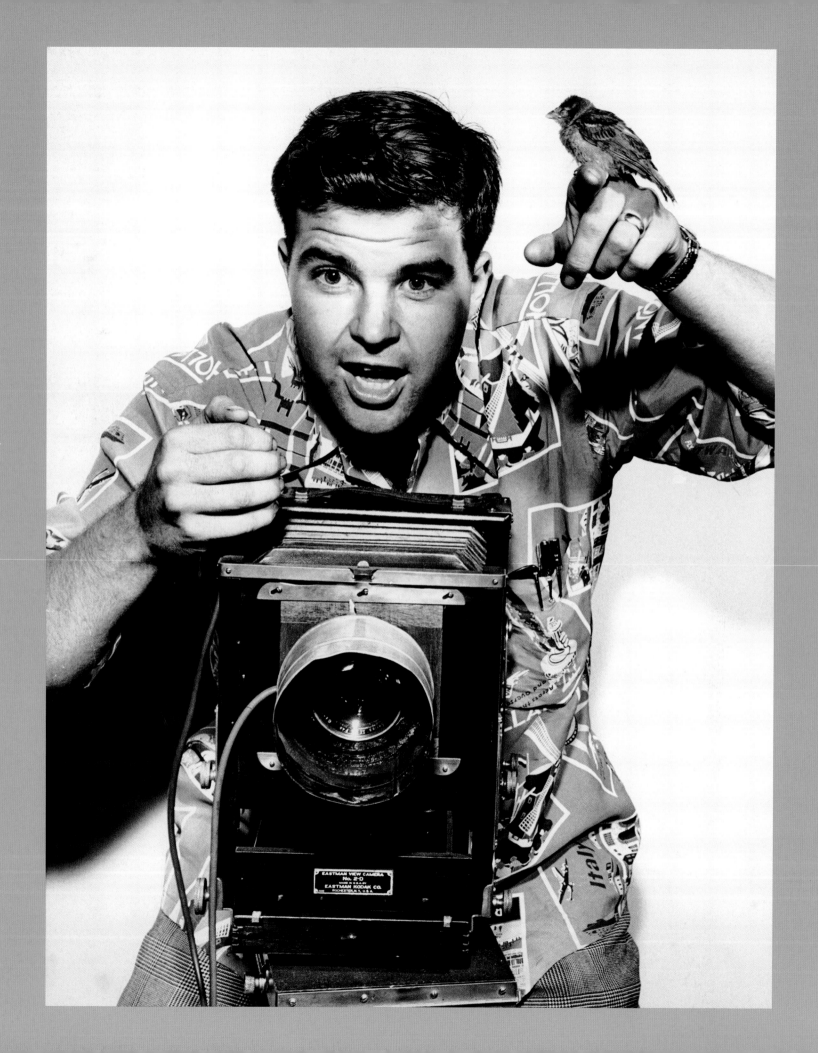

Thomas Abercrombie

Milwaukee, 1953

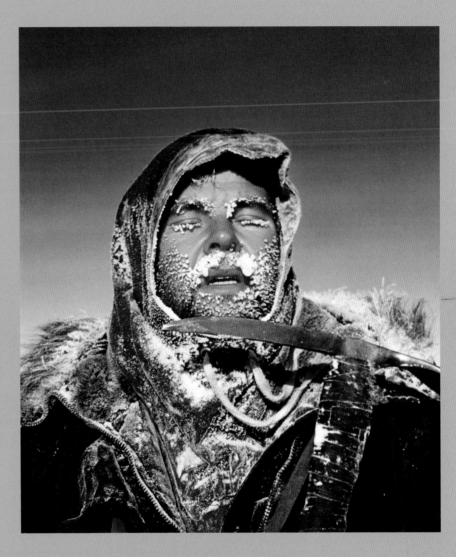

"One never seduced by a foreign culture can ever appreciate the fetters of his own. Life, after all, is a journey— a voyage of discovery. Why not take the high road?" —T. A.

Washington, D.C., 1962 (opposite)

Thomas Abercrombie
National Geographic Field Man, 1956–1994

BY GILBERT M. GROSVENOR

ONE GRAY MARCH DAY in 1963 I arrived at my desk at the National Geographic Society and found a letter awaiting me. I had been expecting it—only not quite this:

Yemen [is colorful or something to that effect]...I seem to have a reputation for surviving at least one motor vehicle crash in each wild land I work. I hope to shake the jinx here since I had to buy my own Land Rover in order to get around. Anyway I didn't want to go away with my reputation completely remodeled so yesterday I creamed a Piper Cub. Did it up brown too. I hit a steam roller head on and junked the Cub after 10 minutes of forced flying with no steering. All this right after scanning the ruins of a Widgeon in which two Americans were cremated 3 months ago. Despite the ruinous effect on the plane we were unhurt. Only a bad case of the shakes which were dispelled promptly with a fifth of Chivas Regal.

Tom Abercrombie, once again, had barely escaped disaster. Just the year before he had been almost knocked out while clinging to the roof of a cable car in Venezuela, barely avoiding a fall to his death. Before that, a mob pummeled him in Lebanon, smashing his camera. Within a few months of this Yemen adventure he encountered another, more murderous mob in Cambodia, escaping by pretending to be French.

Although Tom Abercrombie led a charmed life, more often than not he created his luck through ingenuity, integrity, and hard work. As one of my closest friends for nearly half a century, we worked and sailed together in Chesapeake Bay, Nova Scotia, Newfoundland, and Prince Edward Island and never had a quarrel. To this day I admire his storytelling talent, his astonishing versatility as a National Geographic photographer, writer, and filmmaker. More than any other journalist he educated Americans about the Middle East, particularly Mecca, through the pages of *National Geographic* magazine.

Three years before Tom arrived at the Geographic, I unwittingly witnessed his rapidly blossoming skills when I visited the *Milwaukee Journal* offices in 1955 to observe their pioneering use of color printing. Tom had just won the coveted Newspaper Photographer of the Year award for 1954 and his photographs were on display. That year I had joined National Geographic as a picture editor, but

little did I dream that soon Tom Abercrombie, Bill Garrett, Bob Breeden, and I would lobby *National Geographic* editors to modernize its use of pictures and layouts. We admired how *Life* magazine and other photojournalistic publications used photographic essays.

Abercrombie continued learning his trade for another year at the *Journal*. Though he was still quite young, Tom's reputation for bold, innovative photography was well established—like the time he improvised his scuba gear and slipped beneath the icy waters of Lake Michigan with an underwater camera, secured only by a rope tied to the bumper of his car. Lynn, his wife, waited to pull him out. Everyone liked his energy, creative eye, and wonderful personality. In spring 1965, Associate Editor Melville B. Grosvenor, or MBG as we all called him, made Tom an offer. Although Tom had always dreamed of working for *Life,* MBG persuaded him that the magazine was changing. On July 9, 1956, he joined National Geographic and our golden era began.

Because he was young, inexperienced, and seldom shot color film, no one expected immediate change. Were we wrong! MBG, exploding with energy and ideas, was committed to accelerating his youth movement at the magazine. Immediately, Tom was assigned an atomic energy story. As picture editor, I knew it was devilishly hard to illustrate. Our chief photographer, the legendary B. Anthony Stewart, had struggled with the coverage. The standard photos of scientists posing beside machines were plain dull. Tom was instructed to "brighten up the subject"—a euphemism meaning to save a story headed for disaster. Soon photos flooded my desk—not just accelerators and uranium devices but energy itself—remarkable "first" pictures of speeding particles within a cyclotron and an experimental garden glowing with radiation—a quantum leap in photography. Tony Stewart reviewed Tom's photos in silence, then turned to me and said, simply, "Is that what you want?" "Yes," I replied. Tony's next shipment mirrored Tom's pictures. Tony, the consummate professional, helped usher in the new era.

Tom, Lynn (also a remarkably fine photographer), and I became instant friends. A tousle-haired guy (the beard came later) short of frame, but very long of stature, Tom was brimming with new ideas, always entertaining, and very witty. Many a night we toiled in his home darkroom experimenting with new techniques for making color enlargements. A superb "gadget" maker, Tom helped me devise the aperture-shutter controls for remote cameras that eventually ended up being used on several assignments. Right from the beginning, Tom earned a reputation for his quick repartee and clever limericks. Yet, if the situation required a serious communication, he could craft a compelling letter to an obscure diplomat in Yemen requesting permission to explore areas long requested by, but never granted to, journalists. In the early days, he wasn't worldly; just a clever boy from Stillwater, Minnesota, who had fallen in love with cameras and Lynn at the same time. They matriculated at nearby Macalaster College, where they both honed their photographic techniques. In later years, Macalaster honored Tom with its prestigious Distinguished Citizen Award.

Perhaps because of his success with the nuclear energy story, almost immediately Tom earned coveted foreign assignments. Nineteen fifty-seven found Abercrombie laden down with crates of photographic gear bound for Lebanon, at that time an attractive gem of a country.

When he arrived in Beirut he spoke not a word of French, much less Arabic. On his own, Tom became a skilled linguist, quickly picking up French and eventually a half dozen languages, from Arbic to the Romance languages. Almost overnight he became sophisticated, worldly, with great conversational skills that rapidly furthered his career.

Though not without tensions that would eventually fracture it, Lebanon cried out for the *Geographic*'s old-fashioned travelogue approach. Tom decided to shoot it differently. How well I remember, because once again I was his picture editor.

"I'm busy shooting Lebanon the way it really is and not the way I would like it to be," he wrote me, before I saw any pictures!

Being one of the most picturesque countries in the world, it offers plenty of 'postcard' opportunities, all of which I'm attempting to cover, but more than that it's people, real people, that go to make up Lebanon—or any country, for that matter. It's the souks as well as the beach clubs, the political rallies as well as the festivals, the soldiers as well as the scenery, that make it what it is today, a meeting place of the East and West in a fantastic garden of incongruous mixtures.

Wow! Were those pictures different, from a simple, but poignant, black-and-white image of a boy tossing a ball in the air to powerful images of Ba'albek and the cedars of Lebanon. More important, Tom used his emerging diplomatic skills to persuade Lebanese president Camille Chamoun, a notoriously shy leader, to be photographed informally. Through a friend, Tom secured an invitation to a picnic attended by the president. There, beneath a magnificent shade tree, he created a wonderful, unposed, informal photograph of Chamoun and his wife sharing a quiet moment together. In addition to being a stunning picture of a head of state for the magazine, that unique photo was treasured for generations by the Chamoun family.

Lebanon proved a seminal assignment for Tom as he flourished on that first overseas coverage, which was trend-setting for the magazine. Captivated by Lebanon's culture, religion, and politics Tom instantly became the Geographic's correspondent specializing in the Middle East. Moreover, when the author floundered, Tom was asked, at press time, to try his hand at writing the Lebanon story. He knocked it out of the coliseum!

Everyone realized that the Geographic had a fabulous photographer onboard, as well as a promising writer who quickly learned to transfer his fabled storytelling talents to the printed page. Antarctica 1957. Tom's scribbled note astounded us all. "I have the pleasure of carrying the Society's flag to 0 degrees South latitude as the first press correspondent to set foot on the Pole."

By age 30, Tom had become one of the *Geographic's* most creative, trustworthy, and dependable field men. He was clearly a virtuoso who could write, photograph—even shoot a 16mm film! Once he helped produce a television documentary on Mecca.

Tom even began field recordings of ethnic music he encountered around the world, which led

directly to a short-lived—but recently revived—multicultural music program at the Society. Had Tom, himself, pursued his early music idea, I am sure he would have successfully recorded ethnic music that has long since disappeared. Almost half a century later, National Geographic has entered the international music field big time.

Any assignment challenged him—the more primitive, remote, rugged, or troubled, the better he liked it. If a story had a problem—a failed writer, say, or pictures that were mundane—Tom would be dispatched to the rescue. Early on, he found himself in a civil war in Yemen, a near-coup in Morocco, an earthquake in Iran.

Nineteen sixty-two proved a busy year. Tom juggled *five* difficult assignments in the Mediterranean: marine archaeology off Crete, Ed Link's "Man in the Sea," Jacques Cousteau aboard *Calypso,* the *George Bass* off Turkey, and the USS *Enterprise* aircraft carrier. Each had its unique quirks. Moreover, he was also tasked with the delicate business of negotiating with the imperious Jacques Cousteau for Society access to an experimental undersea habitat. "Jeez, what a summer!" Tom would recall.

Along the way he discovered Athens! In a memo to the office he enthused, "I have a date tonight with Aeschylus, tomorrow Pindor and Sophocles. It's amazing how much knowledge Greece packed into its short history." A note to a friend: "We're looking forward to seeing you all again and getting the firsthand dope on Athanai. We've been rereading Thucydides and Herodotus."

Tom, the fabulous raconteur, relied upon his wonderful sense of humor to carry him through the summer. Despite his atrocious spelling he entertained his desk-bound colleagues with daily dispatches.

Also emerging by now was that latent gift for languages—and not just the French he picked up in Lebanon. From his initial trip to Yemen he focused on Arabic, a difficult language in which he became fluent; and one that opened many doors for him throughout the Middle East. In his retirement, he taught geography of the Middle East and North Africa to over-subscribed classes at George Washington University.

Unsurprisingly, Tom was also a marvelous mechanic. Frequently, his life depended on it. He could disassemble, then fix, Land Rovers with the best of mechanics, in fact better than most, because he could improvise. He traveled in so many remote landscapes that Abercrombie ordered Land Rovers specially adapted to his own specifications. Every part he knew intimately! Often Tom was driven to desperate solutions. Once, deep in the remoteness of Arabia's Empty Quarter, among the most desolate places on the planet, he faced a life-threatening problem:

"The return trip was made less monotonous by vehicle failures along the way. My generator caught fire and we had to bypass it with a short belt and run on the battery. The clutch began to drool oil and chatter but held on. I began using up my first aid kit on radiator hoses. In 125-degree heat we plastered the Dodge radiator (now leaking furiously) with barley-flour paste and camel dung."

Somewhere Tom learned emergency medicine and often his first aid kits saved lives. Once, in Tibet, he amputated the severely frostbitten toes of a stricken Buddhist pilgrim he had encountered.

More happily, Tom brought eyeglasses to an old man deep in the hills of Yemen. "For the first time in God-knows-when he saw the stars that night."

Tom was not without his foibles. On early assignments, he was notorious for shipping cases of peanut butter overseas. Aboard *Calypso* when Jacques Cousteau spotted the peanut butter he leveled a withering scorn. Tom knew how to handle Cousteau, though, chatting in French about their mutual interest in marine engineering or perhaps with more effect, charming Cousteau's wife, Simone. In return, Cousteau quickly taught Tom to appreciate French wine, his first step in becoming a worldly culinary expert. However, his fondness for peanut butter never waned! But peanut butter was the least of his concerns with Capt. Cousteau as expressed in a note back to NGS headquarters:

This is due to Jacques' inavailability (sic) resulting from his here-today-gone-this evening.... I've managed to see Cousteau only twice since I arrived. The first time he evaporated after 20 minutes to due (sic) battle with Italian customs in bringing two hydrofoil boats into France. The second encounter was even less satisfying—Jacques left in the middle of our lunch (between the cheese and salad actually) to catch a plane to Paris."

Cousteau, seeking to maximize publicity, looked far beyond *National Geographic* magazine, which troubled Tom: "We have no dough in the plot so we must swim with the rest which will probably include *Life, Look,* and the Pursuit of Happiness."

Versatility served Tom worldwide. In my opinion, his most valuable talent lay in mingling with people, gaining their confidence, then joining in their most intimate traditional customs.

From Bedouin tents to kings' palaces, from rural mosques to Mecca, he was welcome. He could converse with the lowliest fellahin or the mightiest kings—which he encountered frequently, including the Shah of Iran, King Zahir Shah of Afghanistan, King Faisal of Saudi Arabia, and especially King Hussein of Jordan, with whom he became particularly close. Understanding that the best writers are good listeners, Tom would patiently tug on his ubiquitous curved pipe (dumping ashes wherever they fell), uttering an occasional quip to extend an interview. Not only were kings drawn to him but also movie stars. While covering Cambodia in 1963, he encountered Peter O'Toole there, filming Joseph Conrad's *Lord Jim.* The actor developed a liking for the photographer. Word filtered back to Society headquarters that the tall, rangy O'Toole, a new superstar because of *Lawrence of Arabia,* was carrying Tom's equipment!

Any successful foreign correspondent must learn to pull strings. Ambassadors, military men, mid-level bureaucrats, tribal elders—all control access to crucial people, places, or events. They have a sharp eye for the opportunistic journalist. But Tom's diplomacy and integrity won the "gatekeepers'" confidence, which over the years gained him access to many a sheikh's tent. Once, his diplomacy was stretched to the limit:

"At Madgan we stayed a day or so with an encampment of wonderfully colorful and hospitable Murrah Bedouin.... We found a dozen hair tents and about 400 camels. It was great. I feared somewhat for the reception an unveiled woman might get but the Emir of the bedu thought Lynn was

great and insisted she share the long hours around the coffee fire at his tent—a ritual usually reserved strictly for men. Protocol had to be radically reshaped.... In the end, the foxy old Prince (thinking evidently that Lynn was my daughter) made me a tempting offer for keeping Lynn in his billet for wife #4. But I really needed Lynn. And what could I do with 50 camels?"

Tom made light of it, but in the Middle East, especially in Arab lands, an American correspondent's ability to tactfully negotiate the labyrinth of custom and protocol was all-important to success. One false move and the curtain would close.

Tom managed to keep that curtain open for nearly three decades. As a result, millions of *Geographic* readers were treated to a glimpse of a world that few Westerners had seen. "What happens when an unstoppable force meets an immovable object? An indescribable collision, naturally," Tom wrote of Lebanon. That held true for the entire Middle East, where an apparently unstoppable Western civilization was meeting an immovable Islamic force. This fascinated him.

Since he had first set foot in the complex, exotic world of the Middle East, working in Saudi Arabia was his goal. But the Kingdom was a very difficult place to enter in those days. For years the *Geographic* had unsuccessfully tried to gain access. Then, in 1965, the gate cracked ajar. Tom saw a huge opportunity: Changes were in the offing, Saudi Arabia was preparing to leap from the 11th century into the 20th. Granted unparalleled access to the Kingdom, Tom wrote that he "drove nearly 20,000 kilometers and covered another 20,000 by air. Filled 18 notebooks and took nearly 10,000 photographs." This coverage was brilliant. While in Saudi Arabia he tracked down rumors that a large meteorite existed somewhere out in the sand-swept Empty Quarter. With the help of a Bedouin guide, a compass, and a useless sextant, he set out across the trackless ocean of sand. Not only did he find it but he arranged to bring it back—all two tons of it—so that scientists might study it. Little did he know that one day that meteorite would repose in the National Museum in Riyadh. On assignment in Iraq, his interest in antiquities motivated him and Lynn to photograph almost everything in the Baghdad Museum. Those images are probably the most complete record ever made and could prove invaluable today.

Further astonishing firsts in Saudi Arabia were brewing. Tom's growing fascination with Arabic culture was leading him to a very personal decision. On April 17, 1965, he wrote to MBG:

"Greetings and best wishes from Islam's holiest city. I've just had the singular honor to witness, to cover photographically, and to participate in one of the most moving experiences known to man, the annual pilgrimage to Mecca.... It has been an unforgettable personal experience and, without a doubt, the climax of our coverage of impressive Saudi Arabia."

Tom had converted to Islam. Not one to talk about such things, he remained reticent. If probed too hard, he would joke that the only hotel he ever swiped a coat hanger from was the "Mecca Intercontinental." Over the years he became a Sufi initiate and whirled with the dervishes in Turkey.

At the Abercrombie Shady Side, Maryland, home—a museum really—Tom had shown me his beautifully illuminated, hand-bound Koran he acquired in Kabul. His most prized possession, though, was a fragment of the black brocade drape that covers the Kaaba in Mecca.

While Tom's chosen beat became the Middle East, the coverage I most envied him was Afghanistan. That was a plum assignment in 1967. Actually, I was slated to go there, but when Ted Vosburgh became editor, my duties expanded, keeping me desk-bound in Washington. I asked that Tom go instead. Tom crisscrossed that notoriously difficult, rugged country where camel, horse, and yak often supplanted the Land Rovers. He thrived in Afghanistan. As a consolation prize, Tom brought home a magnificent antique rifle I cherish to this day.

Though not an athlete, Tom had remarkable vigor and stamina, always eager to tackle a difficult mountain climb or an obscure tribal sport. He stretched his limits on the plains of northern Afghanistan when he engaged in a rough-and-tumble bout of *buzkashi*, the national sport. More a cavalry brawl than a game, he spurred his horse into the fearsome melee, nearly succeeding in carrying the "ball"—a headless goat—into the scoring circle. Most remarkably he escaped unscathed. While I'm sure Tom had previously ridden various animals, he was no Olympic candidate.

By the 1970s, when I was the editor of *National Geographic,* we dispatched Tom to the farthest corners of the Islamic world. On one such trip he visited 22 countries, from the Mediterranean to Central Asia—filling three passports in the process—which resulted in a brilliant article, "The Sword and the Sermon," July 1972. That story remains *the* classic reference on Islam. A few years later, retracing the journeys of Ibn Battuta, the extraordinary 14th-century Arab traveler, he cast his net even farther, reporting on countries from Morocco to Indonesia to China.

Tom Abercrombie understood the Islamic world as did few—if any—other American journalists. Steeping himself in its history, poetry, people, and lore, he could discuss the most obscure caliphs as if they were known world leaders. He also knew the geography of the landscape: from mud villages in North Africa to dusty caravan trails across what was then Soviet Central Asia; from the gaudy new oil cities in the Persian Gulf to the ancient warrens of Cairo and Baghdad. With scores of Arab friends, he sipped endless cups of cardamom-spiced coffee in black felt tents. As a Muslim he had access to all mosques, the hubs of Middle Eastern life. About the only place he couldn't roam was the women's quarters. But Lynn, just as curious, equally as adventuresome, did.

As might be expected, Tom witnessed plenty of conflict. "I'm not a war correspondent," he once quipped. "I'm a correspondent trying to avoid war." Yet in the Middle East war was omnipresent. In Yemen, 1964 found him enmeshed in the midst of a civil war, passing through Beirut in the 1970s he was caught in the Lebanese civil war, often being within earshot of the fighting. And, of course, there were always Arab-Israeli wars to dodge.

Having seen so much on the other side of the curtain, Tom had developed some strong opinions. In the 1970s, he invested considerable time and energy in a story about the Palestinian people, then known mostly in the United States by the terrorist tactics of the PLO. Though Tom made the risky decision to visit PLO training camps in southern Lebanon, he was determined to portray another side to the Palestinian issue. But we judged his manuscript to be too controversial for the *National Geographic* of that day. In retrospect, I regret that decision. He was furious.

Over the years, as gray began streaking his hair and beard, Tom faced a new reality. Being responsible for both pictures and text became too difficult for one person in the field. Just as the photography had changed in the magazine, so too had the text. One or both would inevitably suffer; even Tom was no exception. In Saudi Arabia, he wrote back to the office, "The seemingly inexhaustible supply of new friends and contacts (and nearly all of them brimming with stories, anecdotes and information) has left me with bulging notebooks and writer's cramp but left the cameras neglected."

The *Geographic* moved away from the old concept that a Foreign Editorial Staff member could master both photography and writing simultaneously. While Tom, the Middle East expert, was increasingly tasked with writing a story, other people, such as Lynn, were assigned to create the pictures. That troubled him. He fought a losing battle. Tom Abercrombie, the man who ushered in the new photographic era at the Geographic, became a full-time writer.

The Tom and Lynn Abercrombie team took on new meaning as they were among the first American journalists permitted access to South Yemen—he the writer; she the photographer—while retracing the Frankincense Route. Tom believes they were among the first outsiders to visit the largely unknown Nuqman ruins. Their wonderful story appeared in the October 1985 *Geographic* magazine.

Even in retirement Tom proved bold and creative. Being historically motivated, he undertook a project of prodigious proportions: to build a carefully researched replica of a 32-foot Chesapeake Bay bugeye. These 19th- and early 20th-century sailing workboats plied the waters of the Chesapeake Bay harvesting the then-plentiful, oysters, crabs, and fish. Using oak timbers from fallen trees on his Bay waterfront yard plus cedar and ash from his daughter Mari's farm in Maine, he crafted most of his bugeye before failing health forced him to set aside woodworking

One thing Tom did complete, though, was his self-avowed mission in life: "If I even added only one plank to the bridge of understanding between our countries, I will feel my mission was accomplished." Several months after Tom's death, Lynn represented him in Riyadh, Saudi Arabia, at the opening of a prestigious exhibit of Tom's photographs—a rare tribute to an American artist. An added bonus for Lynn was the display of the meteorite Tom rediscovered in the National Museum of Saudi Arabia.

My fondest memories with Tom are sailing our Block Island 40 sailboat, *White Tiger,* named after a rare baby white tiger he photographed in India. Be it foul weather or fair, scorching or freezing, stormy or calm, no matter, we'd shove off. The three of us, including my then ten-year-old son, Graham, would cruise Crab, Harness, or Church Creeks, the Wye River, or St. Michael's on Chesapeake Bay. Graham and I would pick up groceries for the weekend. At the checkout counter, he repeatedly asked, "Dad, did you remember the wine?" An odd prompt for a ten-year-old, I thought. "Why do you ask, Graham?" Said he, "After a couple glasses of wine, you forget to send me below to bed. Then I can listen to Uncle Tom tell stories half the night!"

While I was writing this chapter, Graham called me and we reminisced about the *Tiger*. After a long pause, Graham blurted out in a hoarse voice, "Oh, Lord, I miss Uncle Tom so very much." So do I.

Milles Lacs, Minnesota, 1958

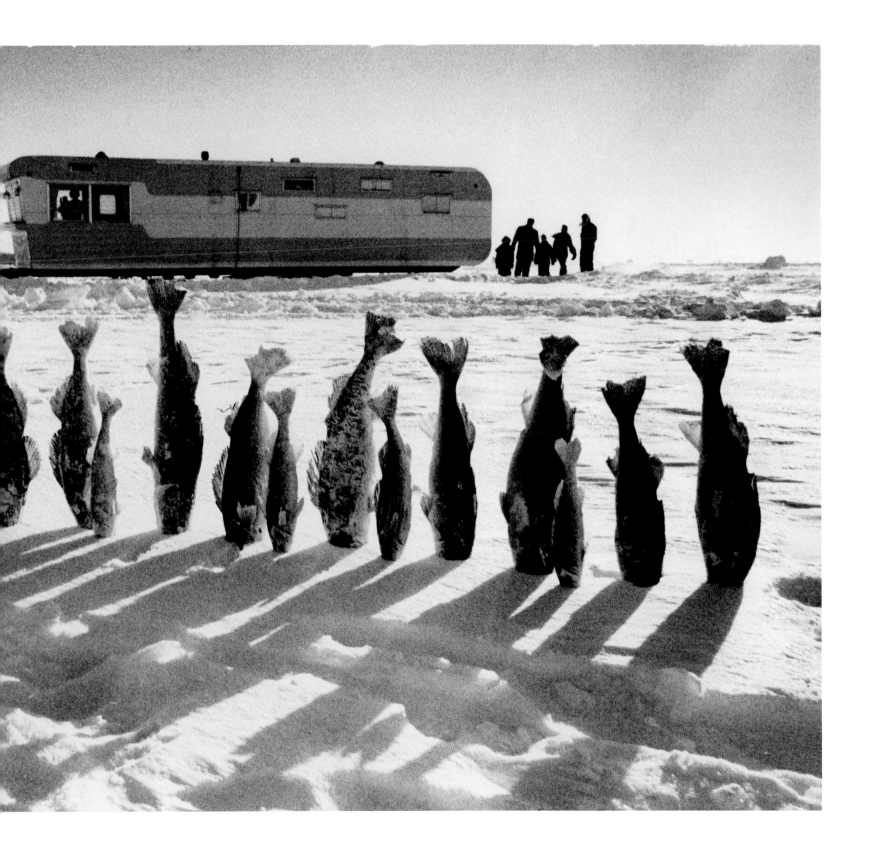

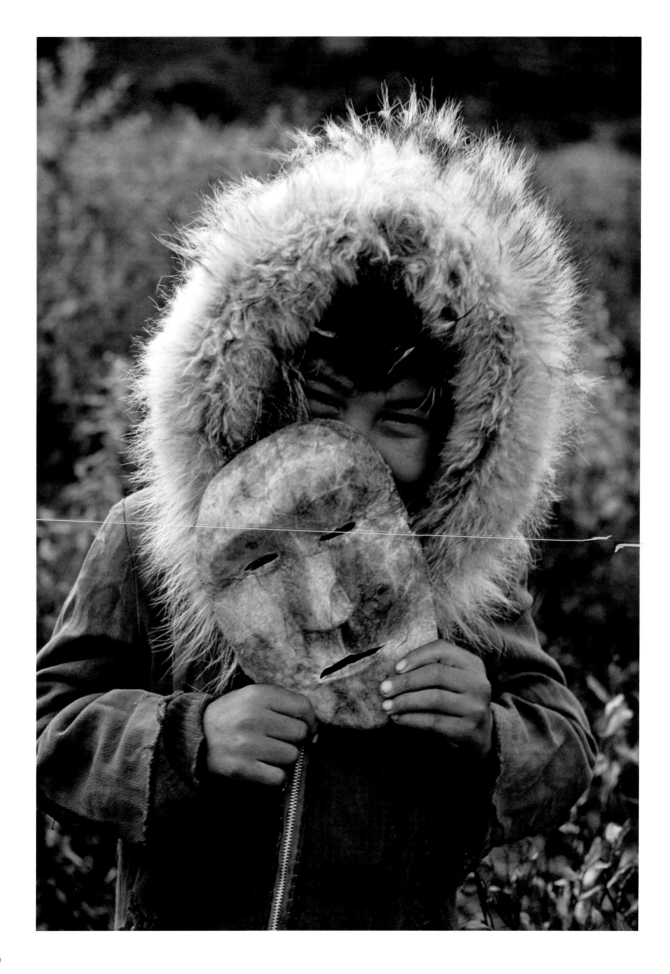

"I remember I was thrilled and excited, of course, to be hired as a photographer. I was walking around a couple of feet off the ground. But at the same time I really didn't want to know what to do or how I'd do it.... Even now I still think of myself as no more than an advanced amateur of whatever status, because I never hasd any training for any of this. I took it seriously, but not so seriously."
—T.A., 1995

Alaska, 1958

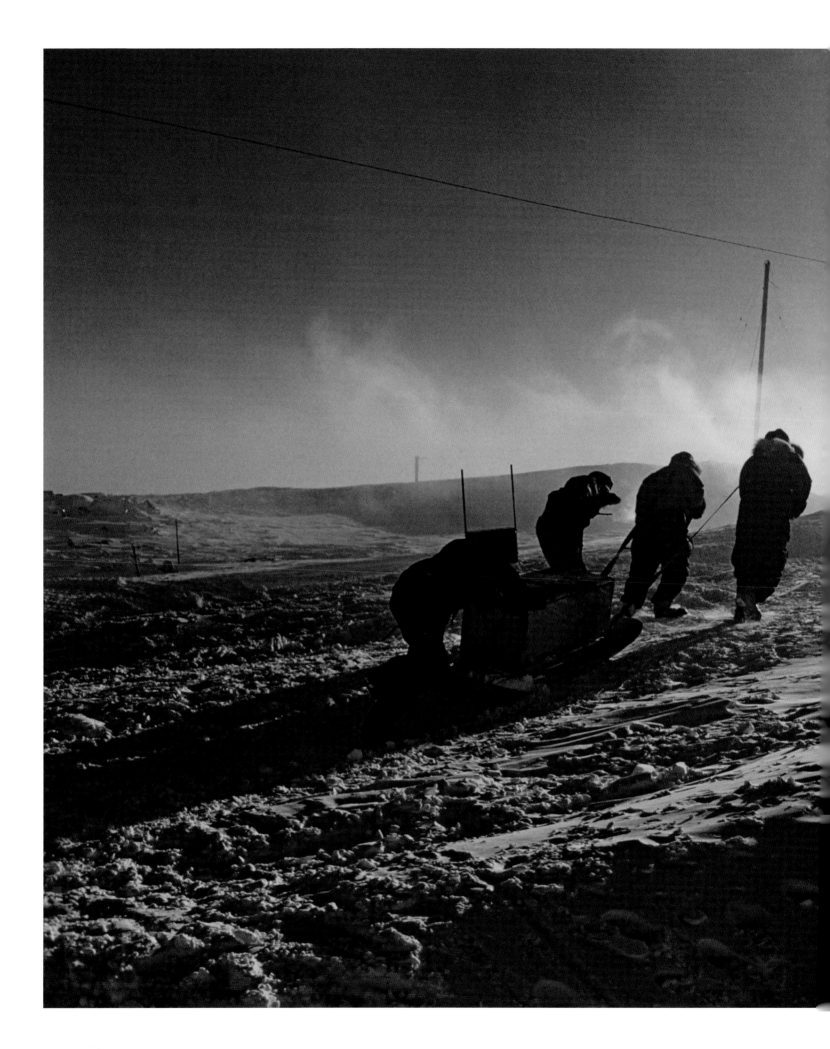

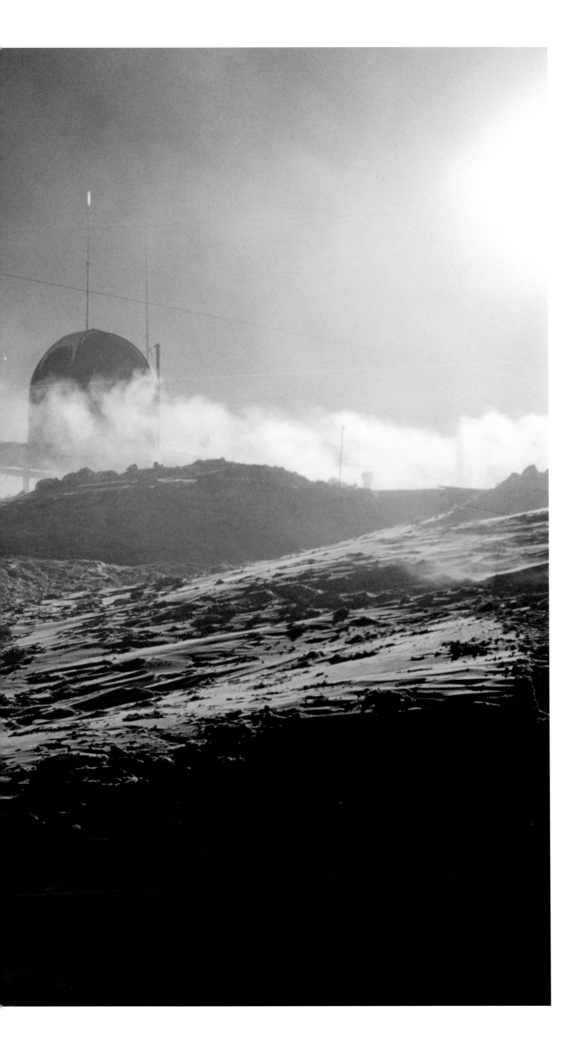

The South Pole, 1958

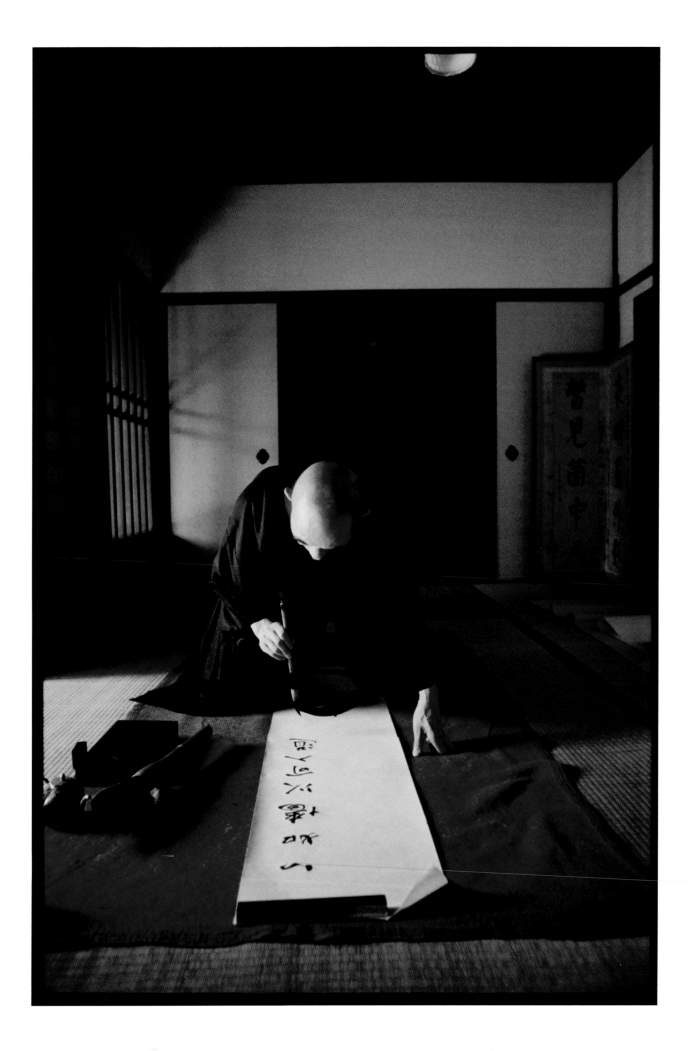

Switzerland, 1968 (below)

Japan, 1969 (opposite)

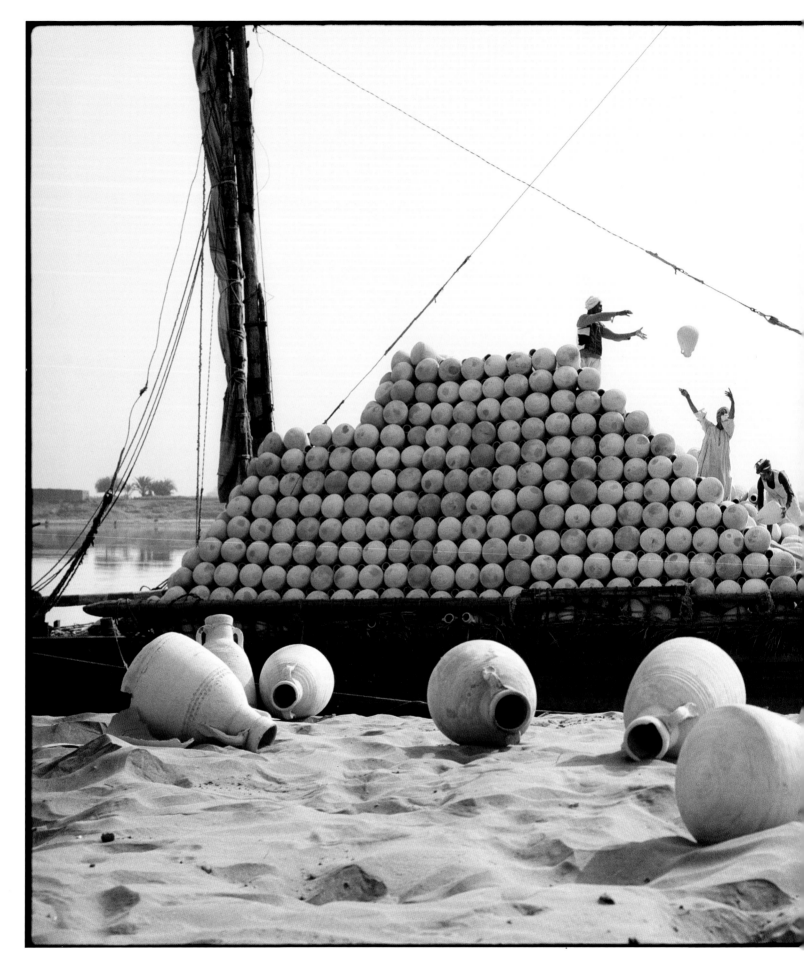

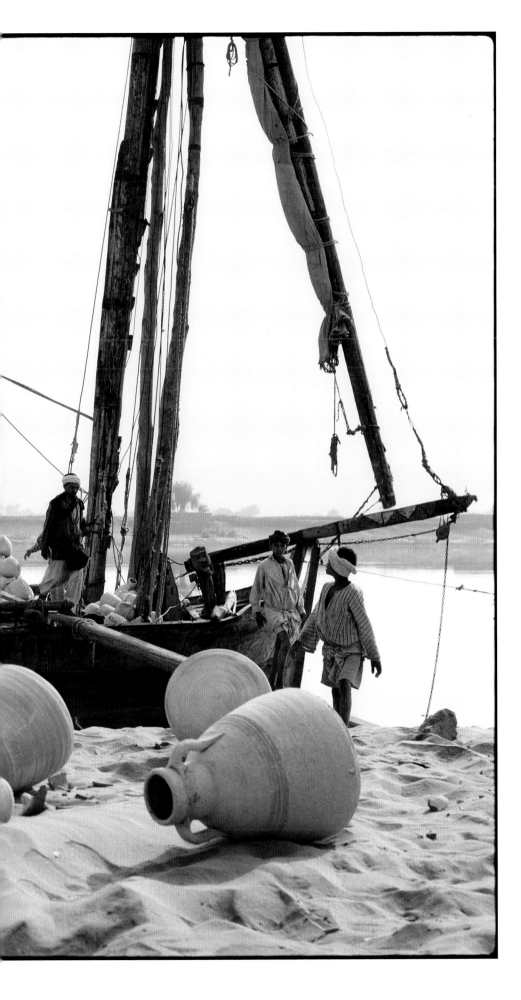

Egypt, 1977

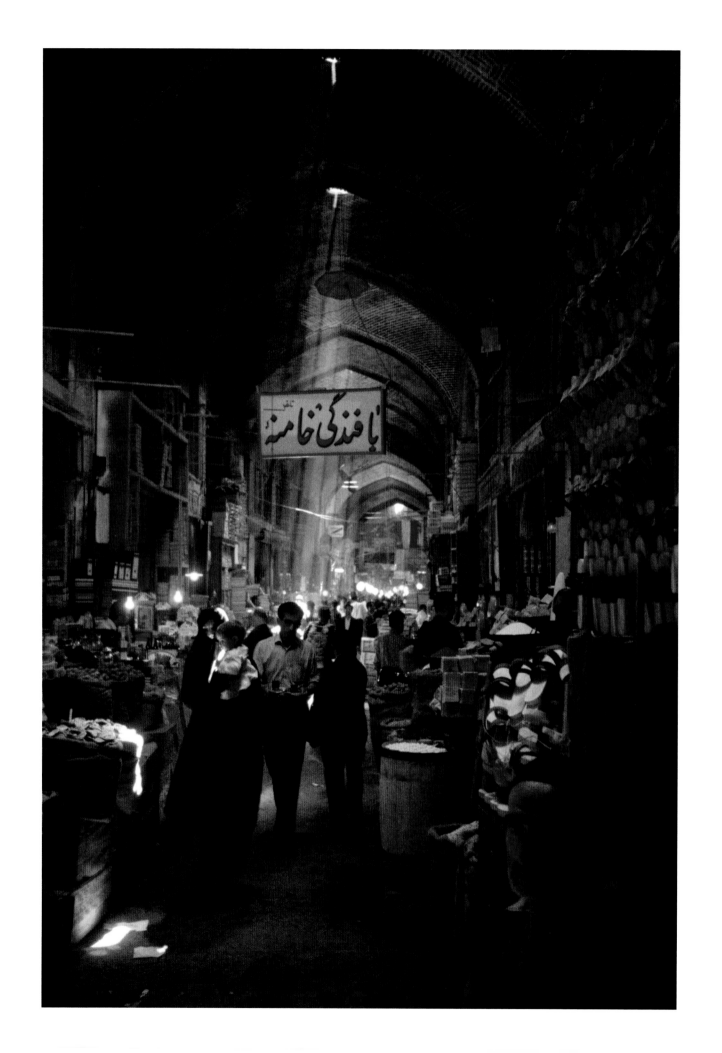

Iran, 1960 (opposite)

Samarra, Iraq, 1988 (below)

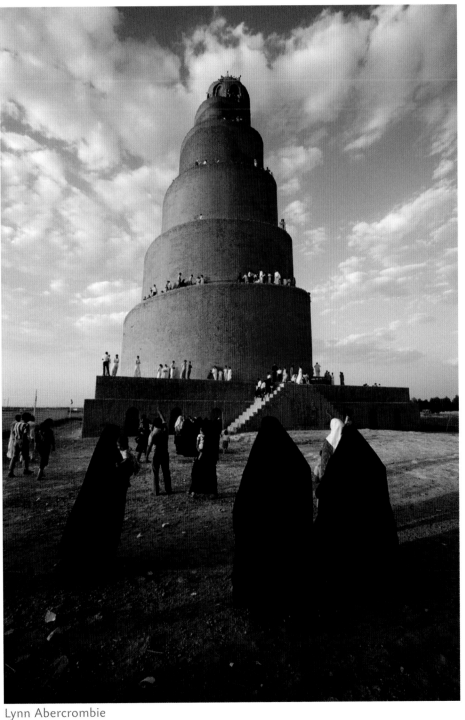

Lynn Abercrombie

Iran, 1960

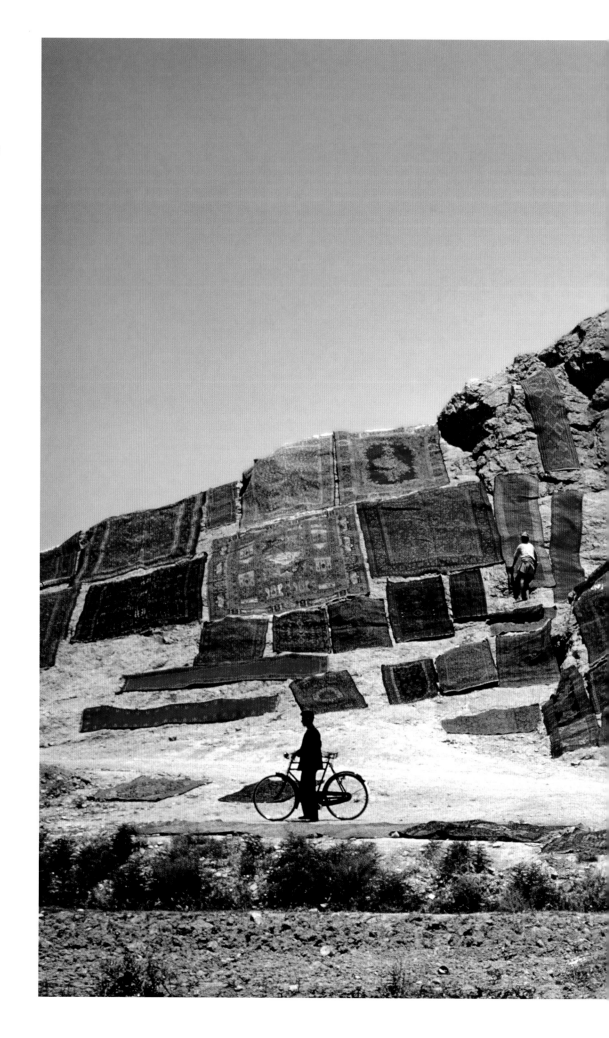

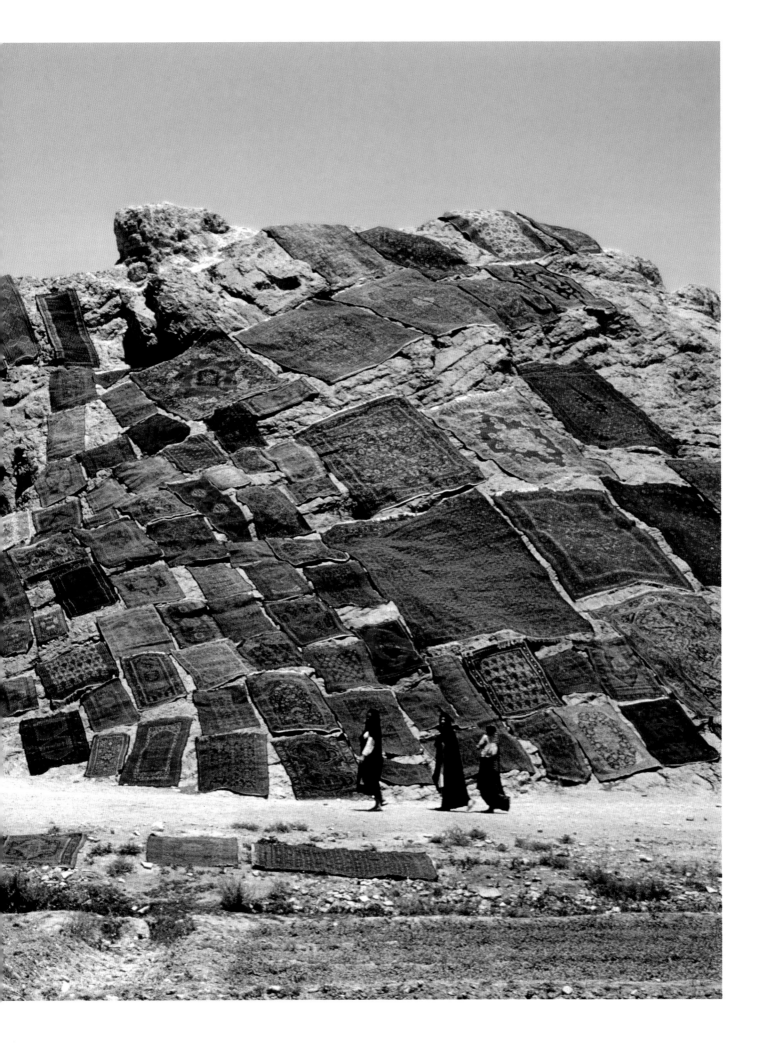

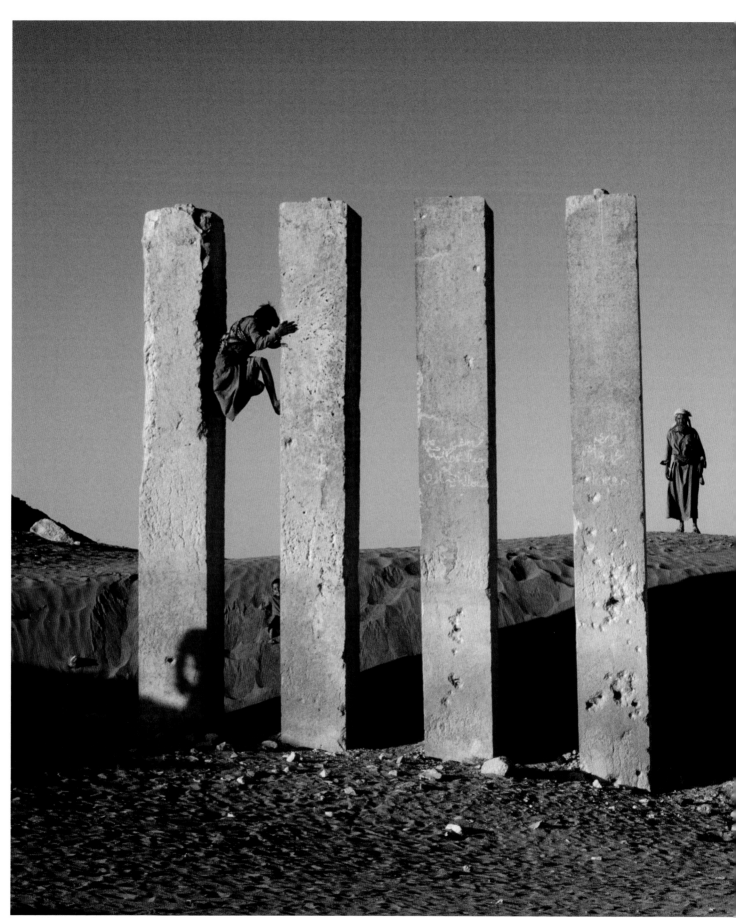

Lynn Abercrombie

North Yemen, 1984

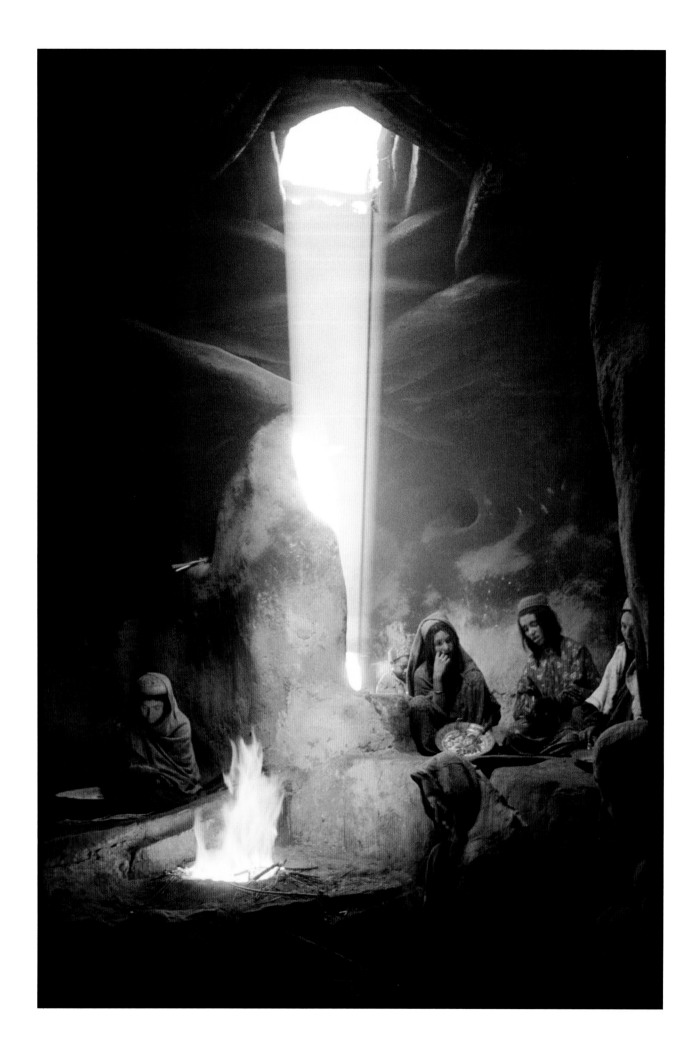

Afghanistan, 1967 (both)

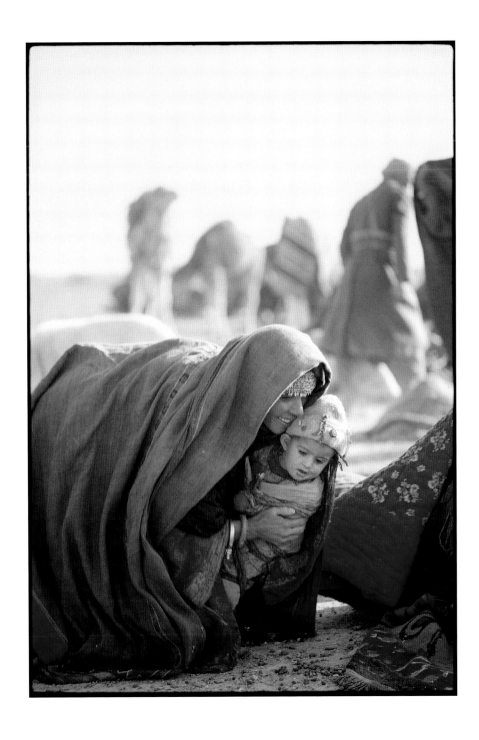

Tom Abercrombie in the Empty Quarter,
Saudi Arabia, 1965 (opposite)

Kuzmar, Oman, 1981 (below)

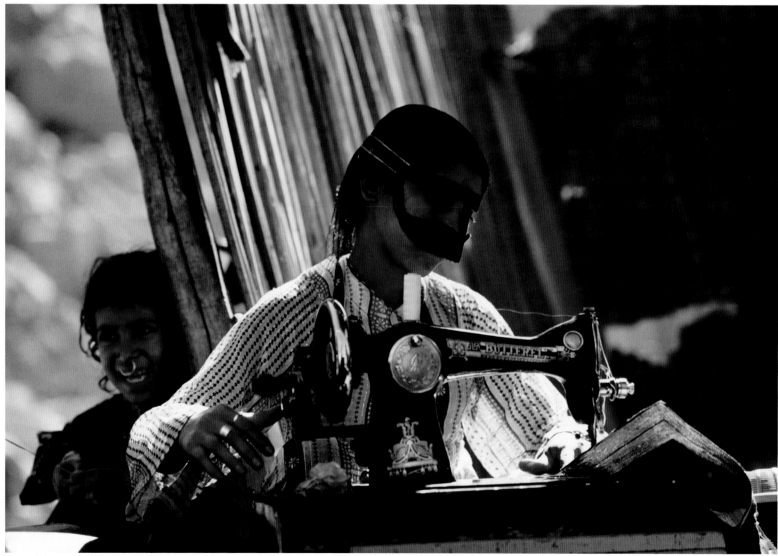

Lynn Abercrombie

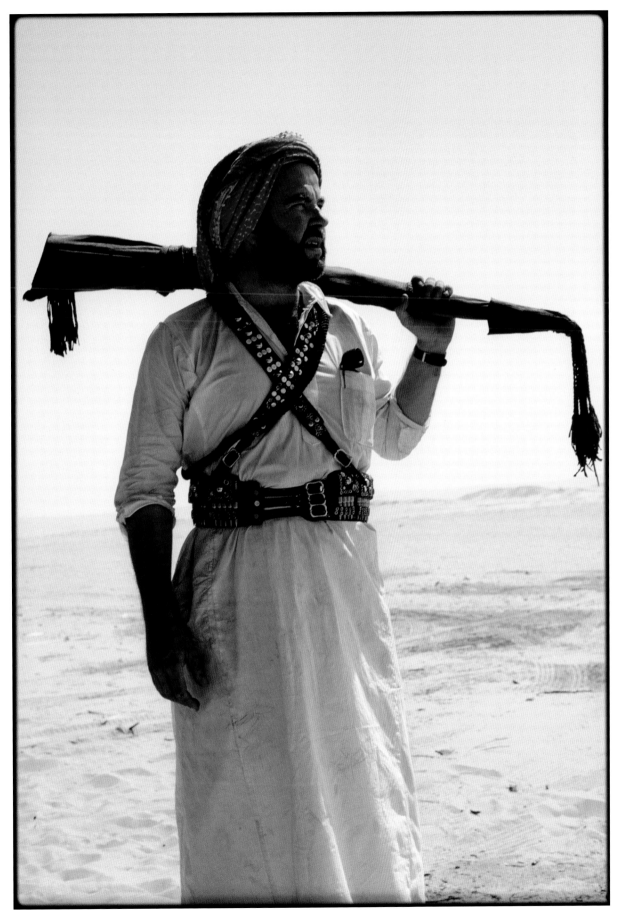

Lynn Abercrombie

Muscat, Oman, 1980

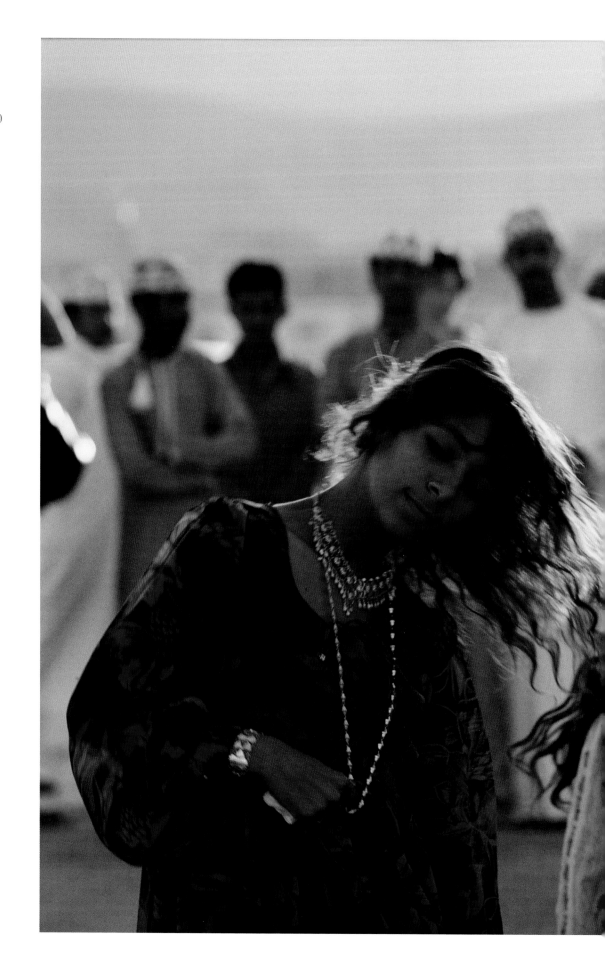

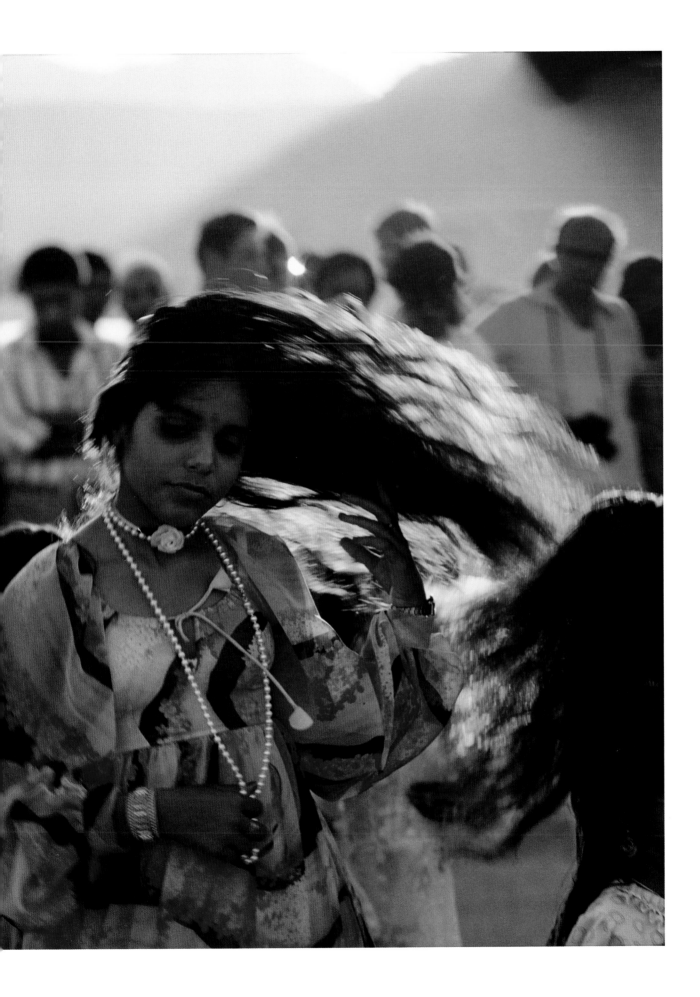

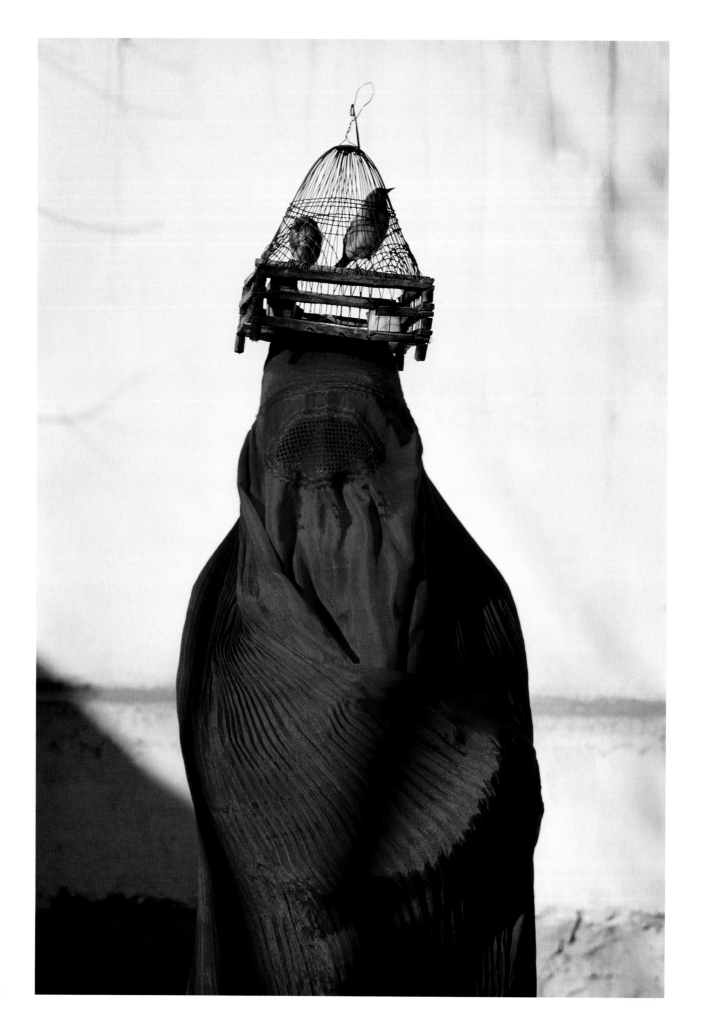

"[Medieval Islam] is an Arabian Nights world of caravans, veiled harems, sailing dhows, whirling dervishes, and forbidden cities—a world of brigands and bow-and-arrow wars, of banquets with turbaned sultans and mirages wrought by threadbare fakirs. Most marvelous of all, much of it survives today."
—T.A., Afghanistan, 1967

"I just took his picture—one shot—and walked on to something else. I didn't know him or talk to him. But his gaze is arresting and captures the fervor of Islam."
—T.A., Saudi Arabia, 1965

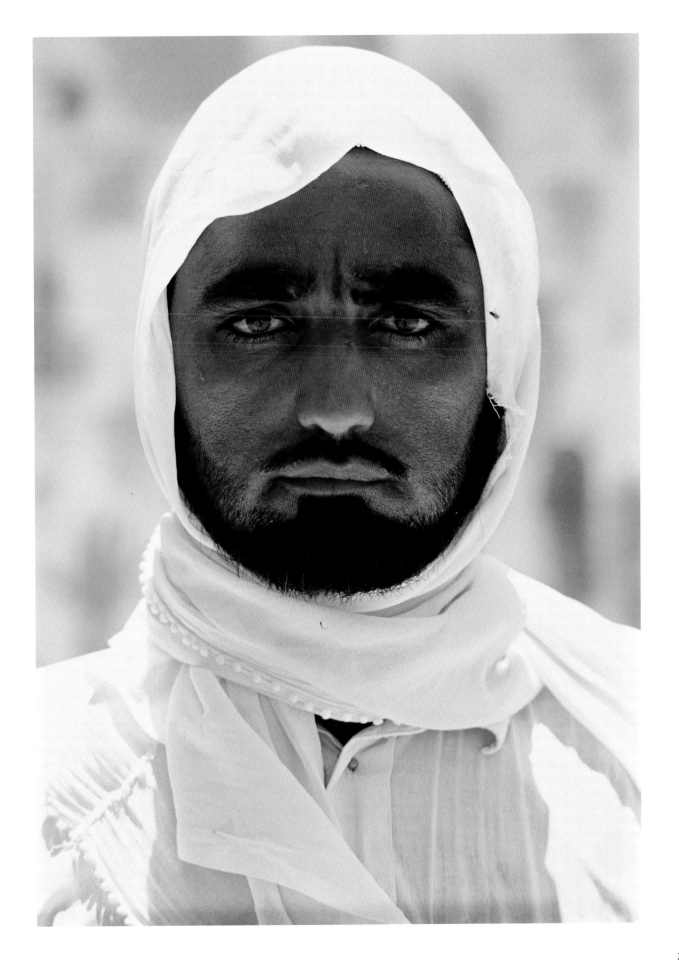

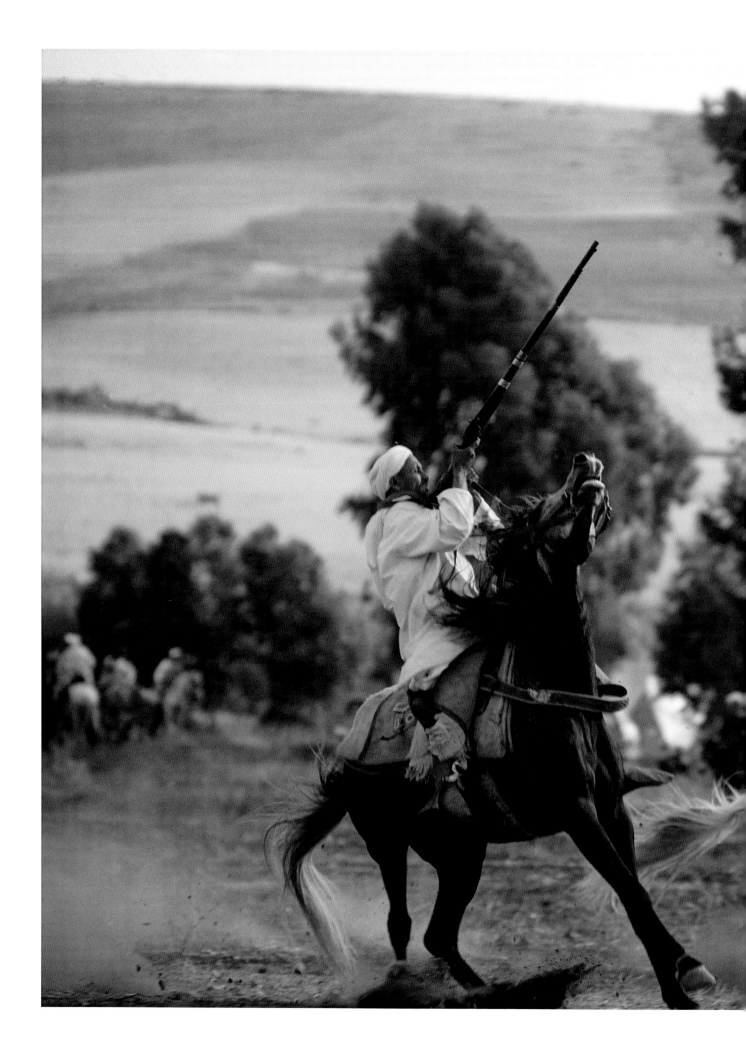

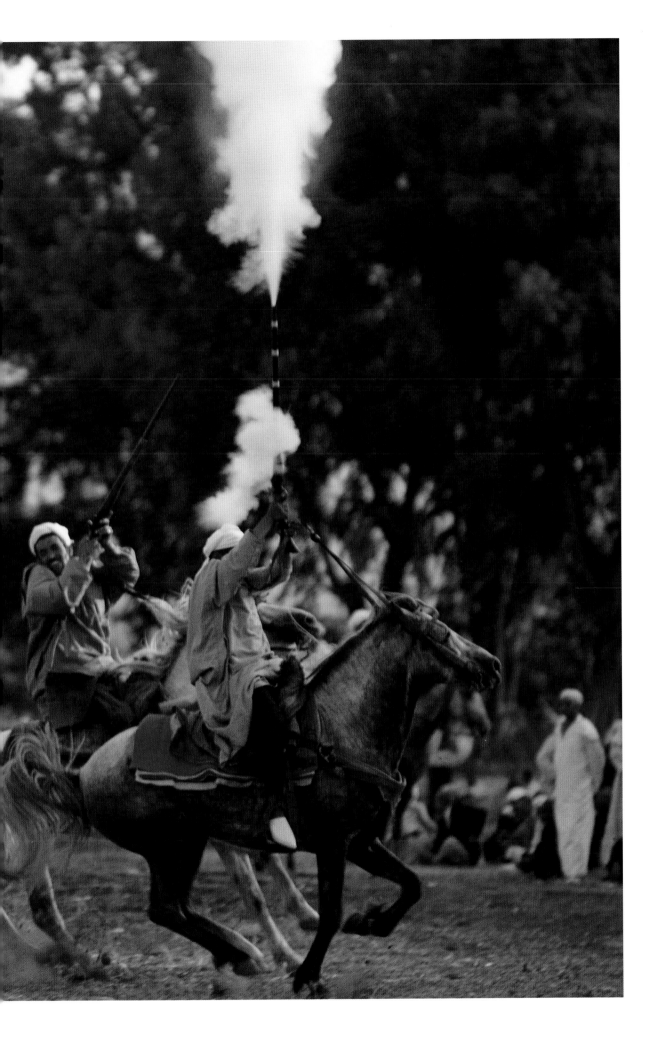

Morocco, 1970

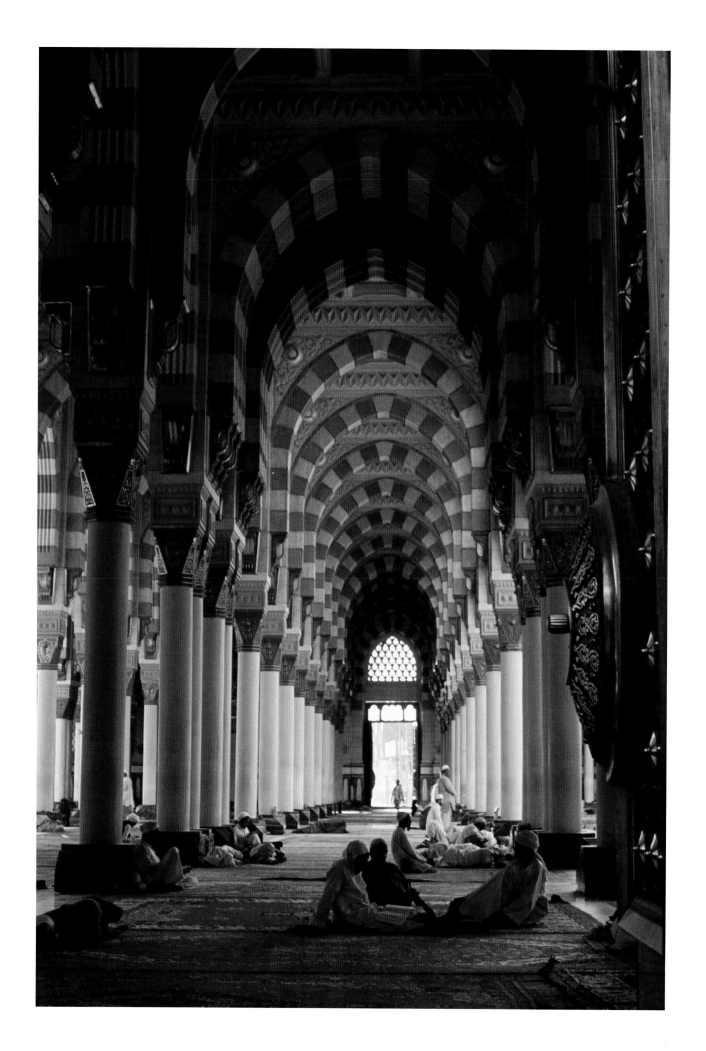

Saudi Arabia, 1965

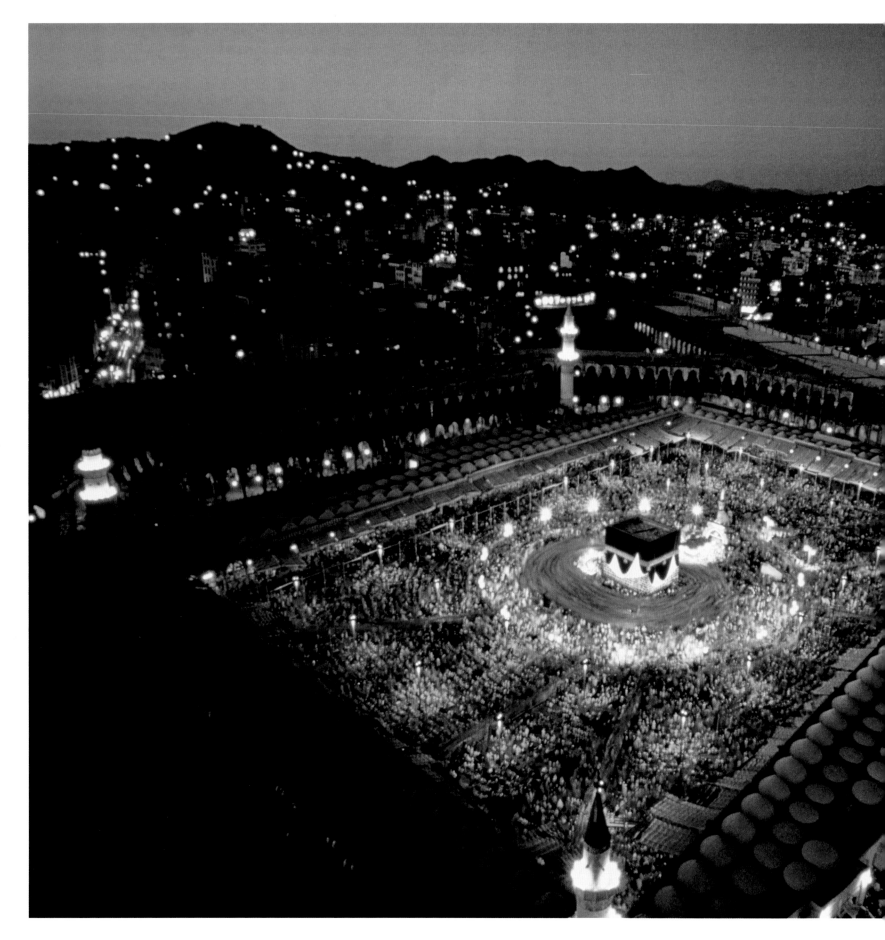

"Greetings and best wishes from Islam's holiest city. I've just had the singular honor to witness, to cover photographically, and to participate in one of the most moving experiences known to man, the annual pilgrimage to Mecca...."

—T.A., Mecca, Saudi Arabia 1965

Tom Abercrombie indicates a feature on the Wabah meterorite, discovered in
the Empty Quarter, Saudi Arabia, May 1965.

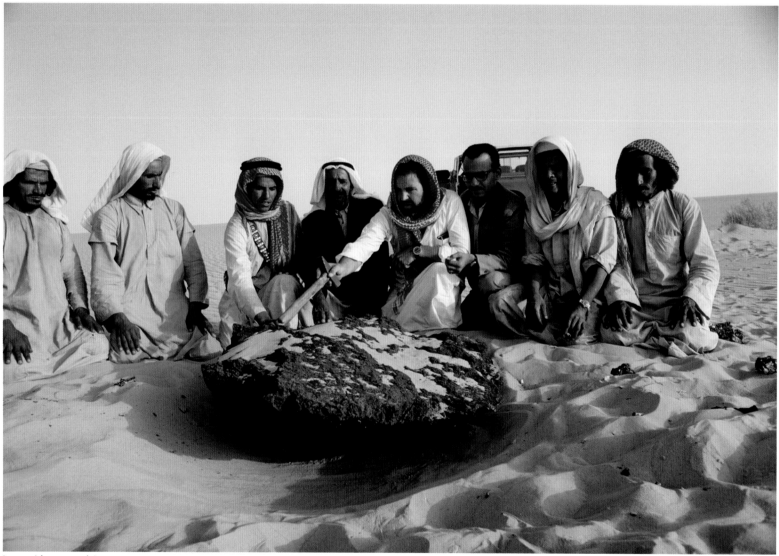

Lynn Abercrombie

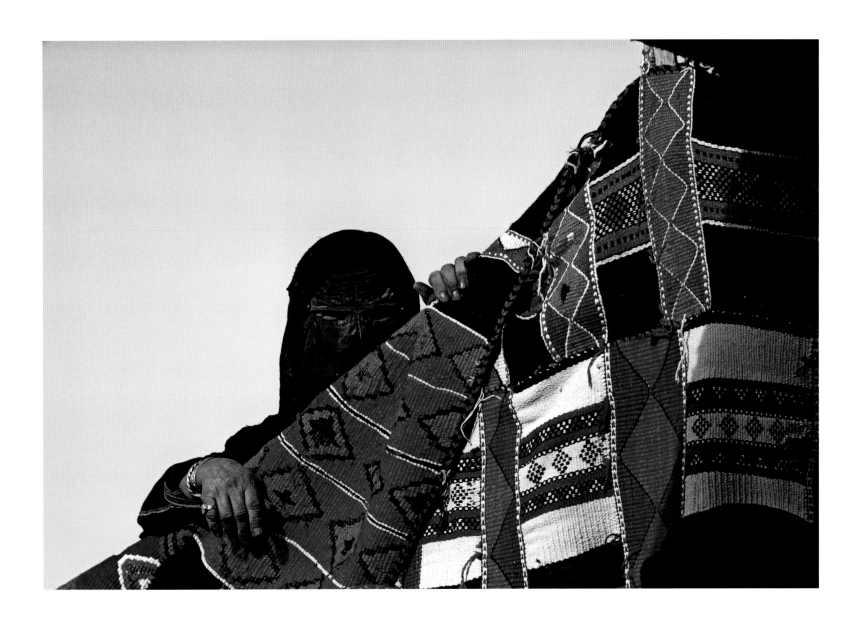

Algiers, 1972

Ladakh, India, 1977 (below)
Ladakh, India, 1978 (opposite)

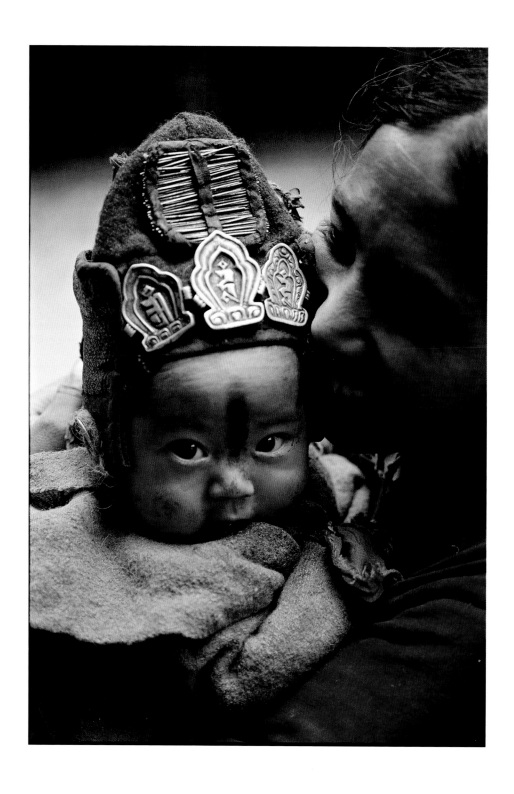

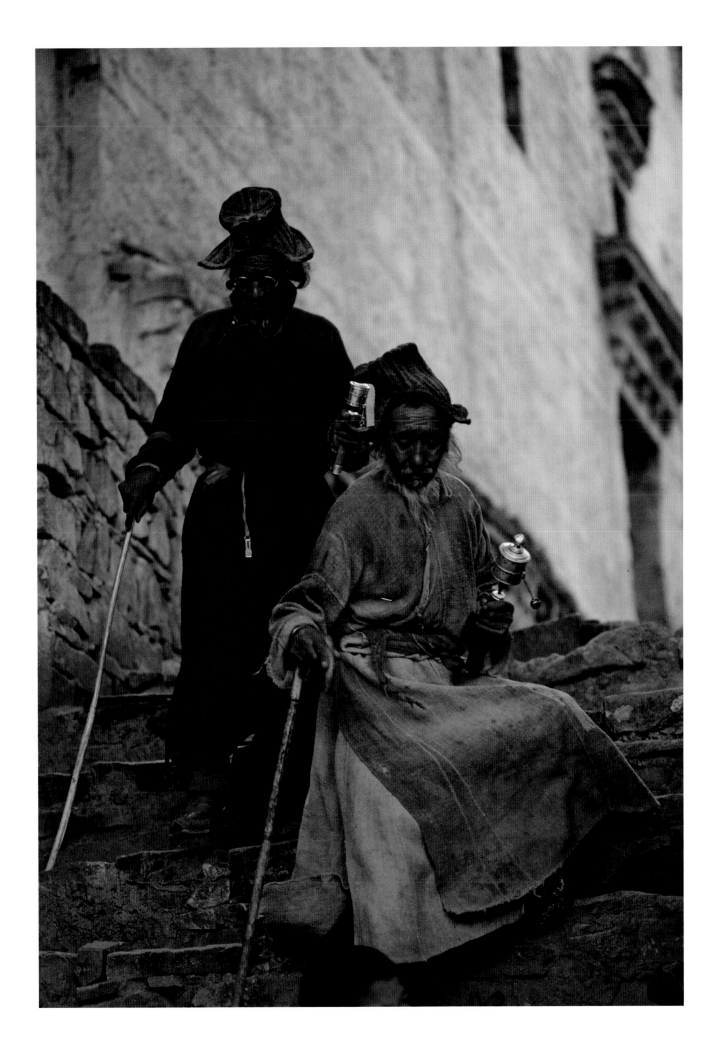

Ladakh, India, 1977 (both)

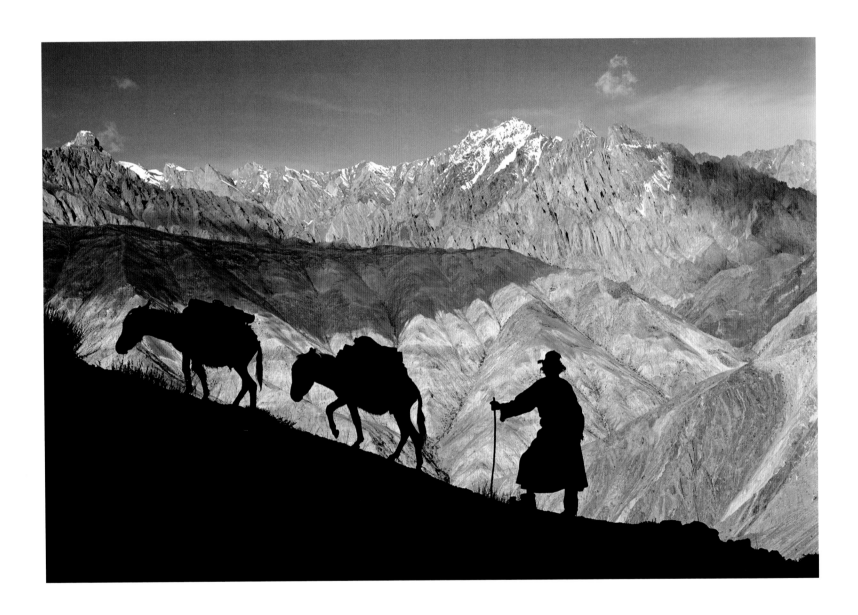

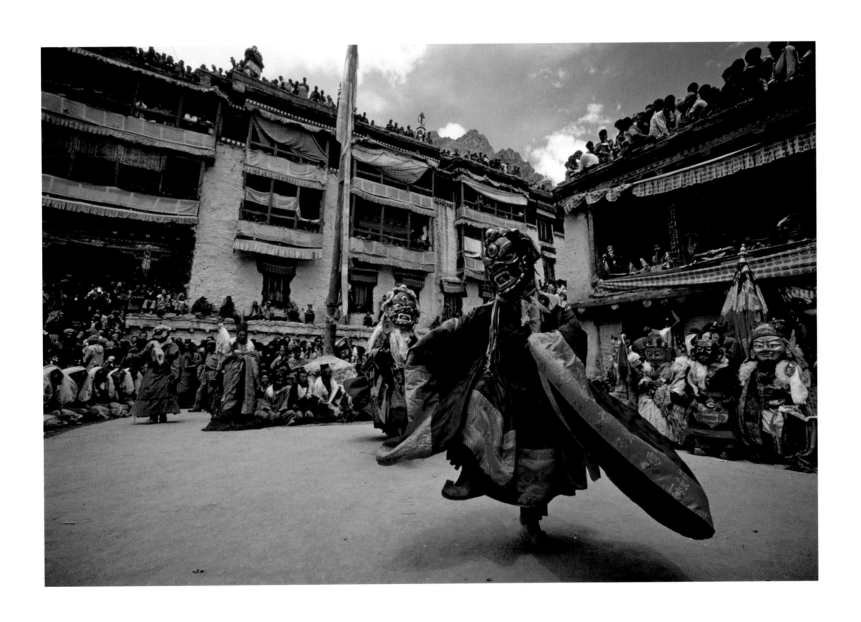

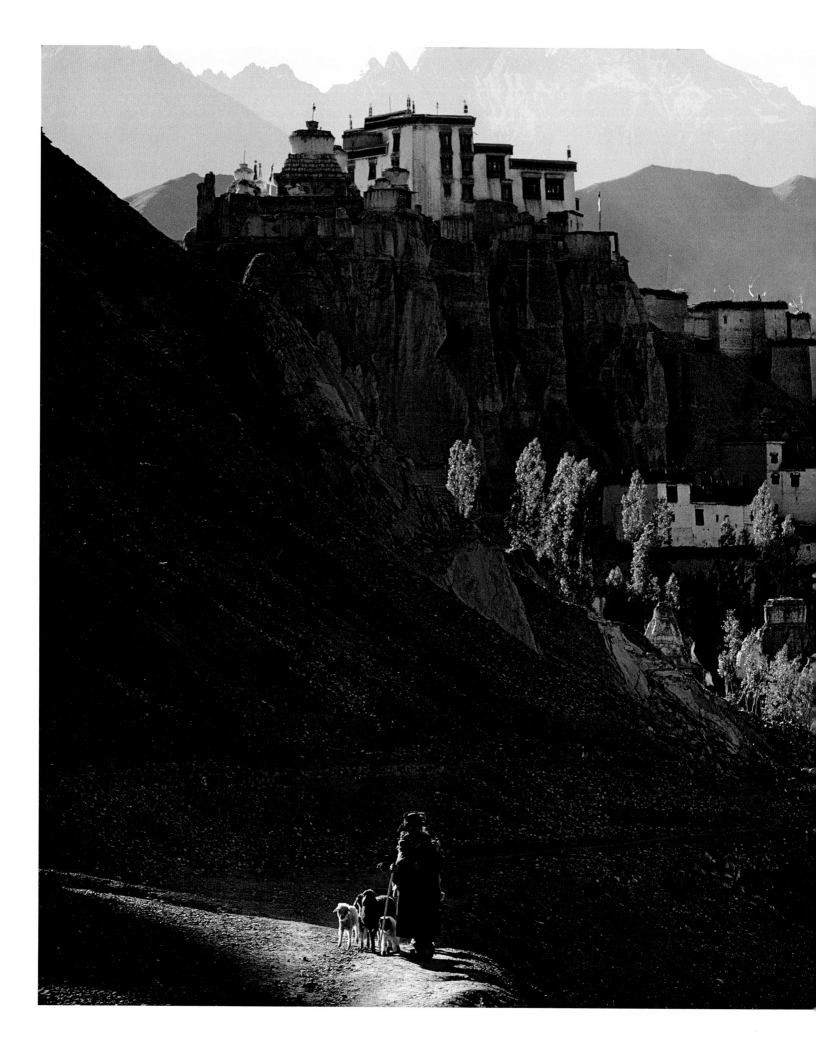

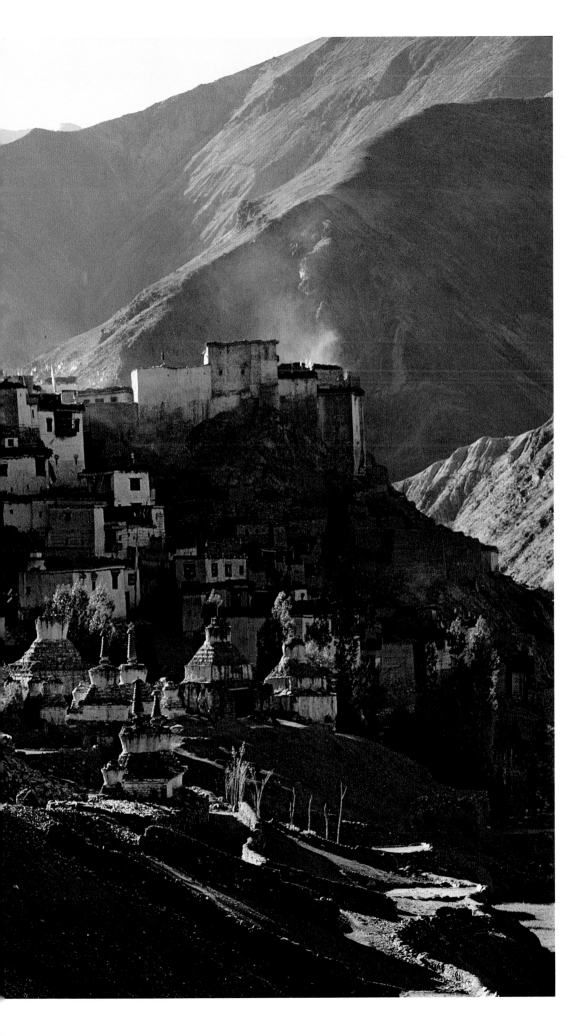

"As a guest in this lamasery, 11,000 feet above sea level, I spent several days, rising before dawn to an adagio of gongs and prayer chants. One day, along a nearby trail, an aged shepherdess and her flock grew larger. I exposed the frame—and they passed forever."
—T.A., Lamayuru Gompa, Ladakh, India, 1977

Epilogue

BY SAM ABELL

WAS THERE A "GREATEST GENERATION" of photographers at National Geographic? I certainly thought so when I arrived in 1970. It was the generation that Volkmar Wentzel belonged to. I was 25 years old, so these men and their colleagues defined for me and for my generation what it meant to be a National Geographic photographer. For 30 years their lives and work stood forth to me as an example of what one could accomplish with the incomparable opportunity of this career.

But which generation would Wentzel and Abercrombie have said was the greatest? Undoubtedly they would have said the postwar generation of photographers led by the remarkable Luis Marden. And who did Marden pattern his life on? It could only have been the man who created this life from scratch, Maynard Owen Williams. Before him there was photography at National Geographic, but no photographic lives. No one from my time knew Williams but we knew and admired Marden, Wentzel, and Abercrombie. Through them we felt a connection to their generation and to the generation of Williams.

The message these men sent forward to our generation was an inspiring one, but also intimidating. Marden, Wentzel, and Abercrombie were members of the *Geographic*'s elite Foreign Editorial Staff. It was composed of those correspondents whose capability was considered complete—they could both photograph and write their stories from anywhere in the world. But gradually I began to understand that there was more than visual or literary skill involved in their assignments. They weren't just reporting, they were often at the center of things, living out their lives on location.

In Wentzel's atmospheric office at the Geographic were artifacts, mementos, and photographs of his far-flung assignments. Most of the memorabilia was from Africa where he had worked closely with tribal people. But one of the most remarkable images on his walls was made far from Africa and it fascinated me. It was of a formal Viennese ball held in a grand palatial room. The dancers were dressed in dazzling clothes and the camera had caught them at a climactic moment of the waltz. The photograph was brilliantly lit with electronic flash but the effect was of a scene from another century. Who, I wondered, could still dance with such style? How would you even know how to dress for such an occasion? How had Volkmar gotten permission to be there as a photographer? And how had he set up the complex lighting and known when to take the picture?

In his wonderfully Austrian-accented English Volkmar explained the lighting and the carefully worked out camera angle. As he spoke it gradually became clear to me that he wasn't only at the ball as a photographer; he was an invited guest. He was one of the waltzers who, for a moment, stepped away from the ballroom floor and made the photograph I was admiring, then resumed dancing.

Volkmar's modestly told story confirmed for me a thought I first had in high school paging through *National Geographic* magazine: The photographs were admirable but there was also the strong suggestion of the life behind the photographs that I could only imagine. The photographs were made by men who had just stepped away from their lives for a moment.

Now I was hearing those stories firsthand. From Marden there were the stories of finding a new orchid in South America and the wreck of the H.M.S. *Bounty* in the South Pacific. His underwater flash photograph of hands emerging from a cloud of silt and holding an ancient amphora is classic Marden. He found the wreck, invented the flash, and co-invented, with Jacques Cousteau, the Aqua-Lung that made the entire enterprise possible. His photograph was about archaeology, but it was also autobiographical.

Realizing all of that made me reconsider what it meant to be a National Geographic photographer. The men of their generation did much more than make photographs. Wentzel spoke the principal languages of Europe. Abercrombie was fluent in Arabic, French, and Spanish. Marden was adept at learning languages. They were at ease in deeply traditional tribal societies and in the world of diplomacy.

Of these men, the one I knew best was Abercrombie. The more I learned about him the more intriguing he became. One day I visited his house by the Chesapeake Bay. In it was a memorable room that seemed to bring alive the essence of National Geographic. The entrance was through a mosque-style wooden door. Inside were oriental carpets, framed famous photographs, maps, charts, mementos, books, manuscripts, and artifacts. Inside a small glass dome was a shrunken human head. "That's a gift from Marden," he said. "His wife didn't want it around the house anymore."

By then I'd been a photographer at National Geographic for more than 20 years. It would be my only career. In honor of that I began thinking I'd like one signature experience that symbolized this life. Tom was to give me that gift. We had been assigned to finish a story in the mountains of Spain. Tom was the writer; I was doing the photography. One morning we were having coffee in an old stone Belgian castle with a woman Tom knew who was living there with her two sons. After coffee, the woman gave Tom a small worn book and asked him what it was. He took his pipe down and turned the book over in his hands, then opened it.

"It's Arabic," he said. I glanced at the elegant undecipherable calligraphy. "What does it say?" she asked. "They're prayers," Tom replied. "Read some to me," she said. Tom looked across the table and thought for a moment. (He thought: "She's Belgian. Her Spanish is weak and her English is poor.") Then he looked down at the Arabic prayers and began to speak them out in French so that the Belgian woman and her two sons could understand them.

I thought, "This is it. A man from Minnesota reading Muslim prayers in French to a Belgian family in a Spanish castle." It was episodes like this that lead me to gratefully and affectionately say that the generations of photographers that preceded mine were the greatest. And our generation? We were the luckiest. We knew Luis, Volkmar, and Tom. They were our teachers and friends.

Publications in *National Geographic* Magazine

Maynard Owen Williams

Russia's Orphan Races: Picturesque Peoples Who Cluster on the Southeastern Borderland of the Vast Slav Dominions, Oct. 1918

Between Massacres in Van, Aug. 1919

The Descendants of Confucius, Sept. 1919

Syria: The Land Link of History's Chain, Nov. 1919

Where Slav and Mongol Meet, Nov. 1919

Adventures with a Camera in Many Lands, July 1921

Czechoslovakia, Key-Land to Central Europe, Feb. 1921

Through the Heart of Hindustan: A Teeming High-way Extending for Fifteen Hundred Miles, from the Khyber Pass to Calcutta, Nov. 1921

At the Tomb of Tutankhamen: An Account of the Opening of the Royal Egyptian Sepulcher Which Contained the Most

Remarkable Funeral Treasures Unearthed in Historic Times, May 1923

The Coasts of Corsica: Impressions of a Winter's Stay in the Island Birthplace of Napoleon, Sept. 1923

The Grand Duchy of Luxemburg: A Miniature Democratic State of Many Charms Against a Feudal Background, Nov. 1924

Latvia, Home of the Letts: One of the Baltic Republics Which Is Successfully Working Its Way to Stability, Oct. 1924

Carnival Days on the Riviera, Oct. 1926

A Naturalist with MacMillan in the Arctic, Mar. 1926

Skirting the Shores of Sunrise: Seeking and Finding "The Levant" in a Journey by Steamer, Motor-Car, and Train from Constantinople to Port Said, Dec. 1926

Struggling Poland: A Journey in Search of the Picturesque

Through the Most Populous of the New States of Europe, Aug. 1926

Color Records from the Changing Life of the Holy City, Dec. 1927

East of Suez to the Mount of the Decalogue: Follow-ing the Trail Over Which Moses Led the Israelites from the Slave-Pens of Egypt to Sinai, Dec. 1927

Round About Liechtenstein: A Tiny Principality Which the Visitor May Encompass in a Single View Affords Adventurous Climbs Among Steep Pastures and Quaint Villages, Nov. 1927

Seeing 3,000 Years of History in Four Hours: A Pan-orama of Ancient, Medieval, and Modern Events Against a Background of Mythology Unfolds During an Airplane Journey from Constantinople to Athens, Dec. 1928

Unspoiled Cyprus: The Traditional Island Birthplace of Venus Is One of the Least Sophisticated of Mediterranean Lands, July 1928

Turkey Goes to School, Jan. 1929

New Greece, the Centenarian, Forges Ahead, Dec. 1930

The Citroën Trans-Asiatic Expedition Reaches Kashmir: Scientific Party Led by Georges-Marie Haardt Successfully Crosses Syria, Iraq, Persia, and Afghanistan to Arrive at the Pamir, Oct. 1931

Bulgaria, Farm Land Without a Farmhouse: A Nation of Villagers Faces the Challenge of Modern Machinery and Urban Life, Aug. 1932

First Over the Roof of the World by Motor: The Trans-Asiatic Expedition Sets New Records for Wheeled Transport in Scaling Passes of the Hima-layas, Mar. 1932

From the Mediterranean to the Yellow Sea by Motor: The Citroën-Haardt Expedition Successfully Completes Its Dramatic Journey, Nov. 1932

Looking in on New Turkey, Apr. 1932

Afghanistan Makes Haste Slowly, Dec. 1933

The Poland of the Present, Mar. 1933

When Czechoslovakia Puts a Falcon Feather in Its Cap, Jan. 1933

By Car and Steamer Around Our Inland Seas, Apr. 1934

By Motor Trail Across French Indo-China, Oct. 1935

Great Britain on Parade, Aug. 1935

The Suez Canal: Short Cut to Empires, Nov. 1935

Down Idaho's River of No Return, July 1936

How Warwick Was Photographed in Color, July 1936

Informal Salute to the English Lakes, Apr. 1936

Paris in Spring, Oct. 1936

Time's Footprints in Tunisian Sands, Mar. 1937

Around the World for Animals, June 1938

Pilgrims Still Stop at Plymouth, July 1938

Singapore: Far East Gibraltar in the Malay Jungle, May 1938

Bali and Points East: Crowded, Happy Isles of the Flores Sea Blend Rice Terraces, Dance Festivals, and Amazing Music in Their Pattern of Living, Mar. 1939

Buenos Aires: Queen of the River of Silver, Nov. 1939

The Celebes: New Man's Land of the Indies, July 1940

Modern Odyssey in Classic Lands: Troy's Treasures, Athens'Parthenon, and Rome's First "Broad Way" Influence Today's Banks, Costumes, Jewelry, and Railroad Timetables, Mar. 1940

Turkey, Where Earthquakes Followed Timur's Trail, Mar. 1940

Airplanes Come to the Isles of Spice: Once Magnet of World Explorers, the Moluccas Again Stand at Crossroads of History in the Netherlands Indies, May 1941

Ancient Temples and Modern Guns in Thailand, Nov. 1941

Classic Greece Merges Into 1941 News, Jan. 1941

The Columbia Turns on the Power, June 1941

Mother Volga Defends Her Own, Dec. 1942

New Delhi Goes Full Time, Oct. 1942

Crete, Where Sea-Kings Reigned, Nov. 1943

Sicily Again in the Path of War, Sept. 1943

Idaho Made the Desert Bloom, June 1944

The Isles of Greece, May 1944

American Alma Maters in the Near East, Aug. 1945

Guest in Saudi Arabia, Oct. 1945

The Turkish Republic Comes of Age, May 1945

American Fighters Visit Bible Lands, Mar. 1946

Back to Afghanistan, Oct. 1946

Bahrein: Port of Pearls and Petroleum, Feb. 1946

The Face of the Netherlands Indies, Feb. 1946

India Mosaic, Apr. 1946

Paris Lives Again, Dec. 1946

South of Khyber Pass, Apr. 1946

Syria and Lebanon Taste Freedom, Dec. 1946

I Become a Bakhtiari, Mar. 1947

Belgium Comes Back, May 1948

In Search of Arabia's Past, Apr. 1948

Lascaux Cave, Cradle of World Art, Dec. 1948

Luxembourg, Survivor of Invasions, June 1948

2,000 Miles Through Europe's Oldest Kingdom, Feb. 1949

Oasis-hopping in the Sahara, Feb. 1949

Operation Eclipse: 1948, Mar. 1949

War-torn Greece Looks Ahead, Dec. 1949

Home to the Holy Land, Dec. 1950

Portrait of Indochina, Apr. 1951

Turkey Paves the Path of Progress, Aug. 1951

Pennsylvania Dutch Folk Festival: Visitors by Thou-sands Flock to Kutztown, Pennsylvania, Each Year for a Sample of "Dutch" Culture—and a Taste of Shoo-fly Pie, Oct. 1952

Pilgrims Follow the Christmas Star, Dec. 1952

Crete, Cradle of Western Civilization: With United States Help, Hard-working Cretans Have Erased War's Scars from Their Historic Bomb-rocked Island, Nov. 1953

Dublin's Historic Horse Show: Horse Lovers on Both Sides of the Atlantic Hail This Annual Event on Ireland's Green Old Sod, July 1953

National Geographic book: Great Adventures with National Geographic: Exploring Land, Sea, and Sky, 1963

Luis Marden

Boston Through Midwest Eyes, July 1936

Guatemala Interlude, October 1936

Yucatán, Home of the Gifted Maya: Two Thousand Years of History Reach Back to Early American Temple, November 1936

The Restoration of Colonial Williamsburg, April 1937

Connecticut, Prodigy of Ingenuity, September 1938

As São Paulo Grows: Half the World's Coffee Beans Flavor the Life and Speed the Growth of an Inland Brazil, May 1939

Buenos Aires: Queen of the River of Silver, Nov. 1939

Down the Rio Grande: Tracing this Strange, Turbu-lent Stream on Its Long Course from Colorado to the Gulf of Mexico Oct. 1939

Caracas, Cradle of the Liberator: The Spirit of Simón Bolívar, South American George Washington, Lives On in the City of His Birth, April 1940

Hail Colombia! Oct. 1940

On the Cortés Trail, Sept. 1940

Panama, Bridge of the World, Nov. 1941

Americans in the Caribbean, June 1942

Coffee Is King in El Salvador, Nov. 1944

A Land of Lakes and Volcanoes, Aug. 1944

To Market in Guatemala, July 1945

Land of the Painted Oxcarts, Oct. 1946

Guatemala Revisited, Oct. 1947

Santiago Atitlán, Guatemala

Shad in the Shadow of Skyscrapers, Mar. 1947

The Purple Land of Uruguay, Nov. 1948

Speaking of Spain, Apr. 1950

Holy Week and the Fair in Sevilla, Apr. 1951

Spain's Silkworm Gut, July 1951

Down East Cruise: [Nomad] Sails Along Maine's Rocky, Tree-clad Coast, Home of Yankee Lobster-men, Salty Fishermen, and Blue-water Sailors, Sept. 1952

Marineland, Florida's Giant Fish Bowl, Nov. 1952

Aviation Looks Ahead on Its 50th Birthday: Now a Billion-dollar Business, Airlines Plan Jet Transports, Fast Freighters, and Downtow Helicopter Ports, Dec. 1953

Fact Finding for Tomorrow's Planes: A Little Fan-in-a-bo Wind Tunnel Made Possible the Wrights' First Flight; Now Screaming Supersonic Winds Test Weird Shapes of Aeronautical Things to Come, Dec. 1953

Gloucester Blesses Its Portuguese Fleet: With Prayer and Pageantry, Venturesome Deepwater Fisher-men Ask the Protection of Our Lady of Good Voyage, July 1953

Aviation Medicine on the Threshold of Space: Ser-vice Doctors, Facing Medical Problems Unknown

Odysseys and Photographs

Leah Bendavid-Val, Mark Collins Jenkins, Viola Kiesinger Wentzel,
Gilbert M. Grosvenor

Published by the National Geographic Society

John M. Fahey, Jr., President and Chief Executive Officer
Gilbert M. Grosvenor, Chairman of the Board
Tim T. Kelly, President, Global Media Group
John Q. Griffin, President, Publishing
Nina D. Hoffman, Executive Vice President;
 President, Book Publishing Group

Prepared by the Book Division

Kevin Mulroy, Senior Vice President and Publisherw
Leah Bendavid-Val, Director of Photography Publishing
 and Illustrations
Marianne R. Koszorus, Director of Design

Barbara Brownell Grogan, Executive Editor
Elizabeth Newhouse, Director of Travel Publishing
Carl Mehler, Director of Maps

Staff for This Book

Leah Bendavid-Val, Editor
Rebecca Lescaze, Text Editor
Susan Welchman, William Bonner, Illustrations Editors
Cinda Rose, Art Director
Mark Jenkins, Picture Legends Writer
Al Morrow, Design Assistant
Richard S. Wain, Production Project Manager
Robert Waymouth, Illustrations Specialist

Jennifer A. Thornton, Managing Editor
R. Gary Colbert, Production Director

Manufacturing and Quality Management

Christopher A. Liedel, Chief Financial Officer
Phillip L. Schlosser, Vice President
Chris Brown, Technical Director
Nicole Elliott, Manager
Monika D. Lynde, Manager
Rachel Faulise, Manager

Founded in 1888, the National Geographic Society is one of the largest nonprofit scientific and educational organizations in the world. It reaches more than 285 million people worldwide each month through its official journal, *National Geographic,* and its four other magazines; the National Geographic Channel; television documentaries; radio programs; films; books; videos and DVDs; maps; and interactive media. National Geographic has funded more than 8,000 scientific research projects and supports an education program combating geographic illiteracy.

For more information, please call 1-800-NGS LINE (647-5463) or write to the following address:

National Geographic Society
1145 17th Street N.W.
Washington, D.C. 20036-4688 U.S.A.

Visit us online at www.nationalgeographic.com/books

For information about special discounts for bulk purchases, please contact National Geographic Books Special Sales: ngspecsales@ngs.org

For rights or permissions inquiries, please contact National Geographic Books Subsidiary Rights: ngbookrights@ngs.org

ISBN: 978-1-4262-0172-1

Library of Congress Cataloging-in-Publication Data

Odysseys and photographs : four National Geographic field men : Maynard Owen Williams, Volkmar Wentzel, Luis Marden, Thomas Abercrombie / authors, Leah Bendavid-Val . . . [et al.].
 p. cm.
 Includes biographical references and index.
 ISBN 978-1-4262-0172-1 (alk. paper)
 1. Photographers—Biography. 2. National Geographic Society (U.S.) I. Bendavid-Val, Leah.
 TR139.039 2008
 779.09'2—dc22
 2008023361

Printed in China